10643777

MASTER CLASS IN SEASCAPE PAINTING

By E. John Robinson

WATSON-GUPTILL PUBLICATIONS/NEW YORK
PITMAN PUBLISHING/LONDON

First published 1980 in the United States and Canada by Watson-Guptill Publications,
a division of Billboard Publications, Inc.,
1515 Broadway, New York, N.Y. 10036

Library of Congress Cataloging in Publication Data
Robinson, E. John, 1932–
 Master class in seascape painting.
 Bibliography: p.
 Includes index.
 1. Sea in art. 2. Painting—Technique. I. Title.
ND1370.R623 1980 751.4'5 79-22284
ISBN 0-8230-3012-1

Published in Great Britain by Pitman Publishing Ltd.,
39 Parker Street, London WC2B 5PB
ISBN 0-273-01510-9

All rights reserved. No part of this publication, may be
reproduced or used in any form or by any means—graphic,
electronic, or mechanical, including photocopying, recording.
taping, or information storage and retrieval systems—
without written permission of the publishers.

Manufactured in Japan

First Printing, 1980

To art students the world over
who hold the sea as their special teacher

I'd like to thank Don Holden and Dot Spencer for digging another book out of me. Also, special thanks to Bonnie Silverstein for a fantastic job of correcting my shortcomings in English, and to Bob Fillie for the excellent design of this book.

CONTENTS

Introduction 8

A Word About Sketching 11

Painting Materials and Equipment 17

PROJECT ONE. THE BIG WAVE 21

PROJECT TWO. CLEAR WATER 35

PROJECT THREE. THE CONFLICT 51

PROJECT FOUR. FOG 67

PROJECT FIVE. OUTLETS 83

PROJECT SIX. THE OPEN SEA 97

PROJECT SEVEN. MOONLIGHT 111

PROJECT EIGHT. SUN GLOW 127

Bibliography 142

Index 143

INTRODUCTION

In a constant effort to improve, I'm always competing with myself. I try to reach beyond what I've done in the past and seek out that which is new to me, a challenge that tries my creativity and my ability. There's no need to repeat the successes of the past when nature has so many new and exciting points of interest.

It's difficult to describe just what will "grab" me, but I know it when I see it. It may be as simple as a new shoreline or a different angle, or it may be the way the light strikes a wave, or a wave of unusual personality. It's not, however, anything I've painted before, unless I can see a way to improve upon the old . . . a new wrinkle, or a better one. The key to this search is time and an open mind. Like me, you must take the time to observe and be ready to accept the challenge when you see it. There are no ready-made compositions just waiting for an artist to come along and copy them. That is why we artists can step beyond the camera and remove a rock, or add a wave, or make a hundred other changes should it suit our purposes. We're creating the best possible surroundings for a point of interest that caught our eyes.

In my first book, *Marine Painting in Oil*, I gave basic lessons on seascape painting. I taught how to paint a basic wave, rock, spray, trickles, and so on in exacting detail. In my second book, *The Seascape Painter's Problem Book*, I selected special problems that confront the seascape artist and showed how I work them through for a particular

result. Now, in this third book, *Master Class in Seascape*, I describe how to use those methods and ideas, along with many new ones, to paint on location.

First, because many of my ideas come from sketches, *Master Class in Seascape* opens with a chapter on how I sketch. It's actually more a lesson on how I select and compose a subject, because a sketch is just a manner of shorthand for what you observe. I also describe the materials I use in sketching, and in the next section, the materials and equipment I use in oil painting. Then I proceed to the heart of the book, a series of projects that show how I paint eight different subjects, each posing another challenge to the seascape painter. Each project begins with a description of a point of special interest that caught my attention on location. Then I show photographs and sketches I made on the scene and discuss how I select and arrange particular elements in order to develop a composition, and how I decide the colors I'll use in the painting. Finally, I review all the information I've gathered so far about the subject (or I may choose to discuss one aspect of the subject that needs particular attention), then I'm ready to start the actual painting. In the full-color step-by-step demonstration that follows I analyze my painting procedure in complete detail and describe how the information I've gathered is put to work.

Each of these eight subjects are taken from a different location, and each presents a different challenge, and a different aspect of the sea. In

some cases, for example, in Project One, where I show the power and movement of a big sea, the challenge is in painting a particular mood. But even there the composition is enhanced by a giant wave that leaves no doubt as to its strength. The second project is also a mood painting. It describes the warm, clear water of Hawaii and I try to capture not the feeling of a particular locale, but also the special personality of its surf. Here the challenge is also to paint clear water, only a few inches deep.

In Project Three, I deal with an entirely different mood, the age-old conflict of land and sea. On a trip to England, I found that mood on the western coast, where I got the impression of ancient battlefields and long-forgotten struggles. In this project, working from careful notes, sketches, and photographs, I develop a composition that portrays this battle, and find a few unexpected problems along the way. Project Four, fog, is also inspired by the English coast. I've painted the sea in fog many times, especially on the Pacific coast, but this time, in England, I had a famous rock to deal with. When I saw it looming out of mist, with a bright surf in the foreground, I knew that painting it in fog was the challenge. Fog, by its nature, contains interest and mystery. It also gives you a chance to be really selective as to exactly what and how much of any object you'll allow to show through.

I've also recently discovered that having an open mind and spending enough time in other aspects of the sea can open up many new points of interest. In the next two projects, I

paint new areas of study not found in my previous books—a shallow rocky creek and the open sea.

Only recently, when I stepped back far enough from the surf to realize that there were challenges on the beach as well, have I discovered that having an open mind can open up other new points of interest. The next two projects deal with new areas of exploration and challenge for me. In Project Five, I find painting a shallow rocky creek quite a challenge, but a fascinating one and I demonstrate how I gather material and work up a composition around an outlet creek on a beach. In Project Six, I discover a new, exciting subject in the open sea, where there are no rocks, headlands, or breakers to focus attention on. Here the challenge is in filling a canvas with just water and still having an interesting composition.

The last two projects are concerned with handling natural lighting—that of the moon and the sun, respectively. In Project Seven, I make a new improvement on an old theme and portray a moonlit scene I recently observed on a beach with driftwood and an outlet. Though the moon is partially obscured by clouds and the rest of the scene is quite dark, the moonlight reflected on the beach carries more impact than the relative darkness of the scene. In Project Eight, while painting an Oregon beach, I find that making the sun glow still presents a challenge, even though I've done it many times before. I show you how to use contrast to make the light show up better and describe the transitions of color that add to the glow effect. I also find a few more reasons for reflecting the light.

I wish to add that the photographs in this book are my own. I rarely find something of use in someone else's photographs. I used a good 35mm camera with plus X-pan professional black-and-white film. I like black and white because it clearly shows values without the influence of color. When I'm shooting for color, I use the same camera with C-135 Kodacolor II film for color prints. But a word of advice about using photographs: I've never yet found a photograph that was suitable for copying. If you're looking for anything that easy, you're not reaching out. Besides, copying a photograph is only a short step beyond being a camera. As a creative artist, you should select your subject from many sources to compose something that best expresses your own personal view of the world.

As an artist, you're in the business of speaking to others through your paintings. You're not just a camera that records a scene, but a human being that records for the world what you see through your eyes. You give the world moments they've missed, along with your thoughts, your interpretation according to your own special background and, finally, your interpretation of life. It's a very personal view of the world, but there are many who'll share that view.

Too often I see paintings that are the result of too much impulse and too little preliminary study. Those paintings I see are my own. I'm constantly trying to control my urge to paint without first working out the problems. But on the other hand, never underestimate the importance of impulse in sketching. Often, your first impulse or view of a subject is the freshest and should be recorded as quickly as possible. Then (as I'll demonstrate) think it through for the best results. It should capture the essence of the inspiration without being overworked or corrected. But before flying blindly to the canvas, take the time to compose.

Think of your special inspiration as a potentially great message. Nurture it carefully with all the time and love that it requires. Find subjects of interest that support it without distraction and eliminate those that would fight for attention. Keep only one major thought to a picture. Place your center of interest in surroundings that enhance it. Bring it to fruition and then, but only then, commit it to canvas for that special immortality that goes with a painting.

Our canvases are extensions of ourselves. They're not just pictures of the sea or the sky or the land. Remember that canvases will outlive the artists that covered them and will be scrutinized by generations to come. Let us not be hasty.

Finally, I ask you to read this book carefully. If you can also get to the sea, you'll have many new tools at your disposal. But if you can't work from nature, you'll still have learned some new approaches and perhaps been challenged to take that extra step. . . . Reach out.

A WORD ABOUT SKETCHING

I make several types of sketches, depending on the time I have or the situation involved, and the materials I use varies with the nature of the sketch, or the individual situation.

SKETCHING MATERIALS

If I must travel light, I take only a pencil or felt-tip marker and a sketchbook. I've gradually come to enjoy the felt-tip pen because it can be used so quickly. I generally take two, both black: one with a large nib for general sketching and the other with a small nib for writing or detail work. My sketchbook has a smooth-textured paper and may be any size convenient to carry.

If I still want to work quickly but can manage to carry paints and water, I sketch in black and white acrylic, either on a watercolor block (where I peel off a sheet at a time) or on sheets of 300-lb watercolor paper cut to whatever size I choose to carry. (I use 300-lb paper because it doesn't wrinkle while I'm using it.)

If I decide to sketch with oils, everything goes into an old briefcase. Besides paints, palette, brushes, rags, and thinner, I also include a fold-up aluminum easel and a 9"x12" (2.5 x 30 cm) canvas or canvas board, but no stool. I can still sit on the ground or a rock without too much difficulty getting up. (Someday I may have to add a folding stool!)

I really prefer sketching in watercolor. It's light, fast-drying, and not messy. The colors are even more representative of transparent water than oils, and I don't have the feeling that I must paint a small but perfectly saleable painting, which sometimes gets in the way if I sketch with oils. In watercolor sketching I still travel light. I have a tackle box that holds my paints, brushes, viewfinder, paper towels, palette, and jug of water. In addition, I either carry a watercolor block or a board with paper. Again, I do without the stool, but I must tell you, I have learned to watch out for thistles and stickers! On page 19, you'll find a watercolor sketch that's typical of what I like to take back to my studio. It has captured the spirit of the place, has a good representation of the colors as I saw them, and has had most of the problems already eliminated by the procedure I use in sketching, which is to stop, get an overview, then select.

SELECTING A SUBJECT

Outdoor sketching or painting can be frustrating because there's so much to see. Students are often either too excited about the overwhelming inspiration, or they can't find anything interesting at all. I once had a teacher who made our class walk through and around the subject before he'd allow us to paint. Fortunately we were studying landscape and not seascape, but we all eventually learned to block out some points in favor of others. In other words, we began to select what was special to the scene according to how each of us perceived it. The pause helped the more enthusiastic students to eliminate much that would have cluttered their paintings, while those who weren't inspired were given the time to find the painting that was there all along. So take plenty of time before you decide what to paint.

To help find a subject, I recommend using a viewfinder. It can be either a 4"x6" (10 x 15 cm) frame or a hole cut out of a piece of cardboard. Look through it and move it slowly from one side to the other. Make mental notes of the most interesting features, then come back to them. Zero in on what could be a center of interest in a painting first, then begin looking for other, less interesting, points that will support the main theme.

A FINAL WORD

Sketching is the prerequisite of successful painting. It's the record of valuable first impressions from on-the-scene studying and is the essence of the creative mind. As I've already said, take plenty of time when sketching. That means take time before and between strokes of the pen or the brush. Those are the creative moments, the times of thought and impressions, the moment to communicate. Making marks on paper or canvas is the mechanical part, the transference of those thoughts so others may read them.

Sketching on Location

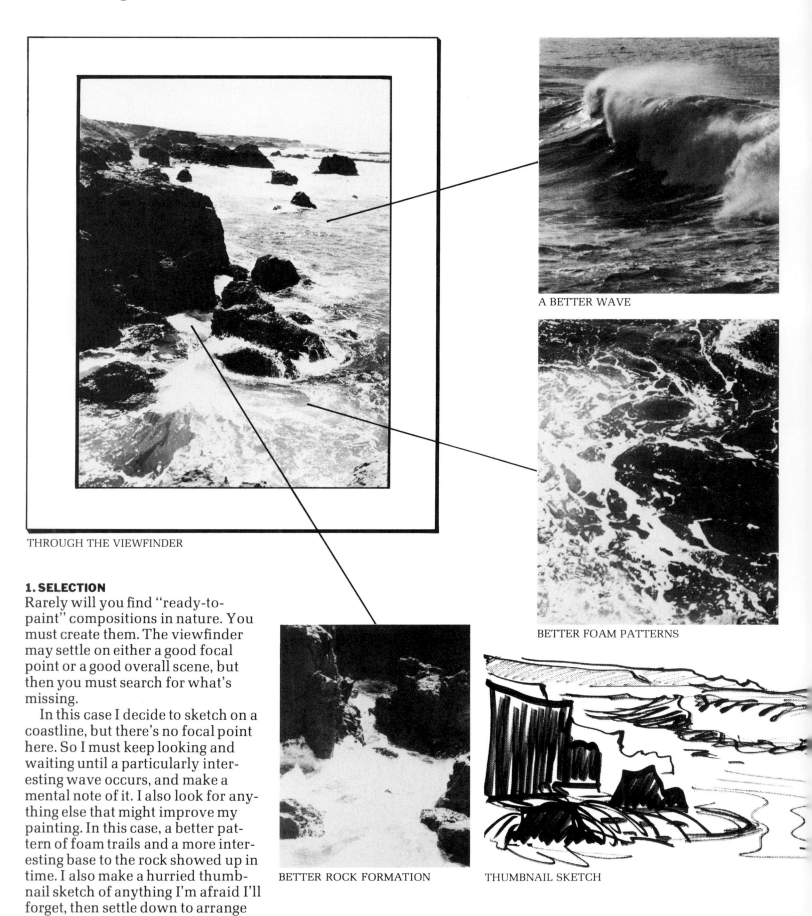

THROUGH THE VIEWFINDER

A BETTER WAVE

BETTER FOAM PATTERNS

BETTER ROCK FORMATION

THUMBNAIL SKETCH

1. SELECTION

Rarely will you find "ready-to-paint" compositions in nature. You must create them. The viewfinder may settle on either a good focal point or a good overall scene, but then you must search for what's missing.

In this case I decide to sketch on a coastline, but there's no focal point here. So I must keep looking and waiting until a particularly interesting wave occurs, and make a mental note of it. I also look for anything else that might improve my painting. In this case, a better pattern of foam trails and a more interesting base to the rock showed up in time. I also make a hurried thumbnail sketch of anything I'm afraid I'll forget, then settle down to arrange what I've selected. Using my memory or any number of thumbnail sketches helps me to record something that may be gone in an instant.

2. OUTLINE
Once I have a clear picture of what I want, I draw a simple outline of it on the paper. I try to arrange the lines for balance and direction, but don't go into detail of any kind. I may, however, put a bit more information into the area of interest than the rest of the composition.

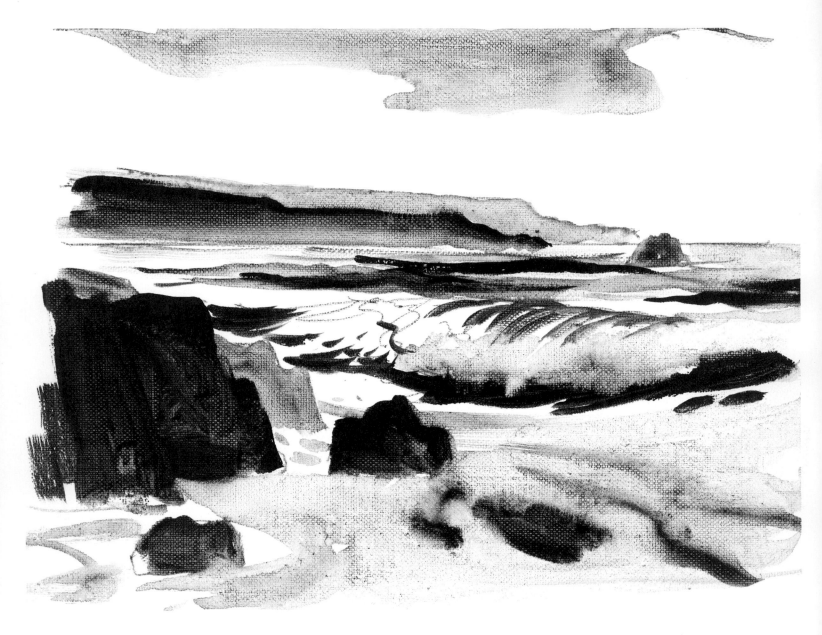

3. VALUES

Before I put in the values, whether I'm shading them in with a felt-tip pen, pencil, or watercolor, I stop and take another look at the scene. I ask myself: Is there anything else that should be added or taken away? Have I made the best arrangement I could? Is there a better choice? When I'm satisfied that I've selected what I think is best, I then think of how the arrangement of values will improve it.

Values can be placed anywhere. I first decide the location of the sun and the type of atmosphere I want. Do I want cloud shadows? Should the foreground rocks be the only dark area in the composition? How will the center of interest show up against everything else? When these and other questions are answered, I work the values into the outline drawing. In a sketch, I think only in terms of light, middle, and dark values. More subtle values fall into place later in a painting.

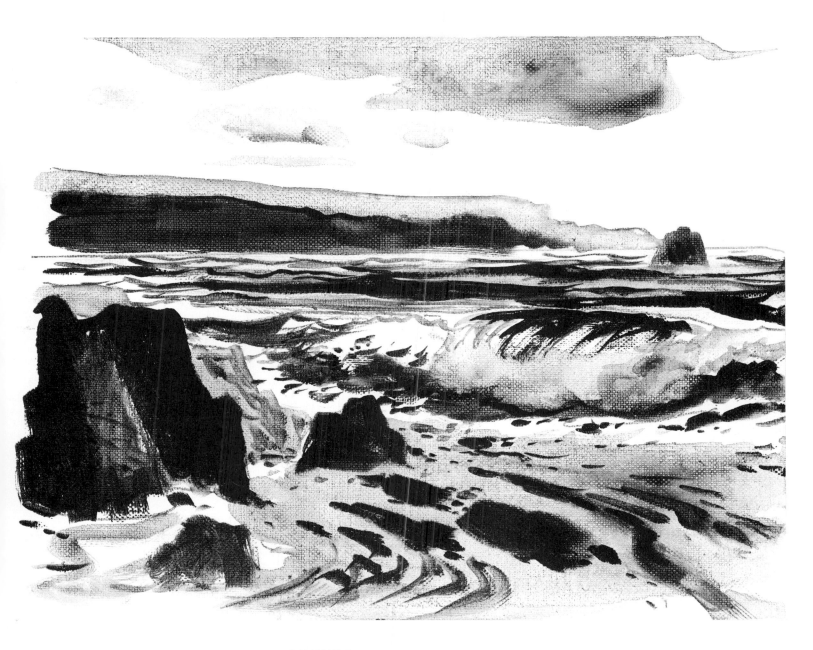

4. DETAILS

The last step is the frosting on the cake, the decoration that finishes the visual communication. But it may also destroy the groundwork I've laid, if I'm not careful. Just how finished you wish to make a sketch is up to you, the artist. However, no matter how far you go with it, don't cover up areas that should be left alone. Although it's hard to know just where to add detail or when to leave it out, it will help to follow this simple rule: Concentrate detail on or near the center of interest. Give less detail to all other areas.

What I mean by detail here (and in other projects, too) is adding the final clips of reflected light from the sky, the sparkle from the sun, and the texture of cracks and crevices on rocks that appear close enough to warrant that detail. The reason I suggest placing more detail in the center of interest than elsewhere is that the viewer will be focusing on this area because of its initial impact, and the additional detail there will intensify that focus.

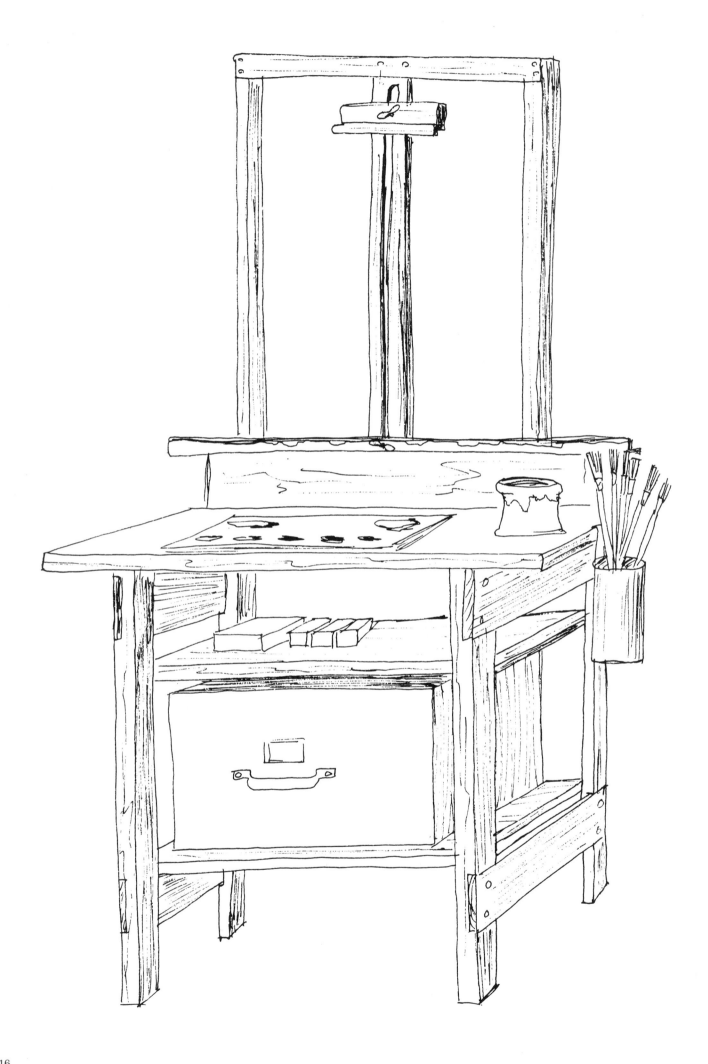

PAINTING MATERIALS AND EQUIPMENT

When I paint in the studio I want as much comfort and convenience as I can get. I don't want the distractions and inconveniences of painting outdoors. Therefore I've arranged it accordingly. My studio is warm, roomy, and well lit; I have my favorite music playing; and no one interrupts me during my painting hours.

EASEL

My easel is large and adjustable. I can raise or lower my canvas, but the easel is too large to wobble under my sometimes vigorous brushing. I made it by attaching the vertical bars that hold the canvas to a shallow table. The table adds stability and also holds my palette and paints. On the side I attached a plastic bottle to hold my brushes.

LIGHTING

I have both a skylight and artificial lighting over my easel. Because the outdoor light is not always strong enough, I use three adjustable floodlights set in a row about four feet (1.2m) above the easel and about two feet (0.6) apart, and focus them on the canvas area. (These are regular outdoor floodlights that can be purchased in hardware stores and building supply stores.)

BRUSHES

My brushes fall into two categories. I do all of my underpainting and larger brushwork with filbert bristle brushes. (Filberts are long and flat but with rounded edges.) I use nos. 2, 4, 6, 8, 10, and 12, depending on the size of the area I'm painting or on how carefully I wish to work. I use the largest brushes to scrub in large areas and the smaller ones for more careful work or on areas that best suit that size.

The second category includes my detail brushes. For this I use small, red sable rounds. They may be purchased with long handles, for oil painting, or with short handles, for watercolors, though they're both quite suitable for oils. Actually, both types wear out very rapidly, especially when used on rough canvases or if they're not properly cleaned after each use. Detail brushes can be as tiny as no. 0000, which is a bit larger than a gnat's whisker. I also use nos. 000, 00, 0, and 1. Be sure your paint is well mixed before you dip these brushes into it. They wear out even faster if you use them to mix paints.

FILBERT

ROUND

BRIGHT

PAINTS

I believe in using a limited palette. While my palette may not give too many choices in terms of mixtures, it keeps my paintings simpler and easier to view (I hope). I buy fewer colors, but pay more for them; I choose quality brands that are well blended and don't yellow with age. I also dislike tubes that ooze puddles of oil onto the palette instead of workable paint.

Here are the colors I used to paint everything in this book:

Ultramarine blue, manganese blue, or cerulean blue

Viridian or phthalocyanine green

Burnt sienna or burnt umber

Lemon yellow

Cadmium yellow pale, light, and medium

Alizarin crimson

Permalba white (made by Weber) or any good titanium white. The white on the left is mixed only with cool colors and the one on the right is for warm colors only.

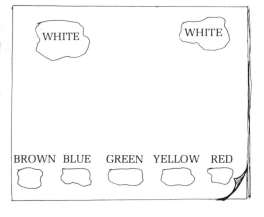

PALETTE AND PALETTE KNIFE

Since I don't like to clean palettes and don't like to get bits of dried paint in my mixtures, I use a disposable-type palette. After each painting, I merely peel off the page and transfer the still-usable paints to the next one. I mix my paints with a regular 3″ (7.5 cm) palette knife, the same one I use for painting rocks or other areas where I need a sharp edge.

CANVAS

I prefer to stretch my own canvases. I use good-quality linen and stretch them over bars with a wide-mouth canvas pliers and a tack gun containing ⅜″ (1 cm) staples. For sketching purposes, I use scraps of canvas, canvas board, or canvas-textured paper.

CLEANING BRUSHES

For keeping my brushes clean, I use paint solvent because I don't like the smell of turpentine. This is also sold as cleaning solvent or paint thinner. It's much cheaper than turpentine and, to my knowledge, won't harm your paints. In any case, use it with

plenty of ventilation, because fumes from any solvent can be hazardous to your health; it's also a potential fire threat.

A FINAL WORD

These are basic materials and are meant as suggestions only. If you are unsure of what materials to use, I can only suggest that you start out with a limited number of supplies and experiment gradually with additional materials.

There are many exotic pieces of equipment in art supply stores and you may find some convenience in buying them. However, do not expect them to guarantee a successful end result. Good materials are essential, but only you can improve the quality of your work. Gather around you what you consider essential, then concentrate your efforts to produce the best results you can. Alway keep reaching. And don't forget, the best teacher of seascape painting is the sea.

PROJECTS

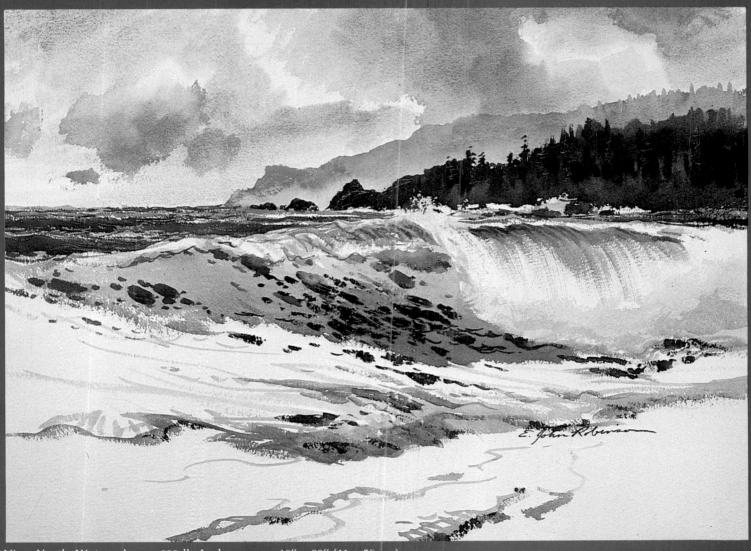

View North. Watercolor on 300-lb Arches paper, 16″ x 22″ (41 x 56 cm).

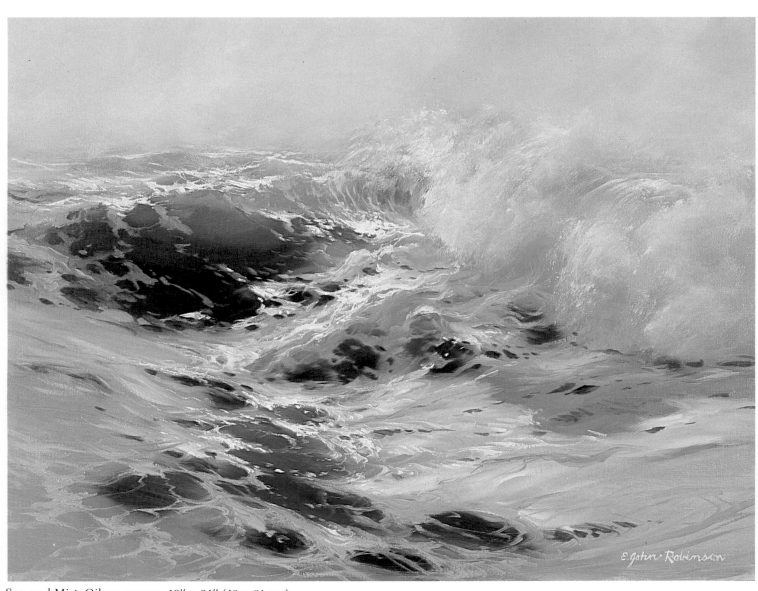

Sea and Mist. Oil on canvas, 18″ x 24″ (46 x 61 cm).

THE BIG WAVE

I love winter storms because they bring giant waves crashing to shore. I stand well back on the bluffs and observe the flying spray and the buildup of the dark waters, and feel the sheer power of unleashed energy and movement.

I'm always inspired by these big waves and head straight for my easel, but I've since learned to pause and reflect first before acting, because capturing those big waves is more of a challenge than it may seem. How do you paint size and power and the feeling of movement? How do you relate the wave to the sky and the land? Before you rush to your easel, let's take a closer look at the challenge of painting a giant wave.

PROPORTIONS

The feeling of size will depend upon how much space you give the wave on the canvas. Obviously if the majority of the canvas is foreground and background, with only a small wave, the feeling of power and size will be lost. On the other hand, a canvas that's nearly all wave with little else to compare its size to would be overwhelming. Therefore, I try to give enough space to the wave so that it draws the most attention. In this project, nearly a third of the canvas is devoted to the major wave.

DETAIL

In addition, I make sure more detail is put here, where I want the attention, than anywhere else in the painting. That is, more texture, more contrast, more glints of light, and possibly a change of color should go into the center of interest; here, the wave itself.

VALUES

While the size of the wave helps give the wave a feeling of power, it can also be achieved with values. Whatever color you mix for the wave, be sure the very darkest value of it is applied at the base of the wave. It may fade lighter as it moves upward, but darkness at the base suggests depth and thickness, therefore adding to the feeling of strength and power. In short, keep in mind that dark values carry weight and portray strength when shown as a massive area.

MOVEMENT

Getting the effect of movement is another challenge indeed! All too often the student spoils an otherwise good painting of the sea by stopping the action when, in fact, just the opposite should be achieved. The sea is moving and it must be portrayed that way.

The key to the solution is in the portrayal of the leading or top edge of the wave. Because it's moving, it therefore should be blurred. This can be achieved by showing soft edges, mist, spray, and many repeating lines rather than just one hard line. On the wave's surface, movement also can be shown by fragmenting it with glints of light and alternating shadow. When there's foam on the surface, you can show

movement by brushing the sky and sunlight reflections onto it in swirling, curving lines.

COMPOSITION

Quite another feeling of movement and power can be achieved by the arrangement of the composition. (See also the chapter on composition in *Marine Painting in Oil*, where there are a number of ideas on values and moods and how to use them.)

ANOTHER EXAMPLE

The painting on page 20 carries the same theme as *The Big Wave*, but is a different composition. The feeling of power is evident in the dark wave base and the size of the wave in relation to the canvas, and the feeling of movement is even more pronounced. Here the top edges of the wave and breaker foam disappear into the mist in the background. There are no harsh edges at all. The wave, the foam, and the holes in the surface foam are all on a slightly different slant, which adds even more movement.

This composition is a simpler statement than the demonstration painting, but if you look closely you'll find many of the same techniques in both paintings. The foam is a series of swirls and contour lines, the sunlight is used sparingly to glance across the wave, and the entire painting is nearly a monotone. Actually, it was painted with Prussian blue, viridian green, white, and a touch of alizarin crimson in places to warm it up.

Studying the Scene

A BREAKING WAVE

This photograph shows one of the big waves as it collapses or "breaks" near shore. While it's not a ready-made composition in search of a canvas, it does show some of the characteristics of a big wave that I have been discussing.

Notice the mist, and at the top edge of the foam where the sunlight sparkles, notice the droplets. There are no harsh edges here, and the feeling of movement is perfect. Behind the wave, swirls of foam and scattered lines of sunlight add to the feeling of movement. The foreground is mostly covered with foam, but look closely at its pattern. Paint the foam with moving, swirling lines to add even more movement to the painting.

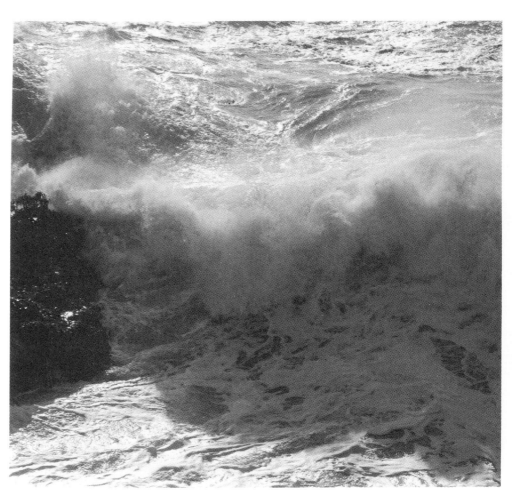

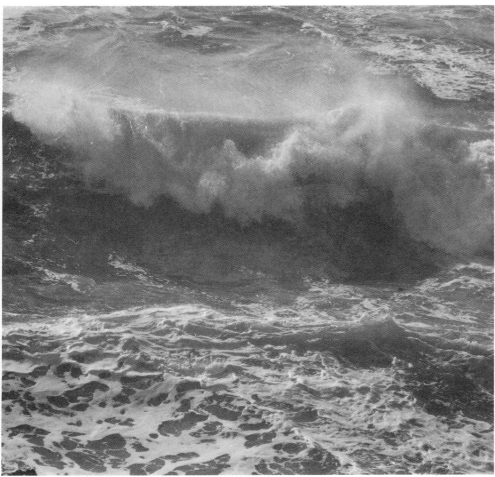

A POWERFUL WAVE

Here the feeling of power is as strong as the feeling of movement. The extremely dark base of the wave makes it wide and deep, which gives it unquestionable depth and strength. Also, because the wave is moving, the leading edge is nearly obscured in mist. This photograph is a great example of what I've been saying: Give your big wave strength and power with dark values at the base and give it movement with soft, misty edges at the top.

In addition, observe the lines that read as movement in both the foreground and background. Also, note how the contours of the wave are highlighted by the sun. You can also control the viewer's attention in your painting by where you decide to texture the surface.

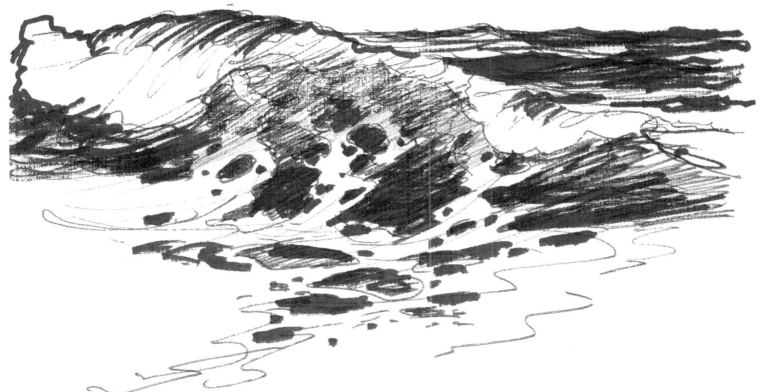

FOAM PATTERNS ON THE WAVE FACE

Since I intend to use foam patterns in the demonstration, this page from my sketchbook, shows how they might appear. Foam lies like a thin blanket over the surface of the water. As the surface moves, the foam is pulled apart and holes form. As the wave rises, the same pattern occurs but, the holes also take on the contour of the wave. Thus, the holes are not truly round, but vary in size and shape according to the surface they're on.

To paint foam, I first paint the color of the wave on the canvas, leaving the area of the larger foam masses unpainted. Next I paint the foam, placing it between both sunlight and shadow, if possible, and allow some foam to cover the previously painted water. Finally, with a small brush, I paint more holes in the foam using the color mixed for the water. (I'll discuss the specific colors later.)

FOAM PATTERNS ON A FLAT SURFACE

The surface foam in the foreground looks the same as it does on the face of the wave, except for the shape of the holes. Because you're looking down (or on a slant) at the water's surface, which is flat, the holes appear to be flattened out or eliptical in shape. On the other hand, when you're looking at the face of a wave, you see it straight on. Therefore because the holes there are vertical, or nearly so, although they're irregular in shape, they appear more round.

Surface foam on flat water should be painted the same as that on the wave face. First start with the color of water, then paint the foam in light and shade, and finally add the detail, that is, spots of color and texture.

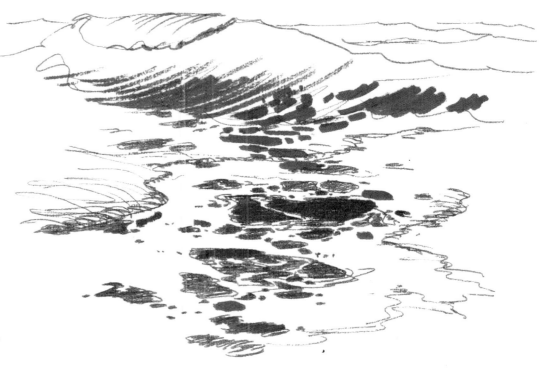

Analyzing the Composition

LINES

I used a felt-tip marker to make this linear composition in my studio. This particular drawing was selected from several I did. Before I made the drawings, I determined that I wanted a moody sky to match the storm wave. The distant clouds are represented by a strong line on the underside, where it's especially dark because ot the rain. (Note that this line is on a diagonal, which is another way of showing movement.) Notice also the line that sweeps from the underside of the cloud. It continues along the leading edge of the wave then zigzags to the foreground. Overall, it forms a loose letter S. In the actual painting this line will be less obvious, but will be there nevertheless to add movement to the composition. The wave takes up a good third of the canvas but is placed near the middle, with the foreground being slightly larger than the background. This is so each area is a different size. Repetitive sizes are monotonous.

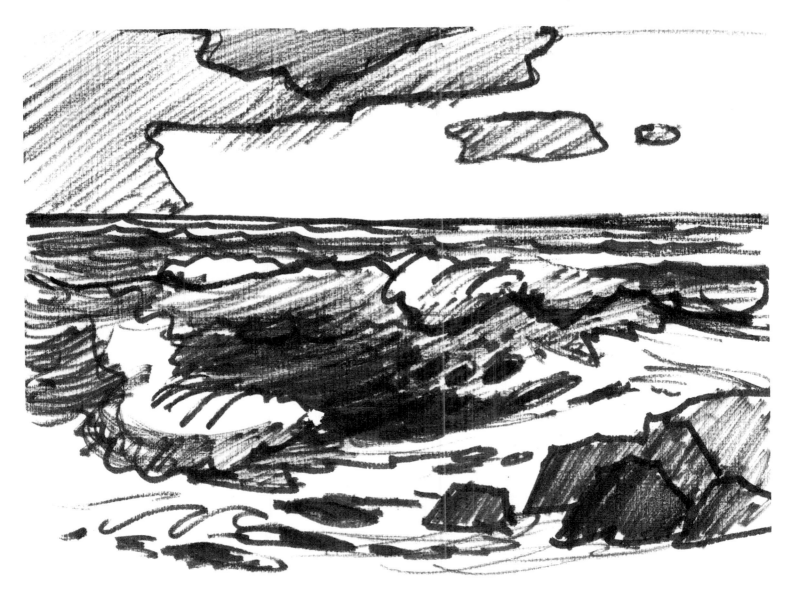

VALUES

Overall, this composition is fairly light in value, with some secondary (in importance) middletone grays and a strong punch of dark for the wave and rocks. In keeping with the theme of power and strength, I want to use as much dark as possible in the base of the wave. However, concentrating so much dark in just one spot could be overwhelming and the wave could appear too heavy for the light foreground I planned. I therefore decide to support the dark wave by placing additional darks in the foreground; in this case, rocks. I could have painted darker water there instead, but rocks give a land-sea relationship that I like.

The sky, while not the darkest of values, nevertheless is dark enough to add to the violent mood of this painting. It's a wet, stormy sky and its lines (see the preceding sketch) lead directly to the central area of interest.

Selecting the Colors

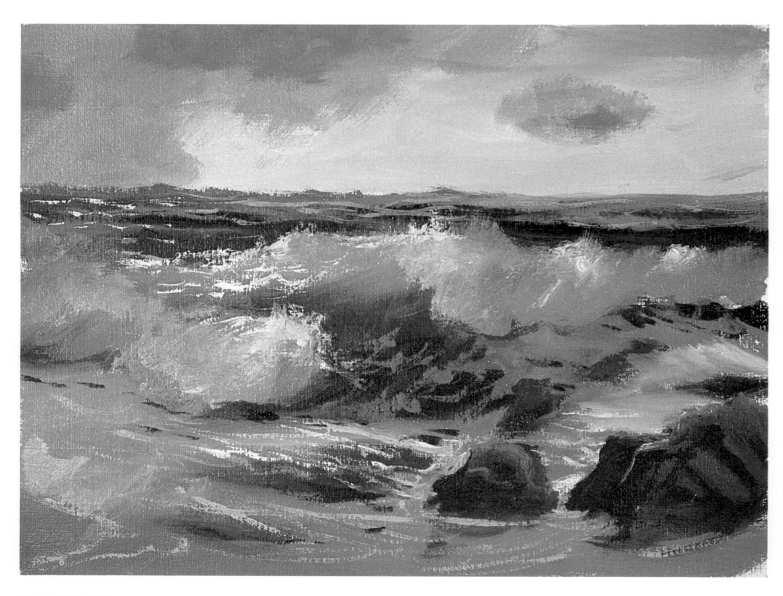

COLOR SKETCH

The final planning is done with color. I often make several sketches on scrap canvas. This is the time to experiment. In making a color sketch, I try to work quickly and not belabor it with details. They'll come later. I use large (nos. 6 or 8) brushes and no medium, and a limited palette. I'm not wasting paint. I'm saving it, and a lot of rubbing out later. This color sketch is only one of several I made. It took all of five minutes and was painted on an 8"x10" (20x25 cm) scrap of canvas. It was not intended to be a finished painting, but it does capture the feeling I wish to convey to the final work. It aims me in the right direction.

I generally prefer to have one dominant color, with two or three others to harmonize and support the main one. In this painting I'm working with a blue-green, supported by brown and highlighted by a yellow-white. (I'll be more specific about the colors I use later, in the demonstration.) I mix gray here by combining cerulean blue and burnt umber and adding it to white paint. This basic sketch is made with a variety of that gray, except for the burnt umber on the rocks and the dark phthalo green in the wave. The green was darkened even more with the addition of some burnt umber.

The challenge of this painting is to portray power and movement. On the preceding pages, I've shown that the power of a wave depends upon its size, its relationship to the rest of the canvas, and the value or darkness of the wave. You've also learned that movement is best achieved by blurring the top edges of the wave and fragmenting the surface with glints of light, swirls, and moving lines.

IMPORTANCE OF COMPOSITION

As you've seen from my analytical studies, it's necessary to decide the linear and value composition in order to avoid later problems. The lines should be moving! The heavy, angular lines of this composition denote strength, whereas soft, gently curved lines would be out of place in a painting with this theme of power and movement.

Values also lend their support to the mood. In this case, I've made use of the strength in dark values to show power in the major wave. Note also that the remaining values are grouped rather than scattered among themselves. Scattered values and a jumble of light and darks are confusing and too busy. They distract from the central theme.

USING PHOTOGRAPHS

Before painting, there are also other considerations to be explored. The photographs and sketches shown here not only inspired this painting but helped me to understand how to portray it. For instance, the photograph below shows a good example of a giant, powerful wave that is moving to shore. It also shows important foam patterns and glints of sunlight. The photographs on page 22 also show the same characteristics and include cast shadows and massive surface foam. It's best to look as much as possible before settling on a final composition. You may see many ideas that can be incorporated into your painting.

SOURCE OF LIGHT

Another consideration I haven't yet mentioned is the source of light. You must determine the position of the sun beforehand because it influences light, shadows, and even color. In this case I chose to place the sun high above the left-hand side and let it slant across the wave. This was a personal choice; I could have chosen another position with equally good results. In the demonstration that follows, you'll note that I use the sunlight in a minimum way for maximum results.

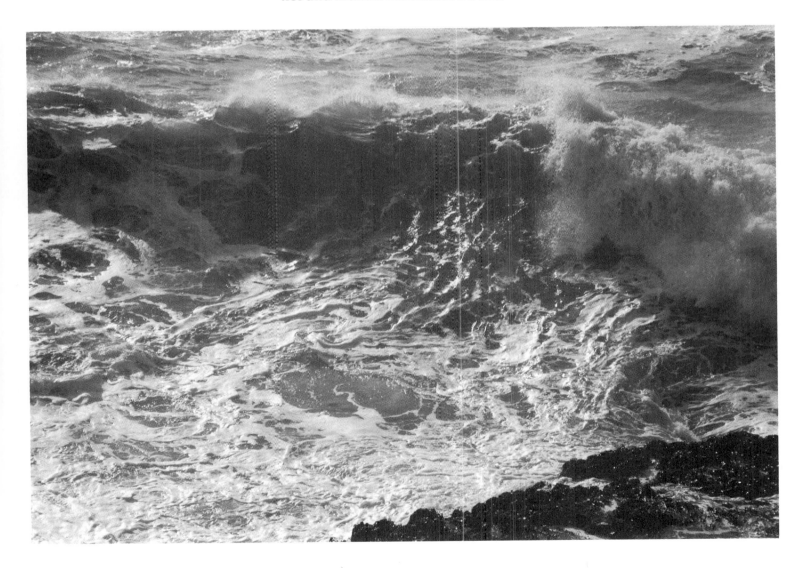

Painting the Big Wave

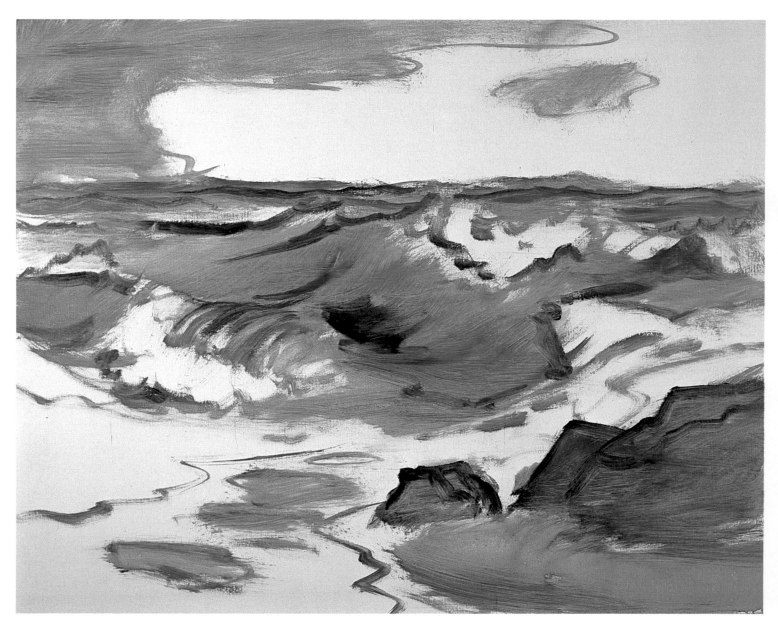

1. DRAWING

The first step is simply a matter of drawing a combination of my linear and value compositions onto the canvas. I used a no. 8 bristle brush and cerulean blue. Where I want a darker line, I add a bit of burnt umber to the blue. In this way I establish the basic outline on canvas just where I want things placed and at the same time indicate the major values I expect to use.

It's not necessary to be precise in this step. In effect, I put down only a rough guide as to what I expect to work on. However, I should point out that I don't expect to make many changes now in my basic plan. While flexibility is of the utmost importance, I believe it works best within established guidelines. Although I allow for change, I don't start off without a guideline. You can't rely on lucky accidents to rescue you from mistakes that could have been avoided.

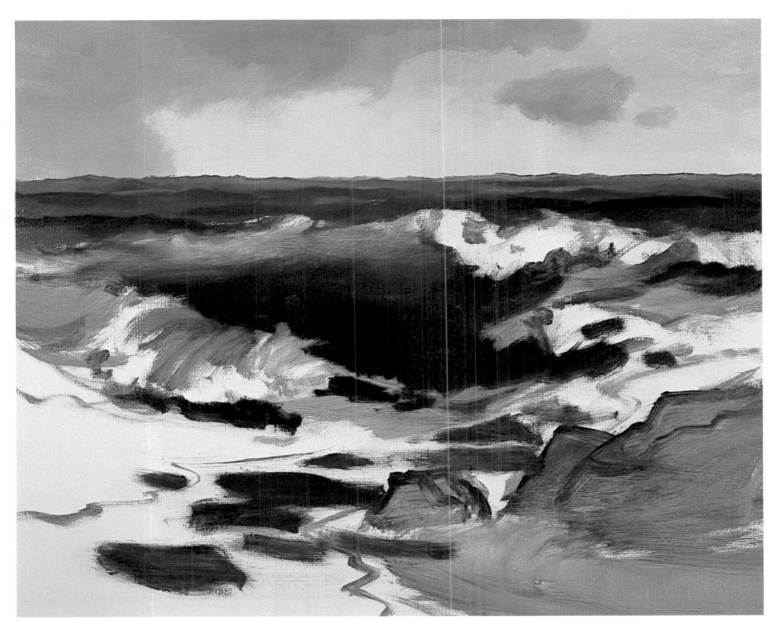

2. SKY AND BACKGROUND SEA

Starting with the lightest portion of the sky and using a mixture of cerulean blue and white, I begin work at the horizon line with a no. 8 bristle brush. The mixture at first is mostly white, but I add more blue as I work upward. The clouds are also a mixture of cerulean blue and white but with a touch of burnt umber to gray them. Using the same brush, I paint the middle-value clouds first, making sure that they're darker than the sky. The darkest clouds come next and are painted with more blue-umber and less white. I whipped a wide, dry varnish brush over the lower edges to soften them and make them look like drippy rain.

The background sea is cerulean blue and burnt umber near the horizon line, and is darkened with phthalo green near the wave. I did not use white. The wave is also underpainted with phthalo green tempered with burnt umber. A touch of white lightens the green near the top of the wave. Because this is still the underpainting, I use a middle-sized bristle brush and work the paint well into the canvas. This way I can easily add more paint on top of the wet paint without it blending where I don't want it to. However, I don't allow the underpaint to become too thick.

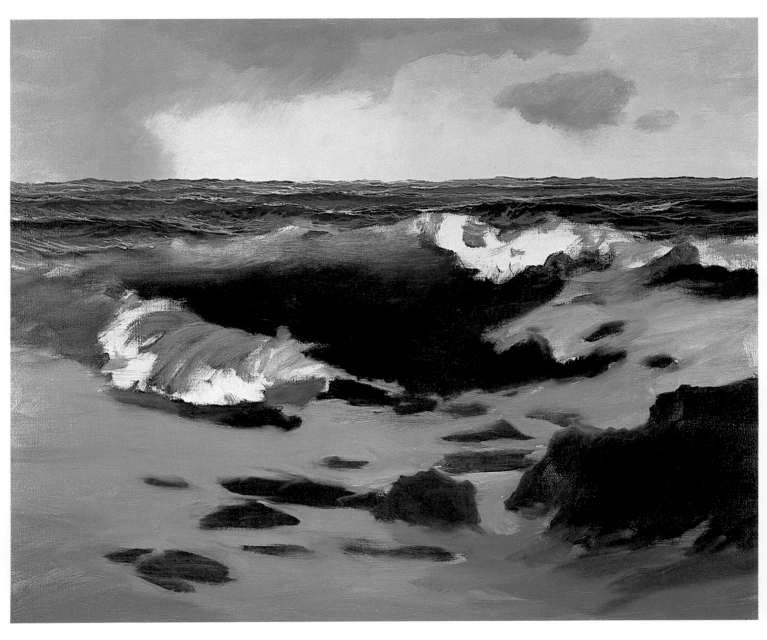

3. REFLECTIONS AND ROCK UNDERPAINTING

I now consider the sky to be finished. Since the atmosphere reflected by the sea is the color of the sky, I mix up a sizeable pile of sky color, blending cerulean blue into white paint. Then, using a tiny, no. 000 sable liner brush, I highlight the tops of the swells in the background sea.

Because the face of the wave is nearly vertical it doesn't reflect the sky above. But the foreground white foam does face the sky and, like a mirror, reflects its blue-white color.

To paint the foam I scrub in the atmosphere or sky color with a no. 8 bristle brush, working around the major holes in the foam, which I leave the color of the big wave.

The rocks, too, are only underpainted at this point. I use the same brush (a no. 8 bristle) and scrub in burnt umber toned down with a small amount of cerulean blue. Remember, the underpaint should be scrubbed into the canvas so that other paint may be applied over the top without blending.

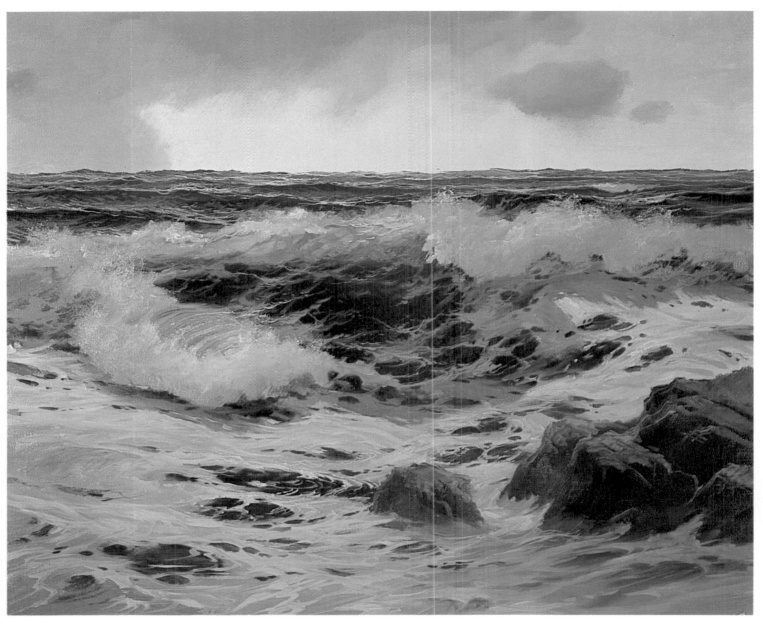

4. FOAM AND ROCKS

This step requires a lot of work. First I paint the foam on the wave with a no. 6 bristle brush and a combination of cerulean blue and white, but with a touch of green to reflect the color of the wave. Then I paint the foam patterns and cast shadows on the face of the wave with a no. 2 bristle brush and a darker version (that is, with less white) of the same mixture. When doing this, I often have to restate the color of the water, spotting in more holes.

The foreground foam takes the most time to paint. I add more white to the atmosphere color so it shows up on the underpainting. Then, with a no. 2 round sable, I paint in the swirls and contours that give the ef-

fect of moving foam. I nearly wear out the brush! As when painting the foam patterns on the wave face, I often have to come back and spot in more holes showing water. But I keep these spots down to a minimum because it's easy to make the painting too busy with spots.

The color of the atmosphere overlying on the rocks is darker here than elsewhere because I assume that the sky reflecting its color directly overhead is darker than the sky near the horizon. At this point, adding light atmosphere to the rocks would also lessen their dark value and they wouldn't have the dark support I feel is necessary to the composition.

October Storm. Oil on canvas, 24″ x 30″ (61 x 76 cm).

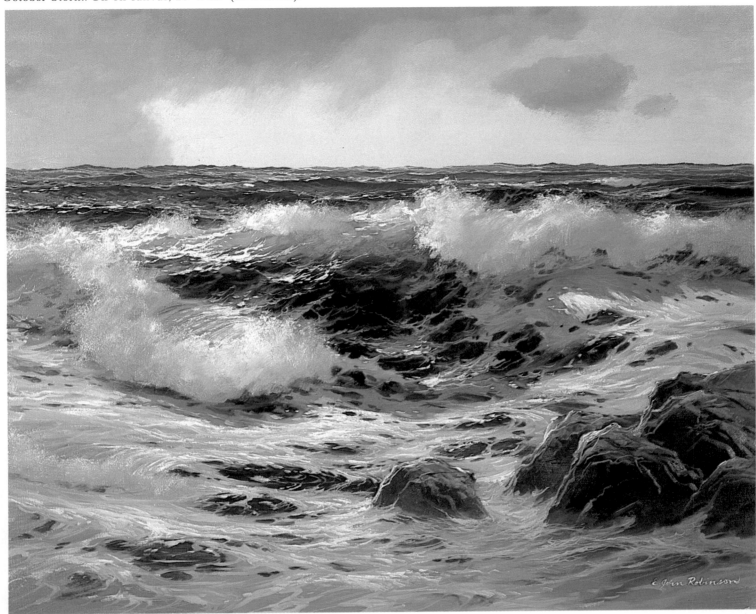

5. SUNSHINE AND HIGHLIGHTS

At this point the painting looks as if it's being painted on an overcast day, so I add some sunshine. I first mix a warm white color by adding a small amount of yellow ochre to the white. Then, with a no. 000 round sable, I apply the glitter of sunlight.

I let the majority of brushstrokes on the wave face emphasize the importance of the wave. Here, small horizontal scallops are laid down to show the sunlight glancing across the wave. The background and foreground need only a few glints of light, otherwise they might distract from the center of interest. I put only

a few highlights on the rock where it faces the sun. The foam on the wave seems to need more, so I daub some of the sunlight mixture onto the upper portion using the end of a dry 2″ (5 cm) varnish brush, and I stop.

It's important to know when to stop. Too many glints of light and the effect would be completely lost. Too few and there would be nothing of interest. The main theme of this painting is the power and movement of a giant wave. Adding anything more now would destroy that feeling and create an entirely different theme.

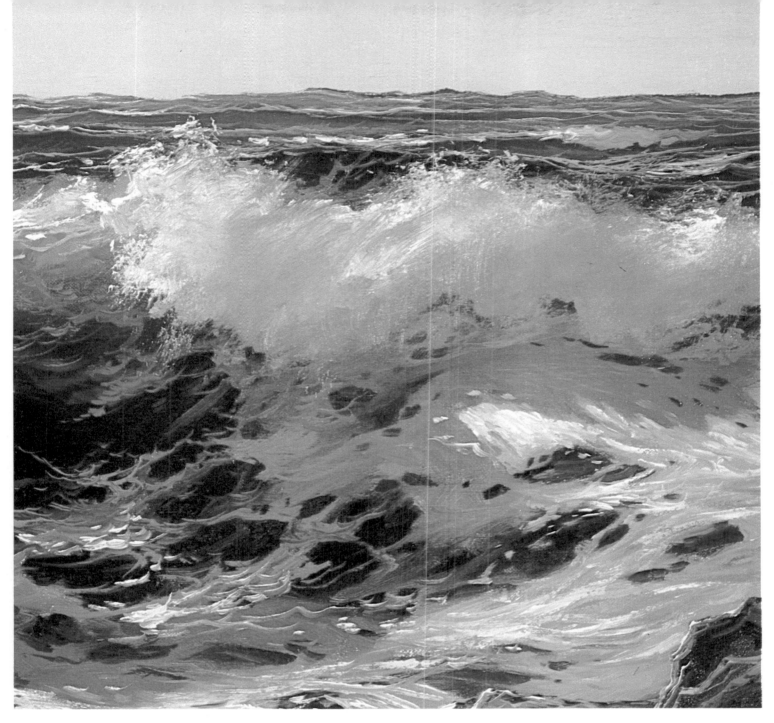

DETAIL OF THE BIG WAVE
You can see here how I play up the power of the wave through strong contrasts and relative size. I also emphasize its movement through blurred top edges, glints of sunlight, and swirling foam. Note how effectively cast shadows and accents are used to increase the size of the wave and describe the activity of the water's surface.

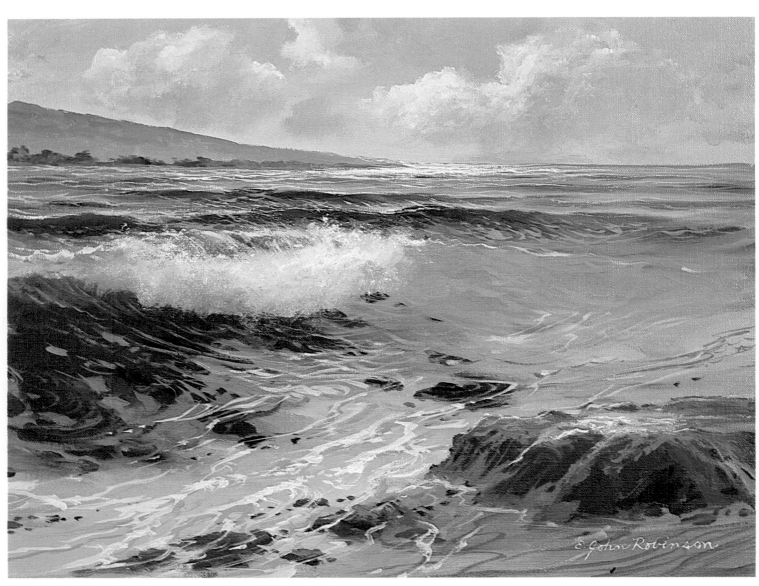

Near Kailua (Hawaii). Oil on canvas, 12″ x 16″ (30 x 41 cm).

CLEAR WATER

There's much about the sea that's the same around the world, but there's also much that changes from location to location. Bluffs have a different effect on the waves from beaches, and beaches may change from one area to the next. Some beaches have seaweeds and rocks that influence their color, and the color of the sand can range from very black to near white.

THE KONA COAST

On a trip to Hawaii, I found out just how different water could be. There I found the clearest ocean water I have yet seen and I was immediately presented with a painting challenge, that of showing the effect of clear water only a few inches deep.

On the Kona coast of the Big Island of Hawaii, the sand was a light beige, nearly white in fact, and the water was crystal clear. There was little wave action so the surf wasn't stirred up, and the average depth of the surf was only a few inches. I could see every pebble, every rock, and every clump of seaweed beneath the surface.

ANALYZING CLEAR WATER

I first spent hours of studying the sea, sketching and picture-taking. Because the water was shallow, I knew I was studying only two levels, the ocean floor and the surface of the water. Gradually I came to understand the influence of the environment on each level.

The ocean floor has its own color, which is influenced by the weeds, rocks, and pebbles that lie on its surface. Of course, the depth of the water determines how well these colors and objects can be seen. Obviously, the deeper the water, the less clear the ocean floor will appear.

The surface water is first influenced by the color of the sky, which it reflects. (The amount of color reflected is controlled by the movement of the water, wind ripples, and swells.) It is also affected by the foam patterns on its surface.

PAINTING CLEAR WATER

All of this adds up to four definite steps that can be followed in painting clear water. (1) First, determine the color of the sand and paint it in. Usually the foreground carries more sand color and gradually blends to the color of the water as it moves further away or into deeper water. (2) Next, paint in the color of weeds, rocks, or pebbles on the ocean floor. Blur their edges because the overlying water makes them less visible and softens their color. I use the lighter color of sand to do this. (3) Then reflect the sky on the surface of the water or sand using the color of the sky. I use a no. 00 or smaller round sable for this, and make short, choppy strokes to show chops and ripples. Longer, horizontal strokes show more movement. (4) Finally, lay a thin trail of foam over the top of all this. This part is the most difficult. Foam trails are usually white, and are influenced by sunlight and shadow. With the nos. 00 or 0 round sable, paint in a few patterns and try to show them on top of the surface. You may have better results if you run the foam patterns in a different direction from the lines and patterns of the sand and surface ripples. It will also help to run them completely over an underwater object such as a clump of weeds, or a larger, submerged rock.

CAST SHADOWS

If you can also cast a shadow from the patterns close by that looks like it's a few inches down on the floor, the effect is even better. Observe *Near Kailua* on page 34. It contains all of the methods just described for the effect of clear water over sand. The step-by-step instructions that follow are more specific and, after following them, you'll find that painting clear water is difficult but by no means impossible.

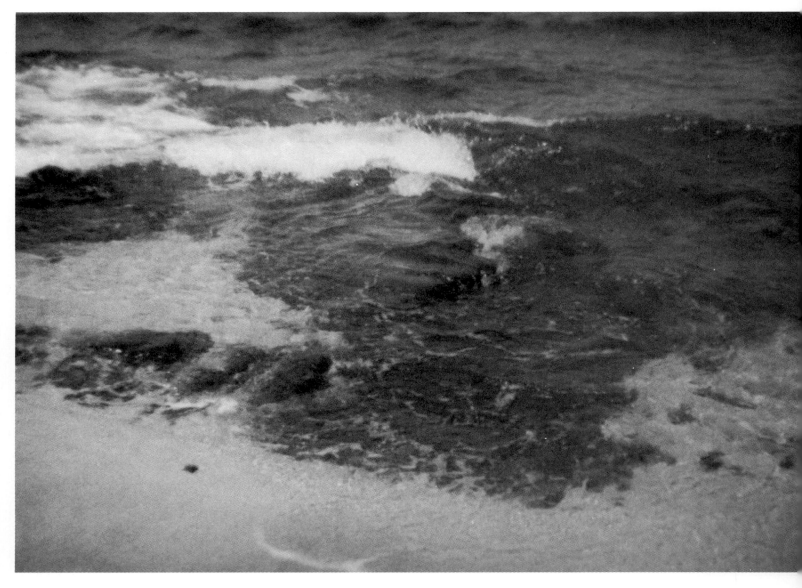

CLEAR SHALLOW WATER AND SKY REFLECTIONS

Note the clarity of the water here. The wave is too minor to disturb the water enough to spoil the clarity. The dark areas are a combination of rocks and seaweeds, though in black and white it's hard to see the difference. In color, the rocks would be browner, and less of a green-brown would be found in the seaweed.

A closer look also shows sky reflections. In this photograph, they're most visible directly in front of the white foam areas and as lighter streaks in the dark mass. Note also the hint of a light foam trail in the central portion of the dark area and the center foreground. I intend to use these trails, but with more prominence, later in the demonstration painting.

The sky reflections create the lightness of the background and are most visible in the dark area on the left. The flecks of light in the foreground are also sky reflections, but they don't show up as well over the light sand.

JAGGED ROCKS

Here's another example (see page 38) of rocks found along the Kona coast. I'm including it to explain why I *didn't* use them in my painting.

The most important reason for rejecting these rocks is that their edges are too harsh and jagged. In my opinion, that would add a sharp, almost nervous line to a painting that is supposed to be tranquil. Another reason for their unsuitability is their angle. They're tilted in a way that better depicts the struggle between land and sea than the tranquil theme of this painting. The rocks I chose are flowing, with no harsh edges, and add to the easy lines of the composition.

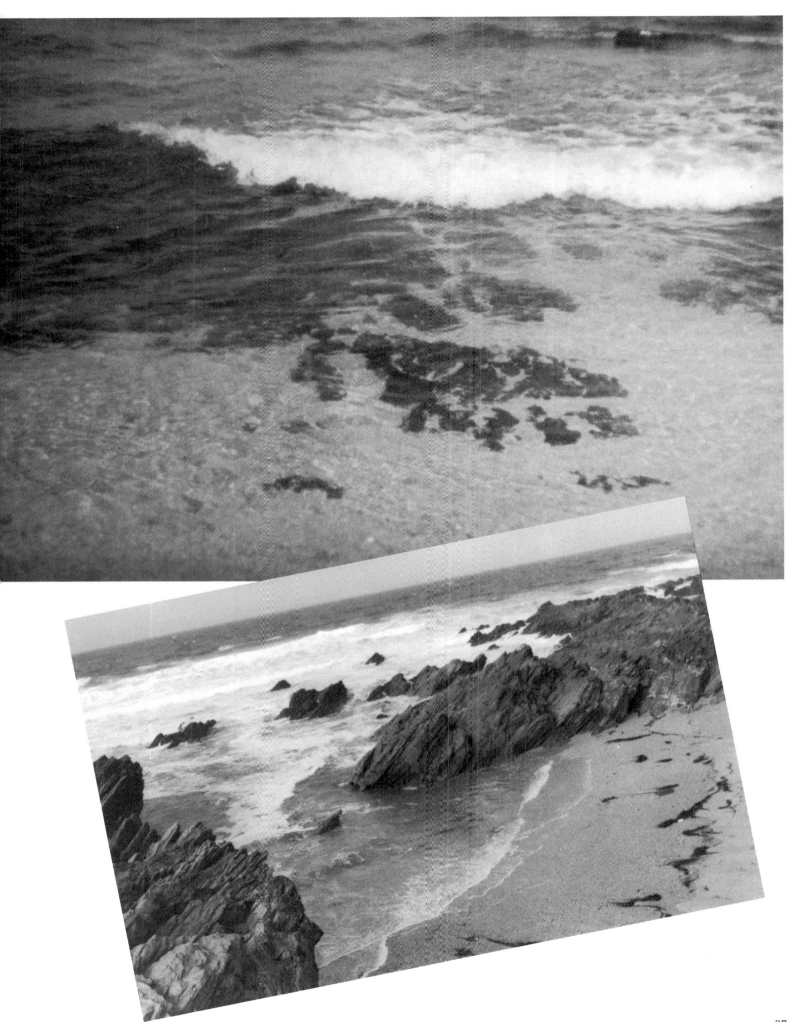

Sketching the Subject

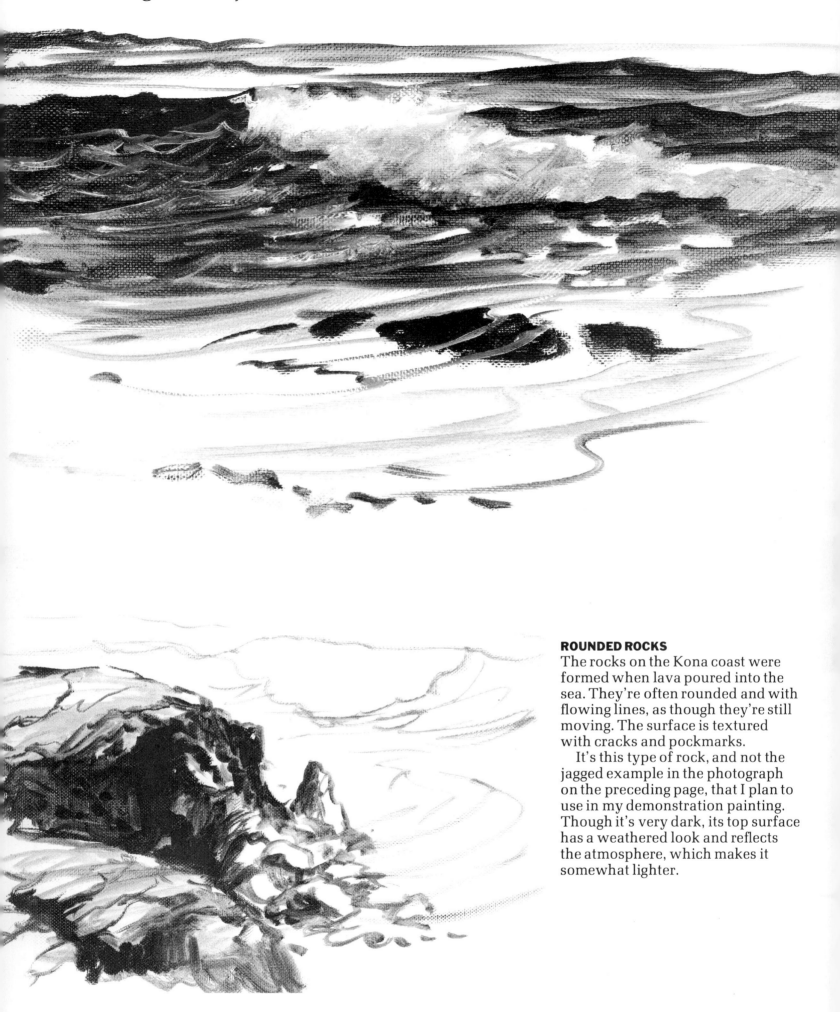

ROUNDED ROCKS
The rocks on the Kona coast were formed when lava poured into the sea. They're often rounded and with flowing lines, as though they're still moving. The surface is textured with cracks and pockmarks.

It's this type of rock, and not the jagged example in the photograph on the preceding page, that I plan to use in my demonstration painting. Though it's very dark, its top surface has a weathered look and reflects the atmosphere, which makes it somewhat lighter.

A QUIET WAVE

Again, because of the quiet mood I wish to portray, the waves I choose to paint can't be very active or they'd stir up the sand and create surface froth. Moreover, they just wouldn't be credible.

Here the wave is little more than a gentle swell with a bit of foam riding the top edge. The wave is also long and horizontal rather than short, squat, and horizontal. This gives it a reclining posture and shows that it's not very active. In fact, it couldn't be more than two or three feet (under a meter) high, and is slowly moving.

FOAM TRAILS

This is an example of the foam trails I mentioned earlier. They're linear and lie on the surface of the water. Not only do they show the location of surface of the water, but they also reveal its contours. Notice how the foam trail curves up the front of the rising wave.

Casting a shadow below the foam trail is tricky, though in this sketch it works rather well. It's mainly a darker repeat of the foam that casts it, and is placed just far enough away from it to look like it's a few inches below, on the ocean floor.

Analyzing the Composition

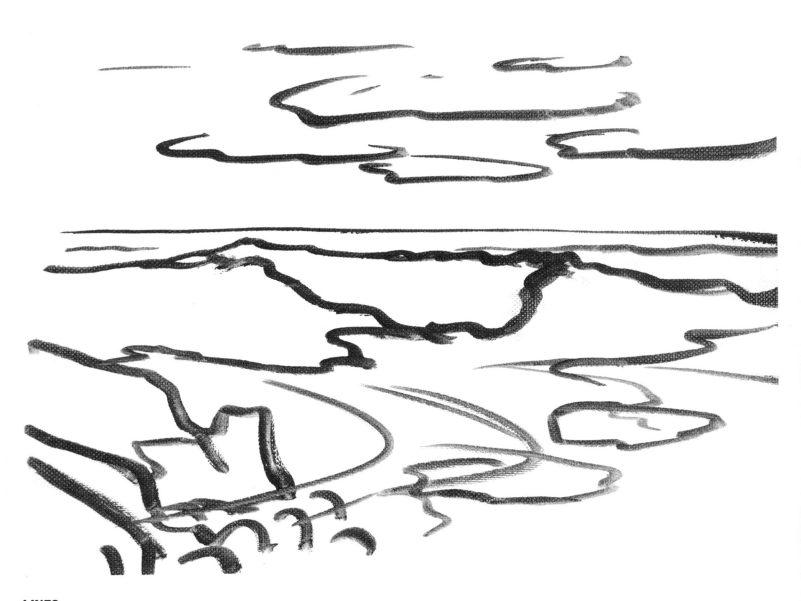

LINES

Since the mood of the painting is tranquil, I decide that the only movement I want in the painting is to be in the wave and the foreground. Therefore, the sky and background must be static. I make the lines representing clouds all horizontal and allow the horizon line to show clearly across the entire background. Any swells in the painting also have to be long and smooth.

The foreground provides relief from the all-horizontal background. The rock breaks up the space and the foam trails are lazy, but diagonal, lines that suggest quiet movement.

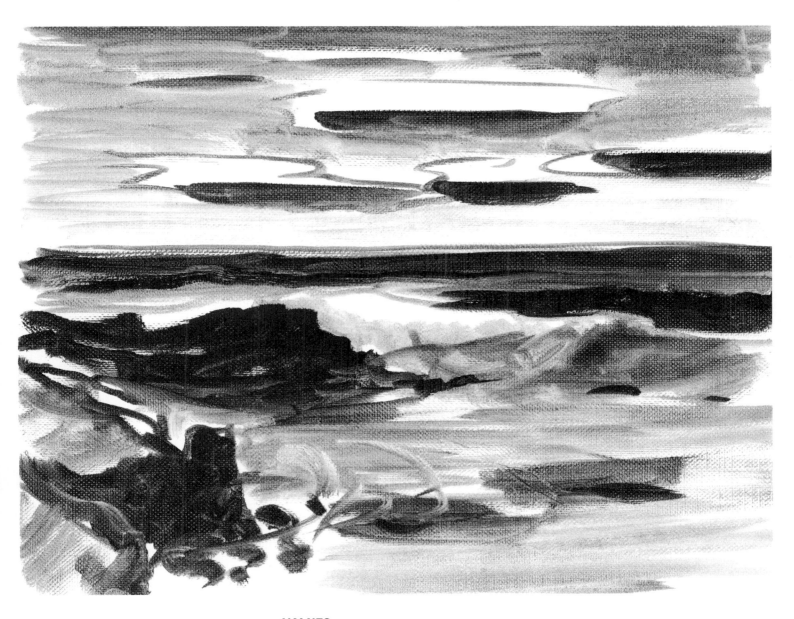

VALUES

The values must also be in keeping with the theme of the painting. In fact, values can emphasize any mood you wish. In this case, the quiet atmosphere calls for a light airy sky, with no threatening clouds or disturbances. The background sea, however, can be quite dark in order to emphasize the horizontal composition. Any darks in the sky should only point out the same thing.

The wave is dark on the left and light on the foam and at the right-hand side. I'm afraid of making it too dark. I only want it dark enough to contrast with the foam and create the center of interest here.

The dark vertical portion of the rock provides a relief from all the horizontal lines. The rest of the foreground is a middle value, with some darker spots to break up the space. The foreground foam patterns lead the eye to the center of interest (the wave), and hopefully lead the eye back to the clear water. Though clear water is the topic we're studying in this chapter, it's not the center of interest in the demonstration painting.

Selecting the Colors

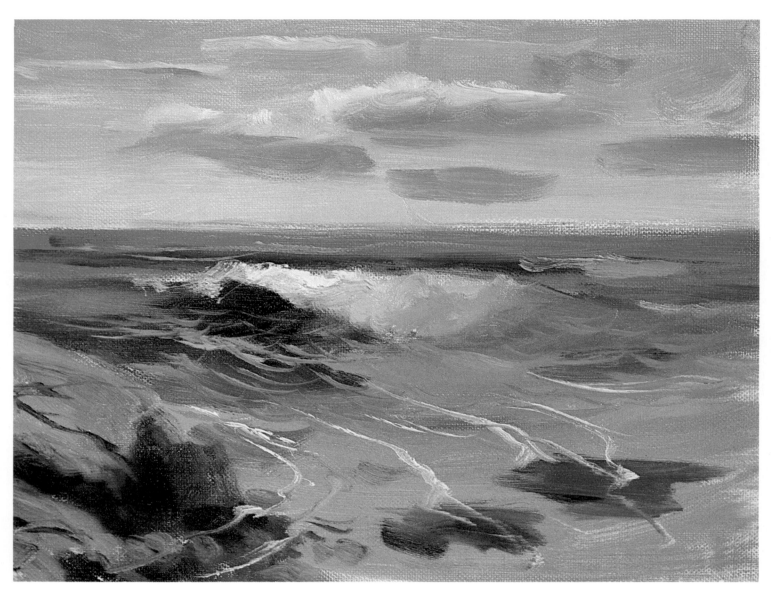

COLOR SKETCH

The thinking I do in the color sketch enables me to decide the colors I'll use in the demonstration. I use a no. 5 bristle brush to paint everything but the foam trails in this quick sketch. (For the latter, I use a no. 2 bristle brush.) It goes quickly because I've already decided in my mind just what colors I want to use and where I want to show sunlight. I decide to limit the use of brightness and concentrate the sunlight effect on the wave, but echoed in the clouds.

The sky is made with cerulean blue that has been mixed into white paint. The clouds are a purple made by mixing a touch of alizarin crimson into cerulean blue, then adding white. The lightest portion of the clouds is white with a touch of cadmium yellow light.

The background sea is a cerulean blue darkened gradually with viridian green as it approaches the wave. The wave is also viridian, but the right-hand side is lightened with white and a touch of yellow, while the left-hand side is darkened with burnt umber. The wave foam is a repeat of the clouds, but without the touch of alizarin.

The sand is burnt umber mixed with white and a touch of cadmium yellow light. It blends gradually into the green of the wave. The rock, which also flows into the sand, is burnt umber and cerulean. The top is lightened by blending the sky color into it.

Making shallow ocean surf look clear is the challenge, and I've shown how I plan ahead in order to paint it. Let's review these preliminary studies and the results of my thinking.

SELECTING THE SUBJECT

First I decided that it was necessary to have a quiet composition as a stage for the presentation of this project of clear water. Although the wave was made the center of interest in the scene, it had to be rather small and lazy to be credible. I also chose a single rock for the same reason. A jumble of rocks would prevent the water from remaining clear. So would too much seaweed.

VALUES

Values also played their role. Since the overall mood was tranquil, we couldn't have a dark, overcast sky but we could have a light one. Skies are like ceilings. Dark ones tend to be depressing and make the room seem shorter than it is. Light ceilings, on the other hand, tend to make a ceiling of the same height seem much higher. Since a light, clear sky is also a quiet sky, it was therefore necessary to this theme.

LINES

To show tranquility I used horizontal lines, though a few, well-placed diagonals serve to relieve what would have been a monotonous repetition. You may notice that I avoided the use of any sharp, jagged lines because they suggest anything but quiet. Too many diagonals or sweeping lines would have shown too much movement and ruined the theme. Lines and values are far more important than most people think.

COLOR

Color is yet another important aspect of preplanning. While I didn't go so far as to use "hospital green" to maintain this theme, I did avoid using warm, sunset reds and oranges. Yes, clear water can be shown at sunset, but not in this composition. I planned a bright daylight color scheme, because that was the way I saw it when I studied it.

As I mentioned earlier, when I studied the area, I made a mental note of the colors. The sand was a light beige. The background sea was a bright blue, more cerulean than ultramarine, which has a purplish cast. The foreground waves were a clear viridian-type green, with no hint of brown or phthalo green in them. A phthalo green would have been too violent or intense for the low-key effect of this painting. The sky was a light, smog-free blue like manganese or cerulean. By the time I finished my color sketch, I knew exactly what colors I'd be using in the demonstration that follows.

Painting Clear Water

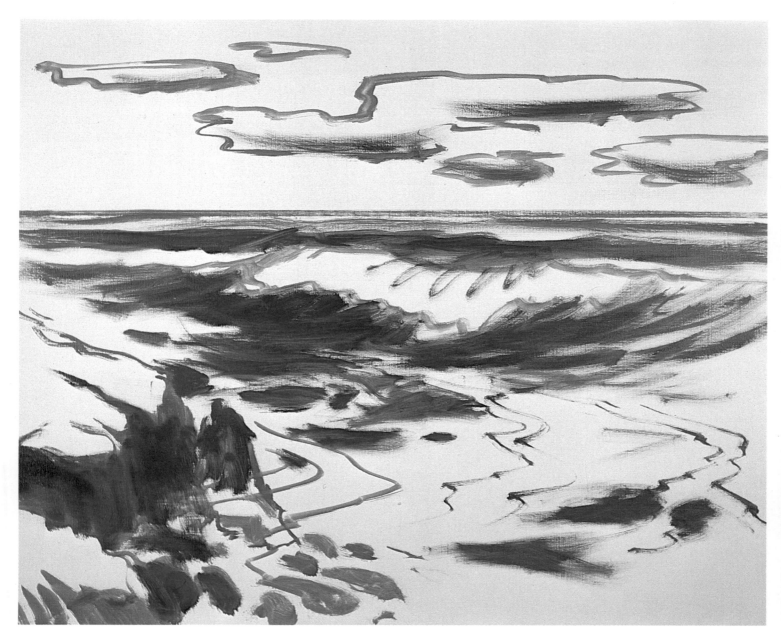

1. DRAWING

I use cerulean blue straight out of the tube and a no. 6 bristle brush for sketching the scene on canvas. As you can see, I indicate the values as well as the line by shading in certain areas. This follows the compositional steps rather closely. When painting anything that will be covered, I always scrub it well into the canvas so it won't blend into later applications of paint.

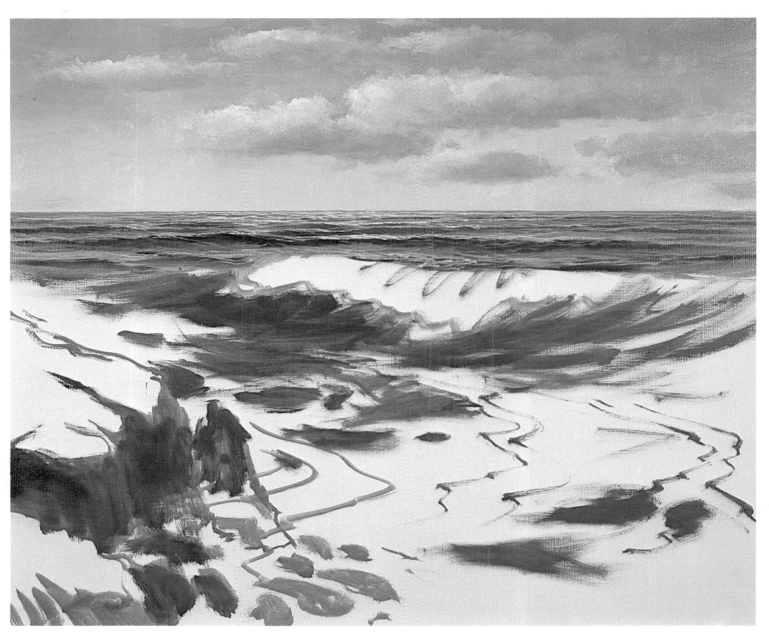

2. SKY AND BACKGROUND SEA

Again I start with the sky because it reflects on and influences everything else. I mix cerulean blue into white paint and make a large enough pile of sky color to work from later on. With a no. 8 bristle brush, I start at the horizon line and work upward, avoiding the clouds. I add a touch of cadmium yellow light to the area just above the horizon to warm it. I also gradually add more cerulean blue to the mixture as I work upward, making the sky gradually darker at the top.

I paint the clouds white with a touch of cadmium yellow light on the top, sunlit side. I make the shadow side cerulean blue and add less white to it than in the sky mix, with a touch of alizarin crimson to give it a purplish cast. I use a no. 8 bristle and carefully fuzz the edges of the clouds to soften them since their distance makes their outline less sharp.

Next I paint the background sea a mixture of cerulean blue with very little white. As it moves closer to the major wave, I add viridian green to the mixture, since the major wave contains it. I paint chops and swells by outlining their top edges with the colors of the sky with a no. 00 round sable—and a lot of patience. Notice that the lighter clouds reflect their light values onto the background sea.

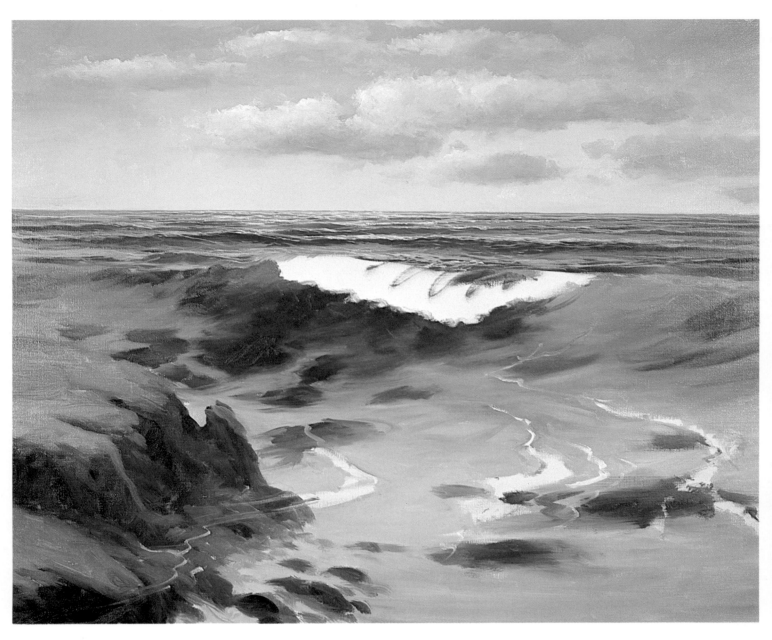

3. UNDERPAINTING THE WAVE AND FOREGROUND

Underpaint can go on quickly, so a larger brush may be used. I use a no. 10 bristle for most of this step. I start with the wave and, mixing viridian green and a touch of cadmium yellow light into white, I paint the entire wave, except the foam area, bringing the color down into what will be the top portion of the sand. Next I mix an olive green from viridian and burnt sienna and paint the seaweed, including the two dark areas in the near foreground.

I create the sand by mixing burnt sienna into white paint. I begin at the bottom and work upward, finally blending it into the green of the wave. But I only blend it a little way up or it would destroy the clarity and transparency of the wave. Finally I mix a dark by combining cerulean blue and burnt sienna and paint the dark portion of the rock and the group of rocks below it. I use the same mixture for the top of the rock, but greatly lightened by the addition of a lot of sky color.

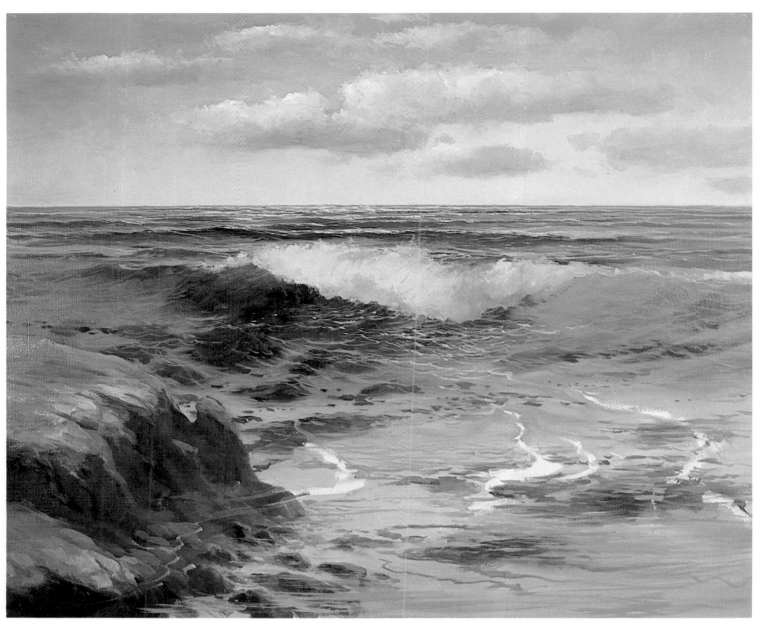

4. BREAKER FOAM AND SURFACE REFLECTIONS

Breaker foam is white but reflects its surroundings. Using a no. 4 bristle brush I paint the shadow portion of the foam with the sky color plus a touch of alizarin crimson. (I like my shadows to be warm, especially in a cool painting.) The lighter area of the foam is painted pure white. Later I plan to add the sunlight color to it.

Painting the reflections of the sky on the surface of the water is time-consuming. I use a no. 00 and sometimes a no. 000 round sable for this. All of the reflections are made with the piles of sky color I mixed earlier.

Since the wave is vertical, it doesn't reflect the sky. Therefore I begin adding the reflection of the sky further down, where it begins to level out. I use short, horizontal scalloped strokes to show the rippling of the surface. As I work into the calmer foreground water, where there is less movement, I change the strokes to straighter, horizontal ones reflecting the sky. I'm careful to run some of them through (over) the dark masses of seaweed and below surface rocks. I also add a few cracks to the rock as well as some more sky reflections.

Island Surf. Oil on canvas, 24″ x 30″ (61 x 76 cm).

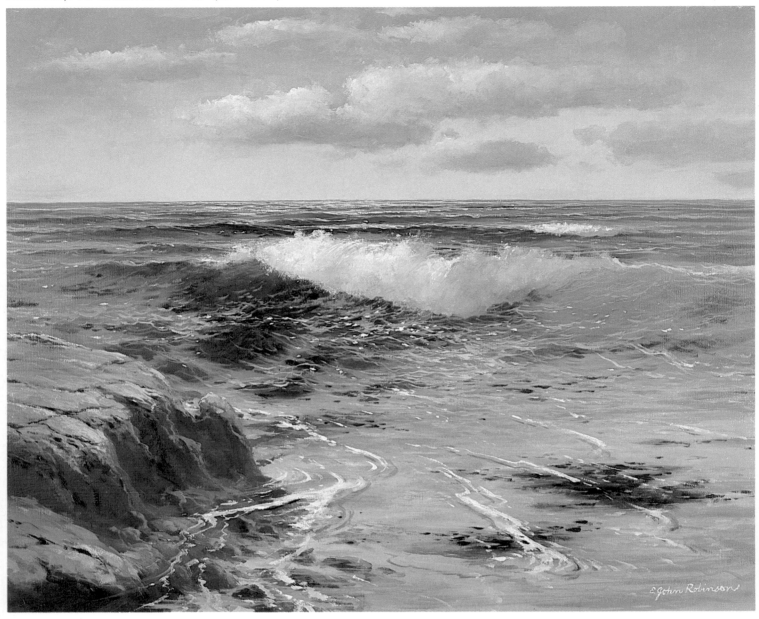

5. FINAL DETAILS AND SUNLIGHT

At first I have trouble with the foam trails because I put too many in the painting, thereby covering too much clear water. I erase them and the sky reflection, which there's also too much of, from the last step and try again. I restate the foam trails with a no. 0 round sable and white paint with a touch of cadmium yellow light, the sunlight color. They finally appear correct when there is only one major trail, with several less-important trails nearby. Notice I run the trails over sand and weeds and rocks to show they're above the floor. The shadows of the trails are painted by adding a bit of cerulean blue and burnt umber to the color of the sand below.

Painting the final touches on the rock means adding some of the sunlight color mentioned above. It also means adding more textures such as cracks the same way as I had in Step 4. I also add sunlight to the scene. I add more of the sunlight color I had already mixed to the breaker foam and make dots of sunlight near the major wave. They appear as sunlight sparkle and add interest to the center of interest. Notice I also place the sunlight on the foam near the darkest portion of the wave. This adds contrast and also helps the center of interest. The final result should be a painting of clear water on a bright day, with an interesting wave as the center of interest.

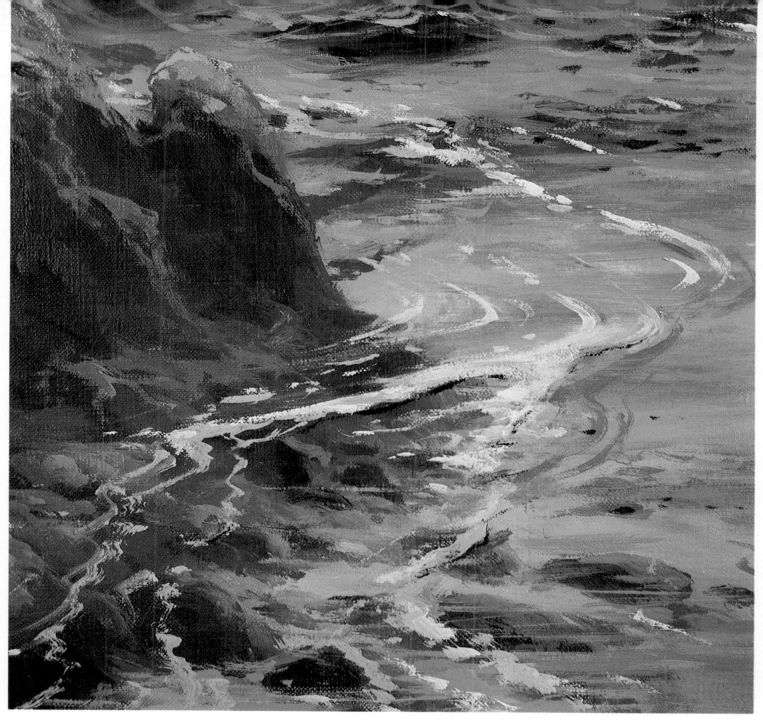

DETAIL OF FOAM TRAILS

After so much discussion regarding foam trails, I think it's necessary to give you a close look at what I've done. The most important role of a foam trail is to show the surface of the water over the floor of the ocean. To do this, I paint the trail over the dark areas of seaweeds and the base of the foreground rock.

The foam trails also swirl a bit at the point of the rock. This helps to show some movement on the surface. The shadows cast by the foam trails establish that the trails are only a few inches above the sand.

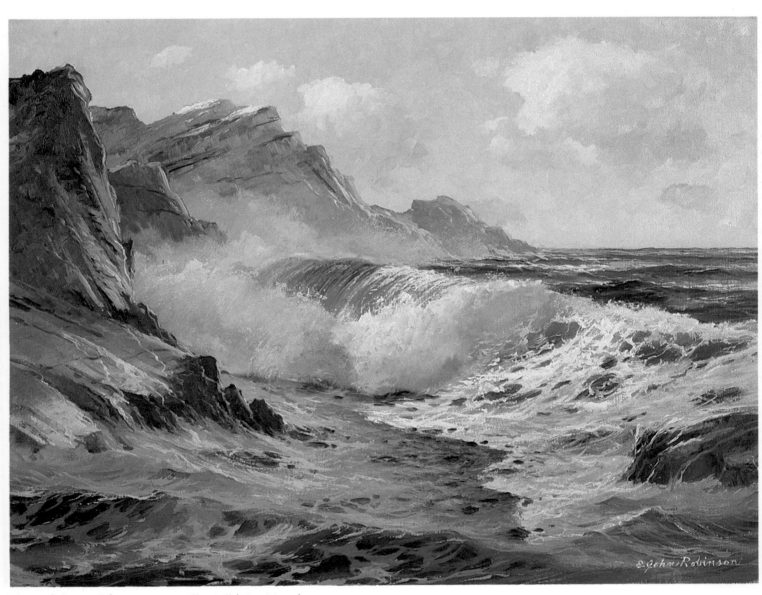

Tintagel Coast. Oil on canvas, 18″ x 24″ (46 x 61 cm).

THE CONFLICT

It was my good fortune to have observed a stormy Atlantic surf near Tintagel in western England. There I found wind and rain and flying mist. But there was more. There was also the age-old drama of sea versus land, the struggle of the elements, the conflict of water and earth. Here was a mood I had to put on canvas but not under those conditions! So I took photographs that could be used later and made sketches with a black, felt-tip marker. I also took in mental images and the mood I felt.

A SECOND PROBLEM
The challenge, of course, was the feeling of conflict, but a second problem emerged that was technical. I observed a shadow cast over the surf and breakers that just had to be incorporated into my painting. Though it was a separate problem, it emerged as a necessary item in the overall mood. (See discussion on page 59.)

ANOTHER APPROACH
The painting on page 50, *Tintagel Coast*, was a preliminary painting for this chapter. Though it depicts the scene and the cast shadow of the bluffs, it doesn't carry the mood of conflict that I'll include in the demonstration painting. On the contrary, there's little drama in it because the atmosphere is sunny with a gentle breeze. The breaker doesn't appear threatening nor do the bluffs look as though they're under attack. If anything, their posture is relaxed.

PLANNING THE MOOD AND COMPOSITION
As I begin to formulate a composition in my mind, I decide to show a huge wave crashing or about to crash against hard, solid-appearing rocks. The rocks have to stand like a defensive battlement; they have to show resistance to the forthcoming assault. To back up the aggressive sea, I plan to show it in a dark, angry mood, running before rain-streaked nimbus clouds. Now the problem becomes a matter of preference for land or sea. I decide to make the struggle more equal than one-sided.

To accomplish this I need to strengthen the position of the rocks. This means making them a bit higher so they're not overwhelmed by the sea. Also, by backing up a short, dark rock with a larger rock

that has a strong base, there should be no doubt as to the strength of the land. They're now nearly equal to the angry sea. To tip the balance, I realize that adding the cast shadow would suffice. There's nothing like having a tall, looming object casting a dark, reaching shadow to suggest strength. The shadow should also give the rocks a threatening attitude to the oncoming sea.

DEVELOPING IDEAS
At this point you may be wondering why I don't just start painting the ideas within me. The main reason is that I have to develop these ideas further, and I find doing this very enjoyable. I believe that the true moments of creativity are now, in the planning stages, where ideas are dissected, pawed over, and evaluated. Naturally there'll be changes during painting—a composition should always allow for flexibility. But for the most part, the true creativity occurs before you even touch a brush to canvas. The actual painting, while not mechanical, is dependent upon the planning.

Studying the Scene

ROCKS

These rocks are typical of those on the Cornwall coast. They're dark, massive, and angular. The cracks and crevices are either near horizontal or near vertical. Quite often, smaller chunks are scattered at the foot of larger bluffs.

This photograph doesn't show the tremendous surf, but it should give you an idea of the rocks in conjunction with the sea. They're sturdy rocks, but the sea has taken its toll over the centuries. Although the rocks stand with strength, they nevertheless are fighting a losing battle.

SURF

Not all photographs turn out the way you want them to, so it's a good idea to make sketches as well. Some of the more spectacular photographs I took weren't suitable for reproduction, but this particular photograph of the surf shows the type of action that occurred close to shore.

Notice the foam patterns. They're the creation of large storm waves that agitate the surface. These are mass patterns, areas of foam with holes showing the water below. The upsurge of the oncoming wave shows the contours of light and shadow. It's this type of foreground action that I want to include in my composition.

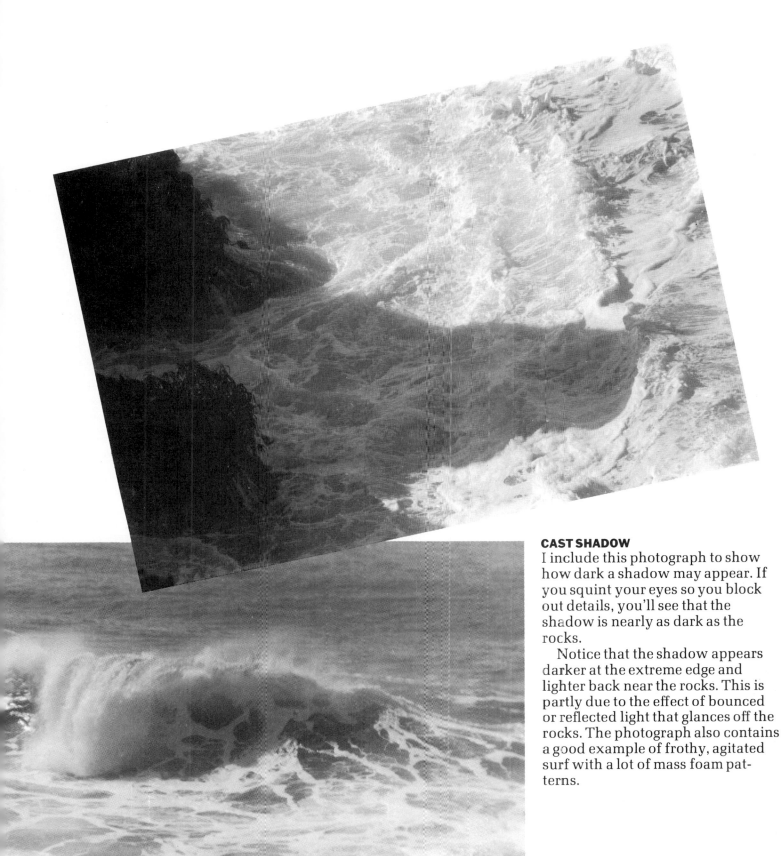

CAST SHADOW

I include this photograph to show how dark a shadow may appear. If you squint your eyes so you block out details, you'll see that the shadow is nearly as dark as the rocks.

Notice that the shadow appears darker at the extreme edge and lighter back near the rocks. This is partly due to the effect of bounced or reflected light that glances off the rocks. The photograph also contains a good example of frothy, agitated surf with a lot of mass foam patterns.

BREAKER

Here's a breaker that's typical of those on rugged coastlines. Notice that this breaker is short in length, rather tall in height, and has a more humped appearance. Waves breaking upon sandy beaches, though, are usually long and not too high.

Take special notice of the soft, misty top edges of the foam, espe-
cially along the top edge of the wave. This effect helps to show the movement of the wave as well as the presence of a breeze or wind.

The foam patterns are linear on the surface of the wave and are of the mass type on the foreground surface. I intend to use both linear and mass types in my painting.

Sketching the Subject

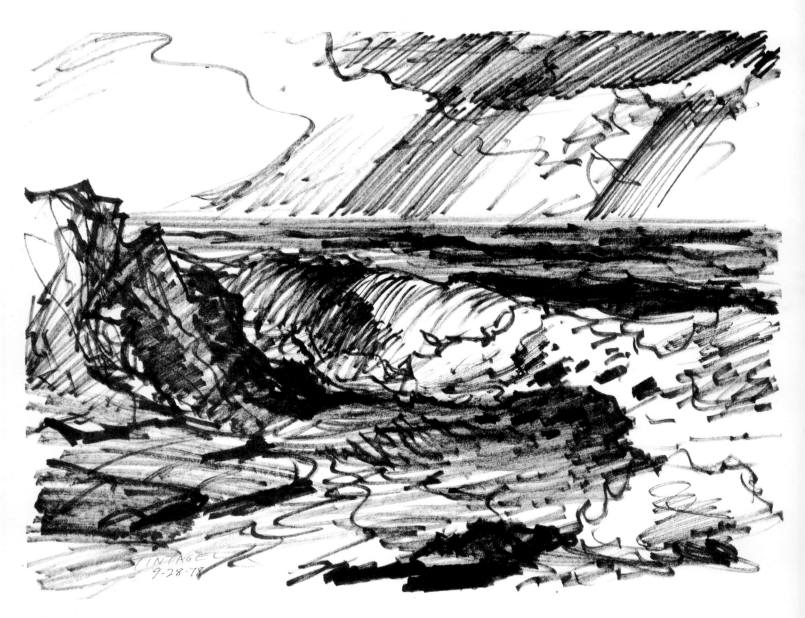

THE ORIGINAL SKETCH

This is the original sketch I did on location and is what inspired me to paint this particular mood when I returned home.

The sky is the driving force, and its slant appears to push the sea and the major breaker into the rocks. The rocks stand in total conflict to the wave. As this is a sketch of the west coast of England, the front lighting is the result of morning light. I chose to cast a strong shadow which suggests bright sunlight in spite of the darkening, stormy sky.

ROCKS

Here's another look at the rocks as I originally saw them. This is the arrangement I wish to make in my painting. The position of the rocks show a dark, massive one where the wave will strike, backed up by a larger one behind it. This position gives the appearance of a line of defense and suggests strength in opposition to a moving force.

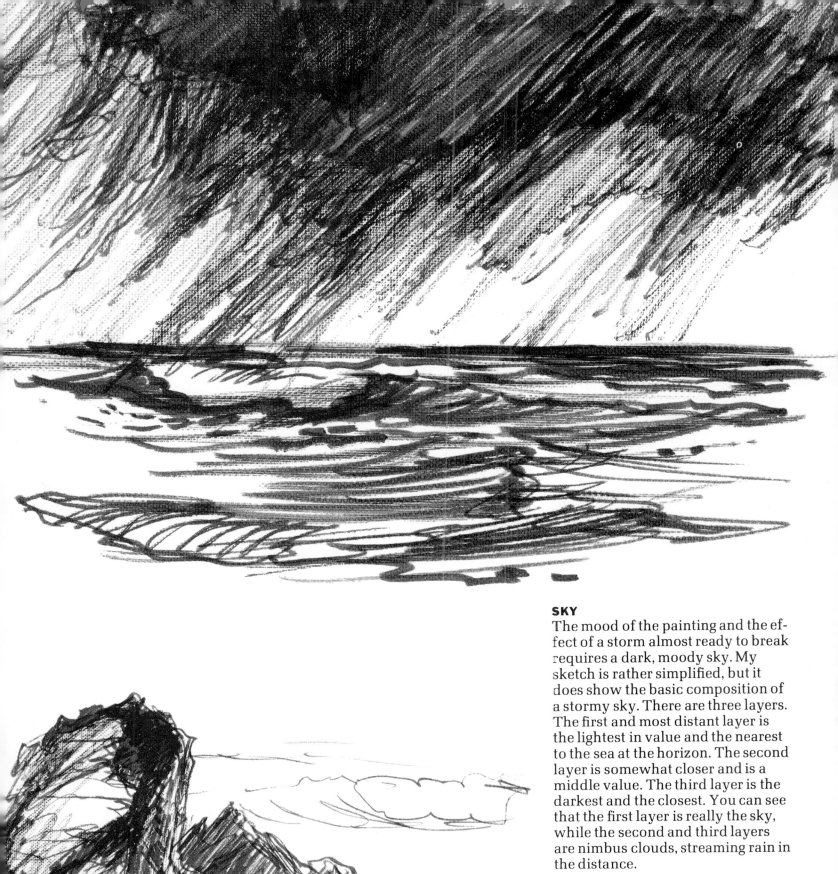

SKY

The mood of the painting and the effect of a storm almost ready to break requires a dark, moody sky. My sketch is rather simplified, but it does show the basic composition of a stormy sky. There are three layers. The first and most distant layer is the lightest in value and the nearest to the sea at the horizon. The second layer is somewhat closer and is a middle value. The third layer is the darkest and the closest. You can see that the first layer is really the sky, while the second and third layers are nimbus clouds, streaming rain in the distance.

Analyzing the Composition

LINES

Although this sketch is simplified, it shows everything I wish to stress as an outline for this painting. The lines of the sky slant to the sea. I indicate waves, though I draw only one in the background. The major wave is clearly outlined, and the direction of the roll as well as that of the foam and the wave face are indicated.

The rocks play such an important role in this composition that I draw them in with a very dark line. I also show the boundary of the cast shadow that cuts across the wave and foreground as a heavy line. I don't want there to be any doubt about the position of the shadow when I begin painting.

VALUES

The mood of this painting requires a lot of dark values, but I must be careful how I use them. The first areas requiring darker values are the sky and background sea. The smaller of the rocks and the leading edge of the cast shadow must also be dark. Adding any more darks than these may be too much for the composition or may confuse the viewer.

The next value to be considered is the lightest one, for with a painting so dark, only a very light center of interest will show up. I choose to use the major wave as a center of interest, therefore I want a lot of contrast there. By using the lightest as well as the darkest values on the wave, I create enough contrast to make it attract attention.

For the most part, everything else in the composition can be made a middle value. Of course there are more than three values to a composition, but three is all that it is necessary to indicate in a value plan.

Selecting the Colors

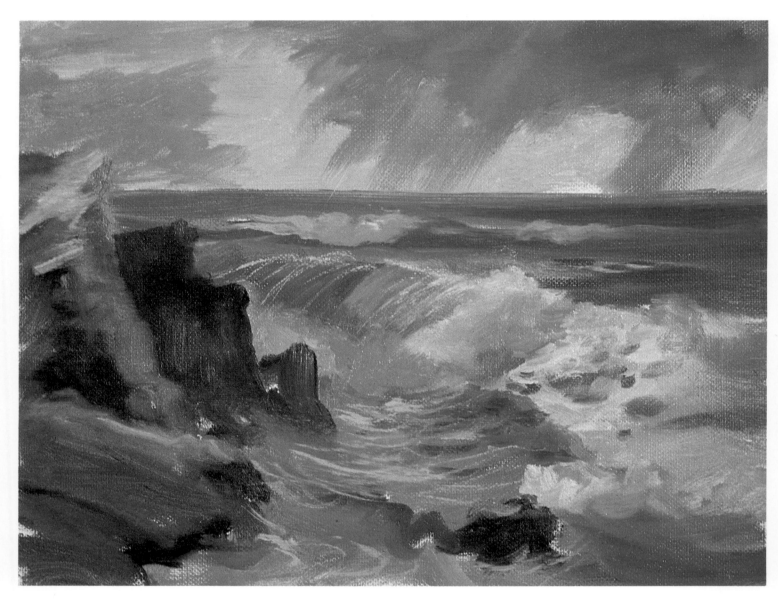

COLOR SKETCH

To maintain the mood of this painting, the colors should be dark but bright. I choose ultramarine blue, viridian green, cadmium yellow light, burnt umber, and white. I plan the painting to be cool in color temperature, but with rich darks.

Ultramarine blue and viridian green without white—the color of this particular sea—give us a rich blue-green, both dark and translucent. Ultramarine blue also takes the flatness out of burnt umber so that the rocks, which are painted with these two colors, are dark but rich in tone.

Once again, notice the lack of detail in this sketch. It would be easy to continue to add details once a sketch reaches this stage, but there's no point in doing it. For one thing, I'm sketching on a canvas-textured paper that simply can't hold up as a permanent painting. But the main reason, of course, is that I'm experimenting and don't want the feeling of having to avoid mistakes. The fact that it's simply a sketch allows me to be free with my strokes and to scrub out colors or simply try another one until I'm satisfied.

As I have pointed out, the real challenge of this chapter is portraying the drama of land versus sea. I've built upon this basic idea in the preceding pages, but haven't fully explained the secondary problem, that of casting the shadow, which plays such an important role in this particular mood.

UNDERSTANDING THE CAST SHADOW

In order to paint a cast shadow well, it must first be understood. First of all, the position of the sun must be determined. I place it behind me but to the left, midway between the horizon line and straight overhead. This is my own personal choice. Once the sun's position is known, I can then decide where I want to place cast shadows.

PLACING THE SHADOW

You may be thinking that the next step would be to place the rock or other object that casts a shadow, but let me explain why it isn't. Where I place the *edge* of the shadow is more important to me than the object that's casting it. Indeed, that object may not even be in the painting. It could be anything—clouds, bluffs, rocks, or trees—that is behind the viewer. It will nevertheless play an important role by casting a shadow.

Once the cast shadow line and the sun's position is decided, it's only a matter of drawing a straight line between the two to determine the height of the object casting the shadow—in this case, the rocks on the left. The illustration here shows a straight line drawn from the sun to the top edge of the shadow across the wave. The top of the rocks must touch that line. In nature, the unevenness of the rocks causes an uneven shadow line. In addition, the shadow must follow the contours of the surface over which it lies.

In my painting, the shadow must follow the forward roll of the breaker before it can angle across the wave to the surf. The shadow on the surf is a bit more accurate in reproducing the image of the rocks in the painting because the surface is less distorted.

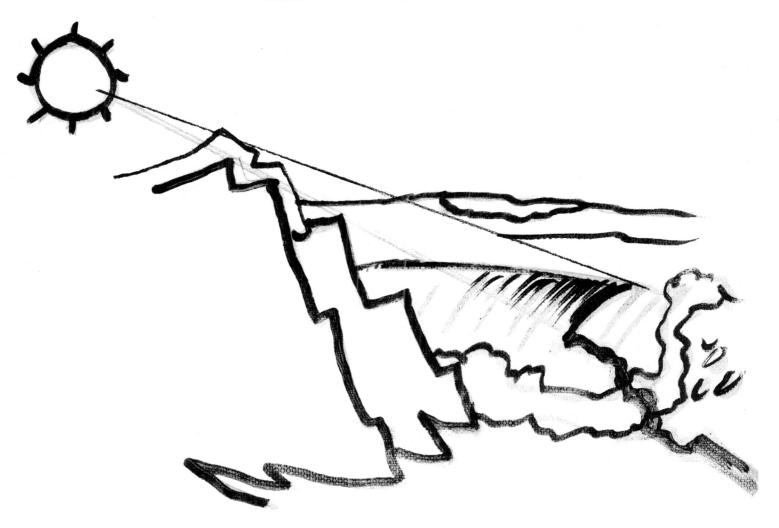

Painting the Conflict

1. OUTLINE DRAWING

"The conflict" at this point should be between sea and land, not between artist and subject! I worked out enough of what I wanted in order to avoid surprises, but not so much that there's no creativity left in the painting process.

To begin, I use a no. 6 bristle brush and pure ultramarine blue to make my outline, following my orig-inal design and sketches as best I could. Even though I was tempted to change everything at the last moment, I continue the original idea, but make notes regarding my new ideas for further thinking or a future painting. Notice that I emphasize the edge of the shadow because it plays such an important role in the composition.

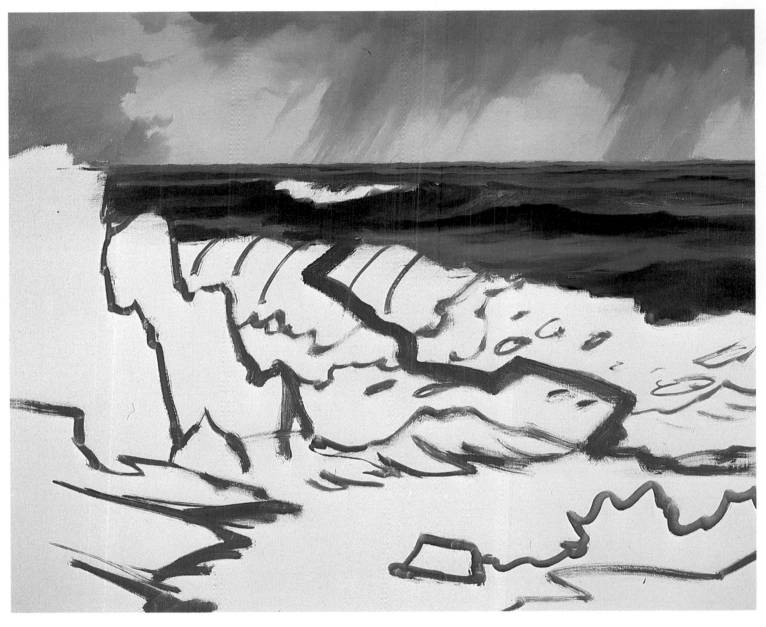

2. SKY AND BACKGROUND SEA

I use ultramarine blue into white for the main sky color. I mix a large pile of it because I know I'll need some later for reflections of the sky on the sea. This time I don't leave the cloud areas unpainted. The clouds are to be darker than the sky and I want a certain amount of blending, so I paint the entire area with the blue/white mixture using a no. 8 bristle brush.

Now I clean the brush and paint in the distant clouds. I use the same mixture as the sky but add more blue and a touch of burnt sienna to gray it. I paint sweeping strokes in the direction of the cloud's movement. The second or top layer of clouds is made with the same mixture as the first group, but with even more ultramarine blue and less white. I sweep the rain so it flows down below the horizon.

For now, I'm only concerned with underpainting the background sea. Using a no. 6 bristle, I paint in the swells with a mixture of ultramarine blue and viridian green. In the area of the horizon I add a bit of sky color to lighten the mixture, but near the major wave I use it pure.

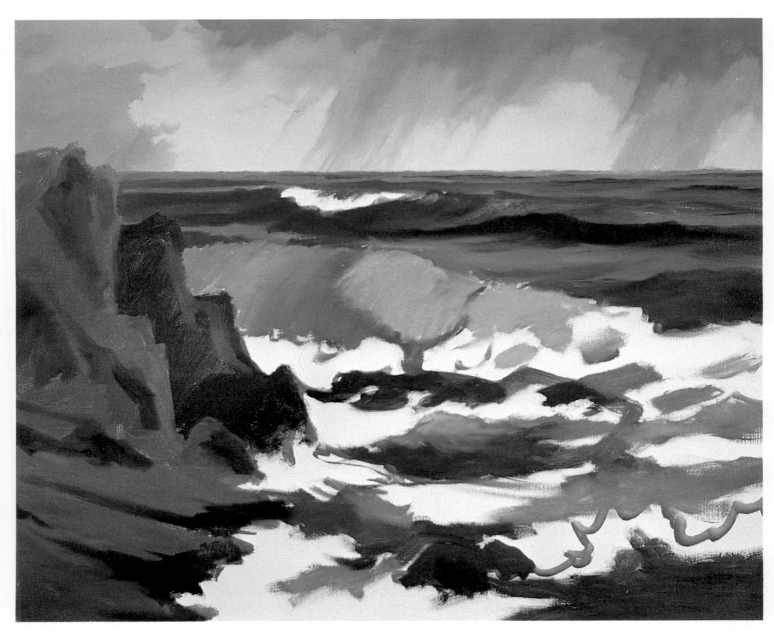

3. FOREGROUND UNDERPAINTING

I underpaint the rocks with burnt umber used straight from the tube at first. Next, to darken some areas, I add ultramarine blue to the umber. For the lighter areas I add just enough paint from the pile of sky color to lighten the umber already on the canvas. I use a stiff no. 6 brush for this underpainting. I plan to texture the rocks later.

The wave and foreground water are underpainted with a mixture of ultramarine blue and viridian green. I use it untinted in the dark areas, but lighten it with the sky mixture in the lighter areas. Notice that not only haven't I lost the shadow line, but I've emphasized it with color. The only areas now left unpainted are areas where I intend to place surface foam.

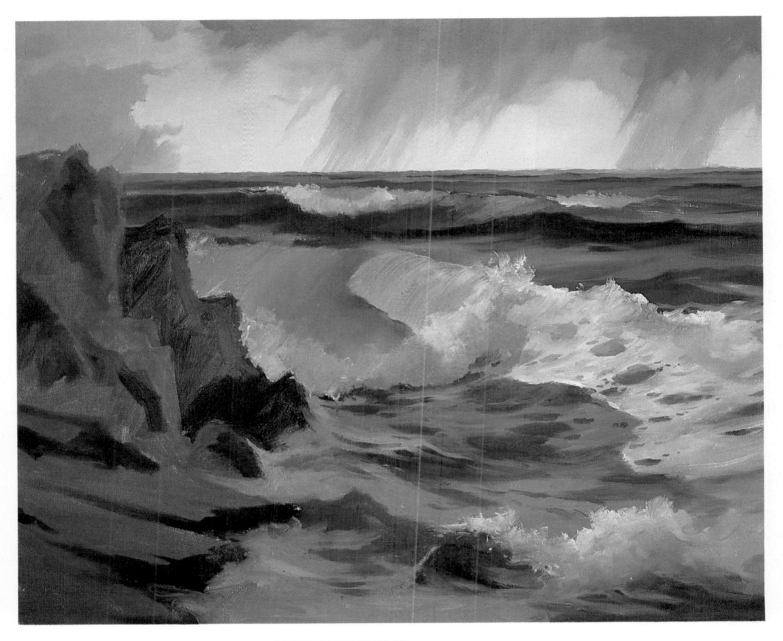

4. FOREGROUND FOAM

All of the foam here is a mixture of ultramarine blue into white, but as you can see, the mixture varies from light to dark. The value is controlled by the amount of white added to the blue. In some places where I wanted a gray-blue, such as near the rocks, I add a touch of burnt umber, a color that the rocks would normally reflect.

The shadow area contains very little white and the light area very little blue. In both areas, I add a few holes where the water shows through the foam. In each case I go back to the same mixture I used to underpaint that area. I am still using a no. 6 brush for these applications and am not concerned with details yet.

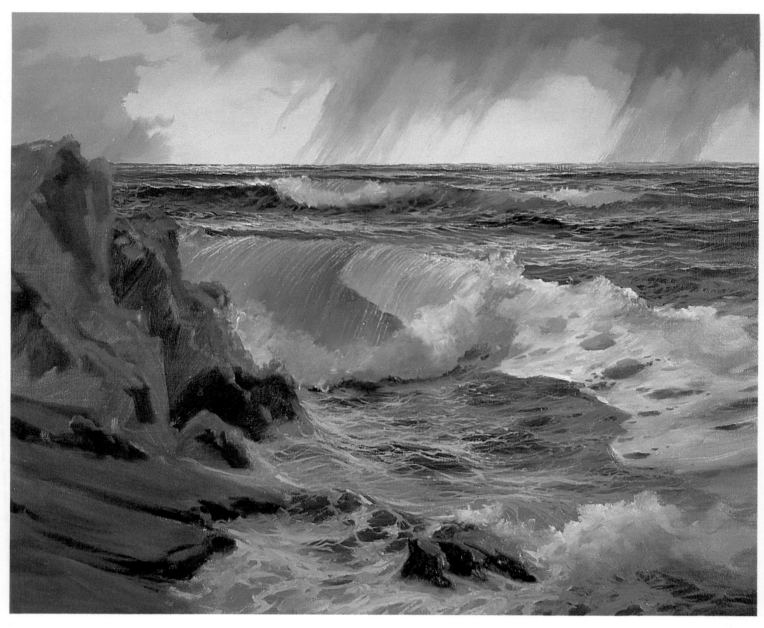

5. ATMOSPHERE

This is the time to break out the tiny brushes. I paint in all of the reflected atmosphere with nos. 000, 00, and 0 round sables. As distance appears to diminish size, I use the smallest brushes for the background and slightly larger ones as I work forward.

All of the color of the atmosphere comes from the large pile of sky color I mixed at the beginning of the demonstration. Though I may darken some areas, such as under the darker clouds, by adding more blue, or lighten others, such as under the wave foam, with the addition of more white, the atmosphere is still a direct reflection of the sky above.

Notice that I also paint a few foam trails in the near foreground using the same color that I used on the surface under the rocks. Even though it may appear lighter than the sky, it isn't. The darkness of the rocks make it seem lighter than it is by contrast. Incidentally, the sky reflections near the rock should be lighter than those at the outer edge of the shadow because they're also influenced by the reflections from the foam of the breaker.

The Conflict. Oil on canvas, 24″ x 30″ (61 x 76 cm).

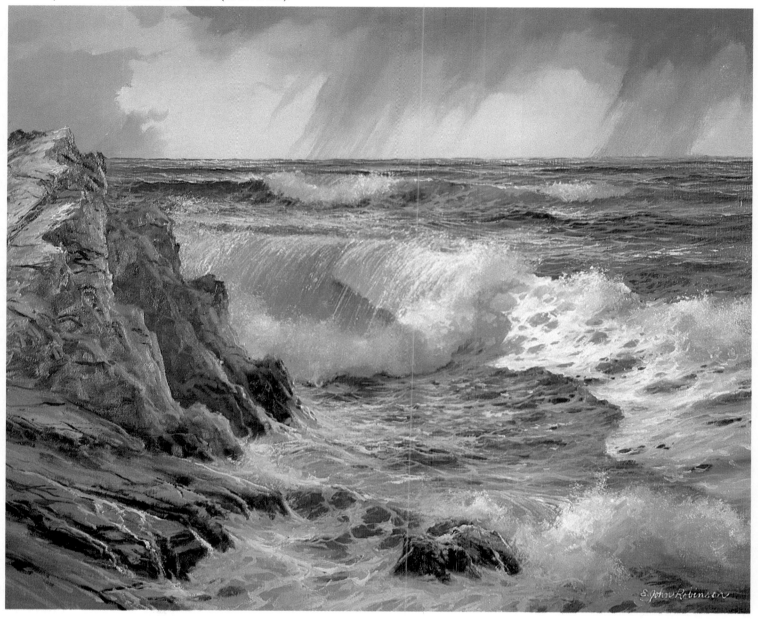

6. SUNLIGHT AND TEXTURES

I mix a large pile of sunlight by blending a tiny bit of cadmium yellow medium into white paint. Still using nos. 000 and 00 round sable brushes, I begin applying the sunlight on the major wave. I always like to follow the movement or contour of an object. Where I want sunlight on the roll of the wave, I start at the top and make curving strokes downward. On the face of the wave I brush in the foam patterns around the holes of water, and on the rock I blend the yellow-white of the sunlight into the still-wet burnt umber, which lightens the rock considerably. Though I'm tempted to add more sunlight, I restrain myself because I know it would destroy the contrast I've achieved.

To texture the rocks I simply added a few cracks with pure burnt umber and a few reflected lights facing the wave on the edges of the vertical rocks with some ultramarine blue-white foam color. The final texturing is done on the foreground surf. I add a few more holes that show water through the surf. I still use the blue-viridian mixture, but work with a smaller brush for more refined spot texturing.

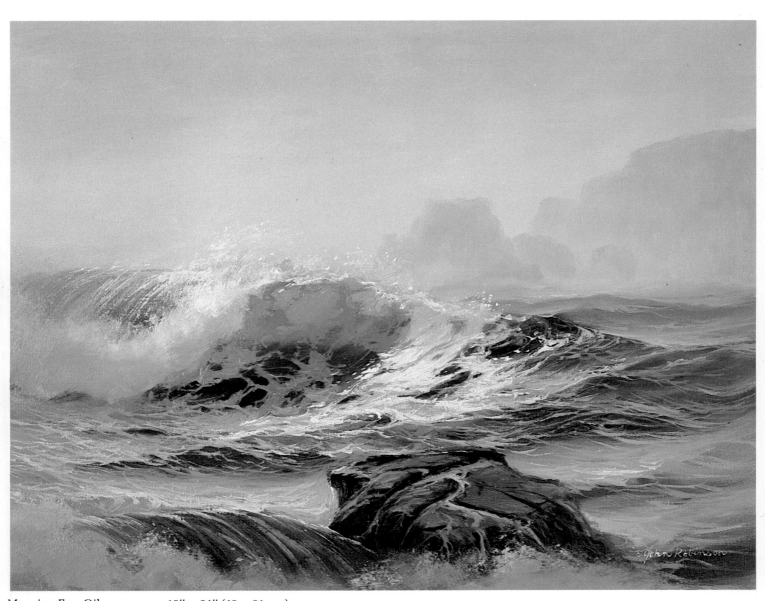

Morning Fog. Oil on canvas, 18″ x 24″ (46 x 61 cm).

FOG

At Land's End on the Cornwall coast of England, the Atlantic pounds in wild fury against the rocks. One of the rocks is called "The Armed Knight" and is a famous landmark. Though I was able to view it under several conditions, including a strong wind (see the second photograph on page 68) I chose to paint the rock and the sea in fog.

There's nothing quite so calming or relaxing to me than to watch the fog come in. Its quiet approach blocks out the panoramic scene and causes me to focus only on objects nearby. It softens hard edges, subdues harsh colors, and even muffles sound. It's nature's tranquilizer in an all-too-busy world.

There's also mystery in fog because you never know what's hidden, what lies beyond. It's this mood that I wish to portray when I paint this demonstration. There is, however, a more immediate challenge. How do you paint fog? What color is it?

DEFINING FOG

Fog is moisture-laden air, a cloud that's settled low. It takes its color from the sky and sun just like everything else, but not nearly as much. Its density doesn't let enough color through, so it appears one of many shades of gray. I personally like fog to have a warm cast, which means that I allow for more sunlight or less density in the atmosphere.

In *Morning Fog* on page 66 I've created a pearl-like color for the fog. It's gray, but quite a warm one, and the sunlight is very apparent in the painting. In this case, the sun is behind the viewer and the fog is still in the background. The sun's rays are reflected off the wave and the fog as well. The result is that the wave and the fog are both lighter and warmer.

MIXING THE COLOR OF FOG

To mix fog color, I start with a gray made with a small but equal amount of ultramarine blue and burnt sienna mixed together and blended into a pile of white. I can control the value of this gray by the amount of white I use. I can also control its color temperature by the amount of ultramarine blue (cool) or burnt sienna (warm) I add. To give the gray a pearl-like effect, I use more sienna than blue for a warm gray, then add a touch of cadmium yellow pale. This would be the influence of the sun coming through.

Once I have a good-sized pile of this color on the palette, I can easily blend it into other colors. This is the way I show the influence of atmosphere on everything in the painting. The amount I use varies with each individual mood.

Studying the Scene

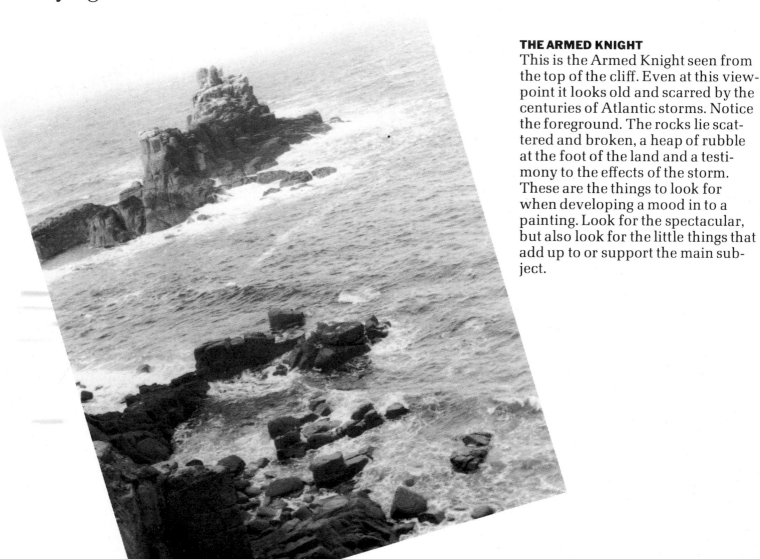

THE ARMED KNIGHT
This is the Armed Knight seen from the top of the cliff. Even at this viewpoint it looks old and scarred by the centuries of Atlantic storms. Notice the foreground. The rocks lie scattered and broken, a heap of rubble at the foot of the land and a testimony to the effects of the storm. These are the things to look for when developing a mood in to a painting. Look for the spectacular, but also look for the little things that add up to or support the main subject.

WIND
Here I'm trying to decide whether to risk life and limb for another view. Caution should always be the first consideration. As it turned out, I found a suitable path that led down to another view of the rock. As you can see, the wind was rather strong that day. I went back another time and was rewarded with the effects of fog. I'm not a lover of wind, except for an occasional effect in one of my paintings!

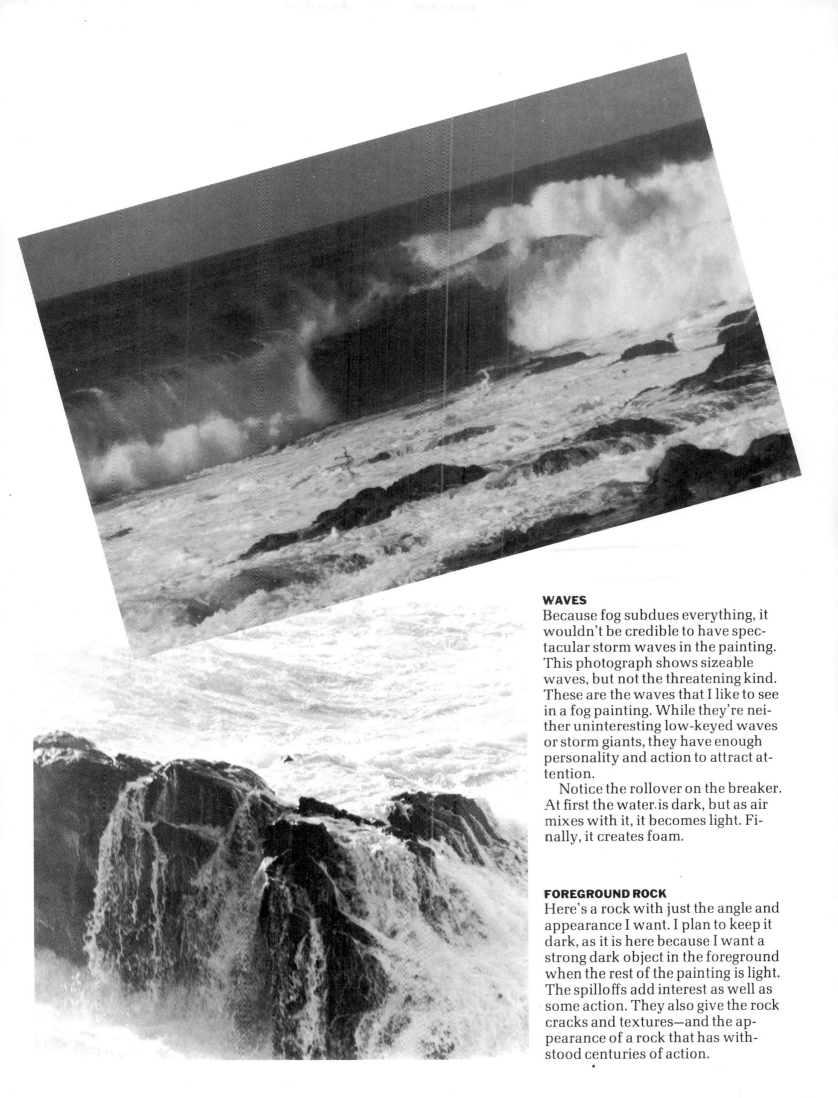

WAVES

Because fog subdues everything, it wouldn't be credible to have spectacular storm waves in the painting. This photograph shows sizeable waves, but not the threatening kind. These are the waves that I like to see in a fog painting. While they're neither uninteresting low-keyed waves or storm giants, they have enough personality and action to attract attention.

Notice the rollover on the breaker. At first the water is dark, but as air mixes with it, it becomes light. Finally, it creates foam.

FOREGROUND ROCK

Here's a rock with just the angle and appearance I want. I plan to keep it dark, as it is here because I want a strong dark object in the foreground when the rest of the painting is light. The spilloffs add interest as well as some action. They also give the rock cracks and textures—and the appearance of a rock that has withstood centuries of action.

69

Sketching the Subject

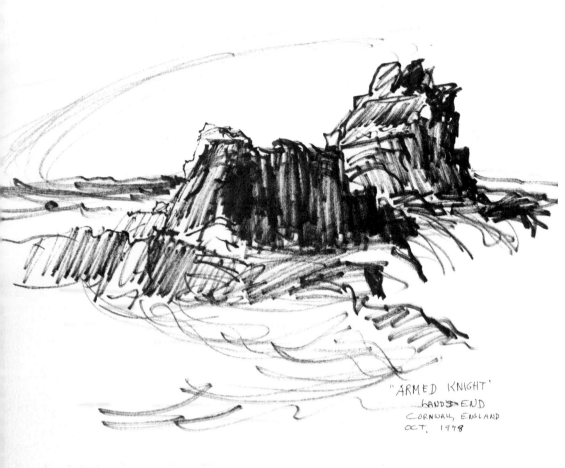

"ARMED KNIGHT'
LANDS END
CORNWALL, ENGLAND
OCT. 1978

THE ARMED KNIGHT
This is a quick sketch of The Armed Knight, when I finally could climb down the cliff to view it. From this angle, a cheesecake view, it looms upward, and takes on a strength that was missed from up on the hill. While this isn't a detailed drawing, it gives me enough information to go back to the studio and paint it. I can see now that The Armed Knight is really a grouping of two large masses of rocks, one higher than the other. Both are a series of vertical slabs with cracks and crevices, and light and shadow.

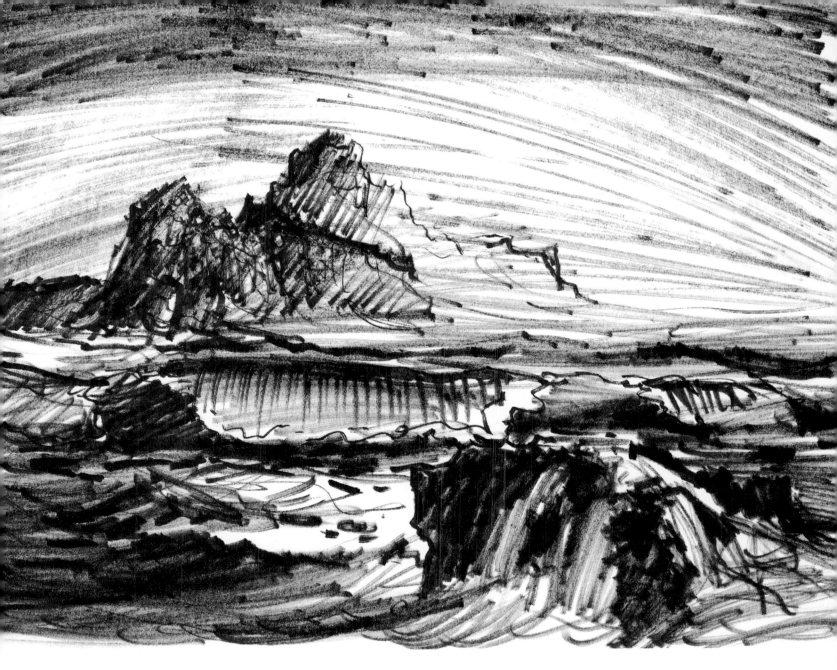

FOREGROUND ROCK
This is drawn with a black felt-tip marker—not the best of drawing instruments, but adequate for quick impressions. And that is exactly what I intend here—not a detailed drawing, but rather an impression of what I see and wish to remember. The most important feature is the rock and the way it fades into the fog. Next, there's the wave, with its peculiar form of breaking with foam streaks. The foreground rock can also be seen in the photograph on page 68. It's actually in another spot, but because I liked it, I drew it in where I wanted it.

WAVE
In this quick sketch you can see the type of wave seen in this particular environment. What I try to remind myself of, for further reference, is the dark area of the roll.

This is the sequence of the action: At first, the leading edge is dark because it's mostly water, with no air. But then, at a certain point, gravity takes control and the water begins to fall. At this point, air mixes with it and the water becomes lighter. It then hits the trough and bounces upward as foam.

If the wave is in foamy water, it often picks up enough foam to carry over the roll. In this case the foam streaks over the top along with the dark falling water. Not only is the effect interesting, but it also reveals the contour of the wave, thus giving direction to the movement.

Analyzing the Composition

LINES

Line can be very meaningful. Notice that I use a wide variety of lines in this sketch. Their weight also varies from very wide and dark to light, thin lines that fade away. The dark lines on the wave stress the need for darkness there, as they do again on the foreground rock. Notice also the contrast between the sharp, angular lines of the foreground rock and the softer lines of the background rock.

In short, I have composed this demonstration painting in such a way that the nearest objects are the darkest and most visible and everything fades from there on back. The center of interest is really the big rock, but the eye is led to it gradually, moving first from the foreground rock, then to the wave, and only then to the center of interest, The Armed Knight.

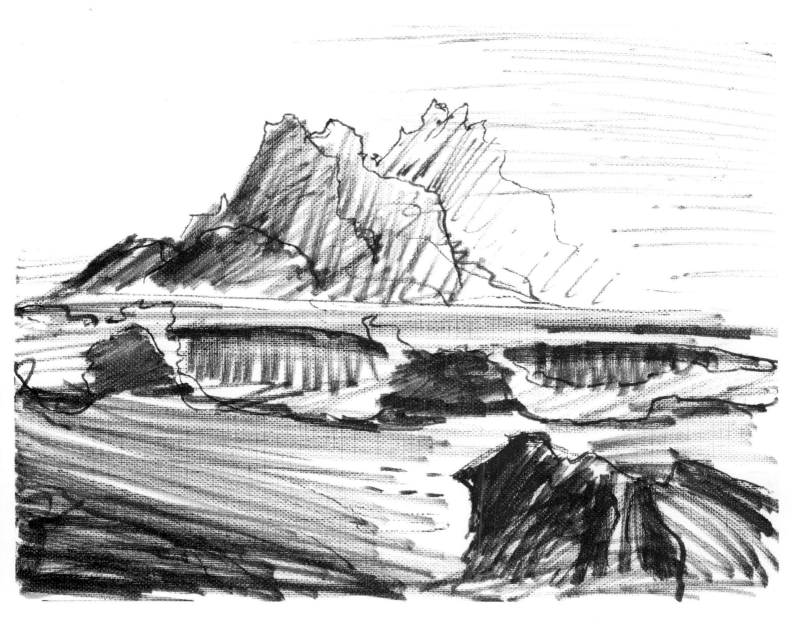

VALUES

The value composition consists of a gradation of light to dark starting at the top and moving down. This is because of the use of fog in the background. Most compositions are predominately either light, middle-toned, or dark, with variations. I decided to keep the variations in value to a minimum here because too much busyness would destroy the effect of softness created by the fog. Note the placement of dark values in light areas and light values in dark areas. This is called *value interchange.*

It's quite easy to control the amount of contrast in a painting that contains fog. Since fog, by its nature, minimizes the contrast in value (and color) between objects and within objects, you have only to decide which objects you wish the fog to affect and mix the color of fog (see page 67) into each of them. The more fog you mix into an object, the more it will fade into the atmosphere and the less contrast it will have.

Selecting the Colors

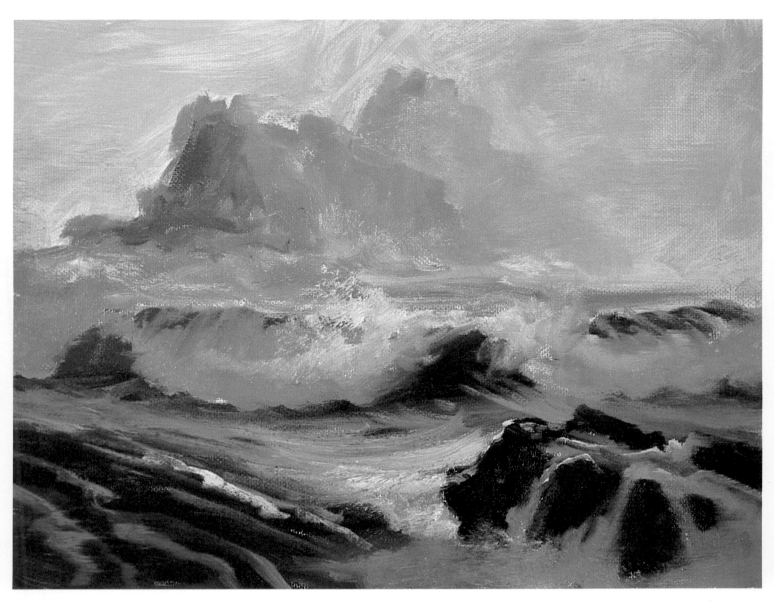

COLOR SKETCH

My palette for this painting is ultramarine blue, viridian green, burnt sienna, alizarin crimson, cadmium yellow pale, and white. Since I want the effect of sunlight through the fog, I want the background warm and the foreground cool. Therefore I paint the sky with the fog color—the combination of burnt sienna and ultramarine blue mixed into white that I described earlier. A touch of cadmium yellow pale helps give it a pearl-like hue. Notice that I make the left-hand side of the sky warmer by using more burnt sienna than blue. I gradually add more blue and less burnt sienna as I move to the right.

The rocks in the background are also a mixture of burnt sienna and ultramarine blue, but with less white. I begin with a dark mixture on the left and gradually fade them into the atmosphere by adding the same fog color I used for the sky.

Since the foreground is barely affected by the fog, it's darker and more intense in color. The water is painted pure viridian green, darkened with some burnt sienna and ultramarine blue, and the foreground rock is made with burnt sienna and ultramarine blue, with no white at all. The shadowed foam is painted with ultramarine blue with a touch of alizarin crimson mixed into white. The lighter portions are white with a touch of cadmium yellow pale added.

As I paint the demonstration itself, I will be using more combinations of this palette. But for now, only a rough idea of the colors I will use is all I need to get started.

I once read that Old Masters taught their students about atmosphere by draping sheets of cheesecloth at varying intervals in front of an object or still life. The further away you sat, the more layers of cheesecloth you had to see through in order to paint the subject.

While I recommend outdoor painting as much as possible, when you can't go to nature, then try experimenting in your studio. Indoors you will not only be able to work as long as you want under an unchanging light, but you'll also be comfortable while doing it. For example, I've already suggested studying shadows on an object by placing a lamp over or near a small rock and then drawing it (see page 59).

STUDIO STUDY

If you don't have the time or can't get to the ocean as often as you'd like, one of the problems you can study in your studio is the effect of spilloffs on a rock. Water spilling over rocks happens so fast in the surf, it's difficult to follow and know just where to place the spilloffs. So try this simple studio experiment.

Pour a thin solution of white paint over a small rock. (I've done this using watered-down gesso, but any thinned white paint will do.) The rocks should be some you've collected at the beach or at whatever location you'll be painting. In other words, they should be small models of what the larger ones look like.

Place the rock on a piece of plywood or heavy cardboard. Hold the container of white liquid over the rock and let it trickle slowly into the center area. You'll see that the liquid, which should be thin enough to run freely, follows the paths of least resistance. It falls first through the largest crevices, then runs into and along the smaller cracks. Once you've poured the liquid over the rock, you can study it from different angles. Put a desk lamp over it and study the light and shadow effect along with the spilloffs.

Painting Fog

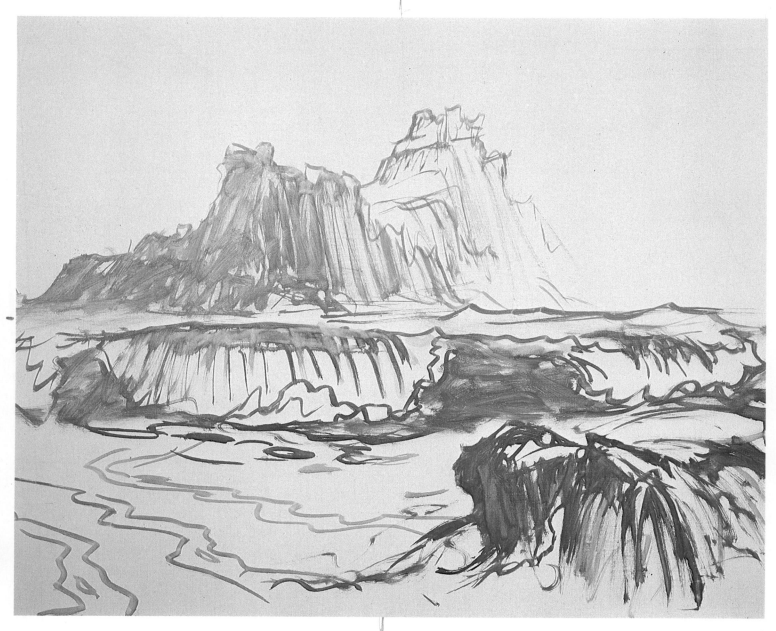

1. OUTLINE

I draw the composition on the canvas with ultramarine blue, using a no. 6 bristle brush. To set the stage for later values, I indicate where I want each of them to be. Notice that the foreground rock is the darkest value, the wave is a bit lighter, and the background rock is still lighter. I also show where I want the major rock to fade into the fog. If you compare this drawing with the final step, you will see that I haven't deviated too much from my initial value plan.

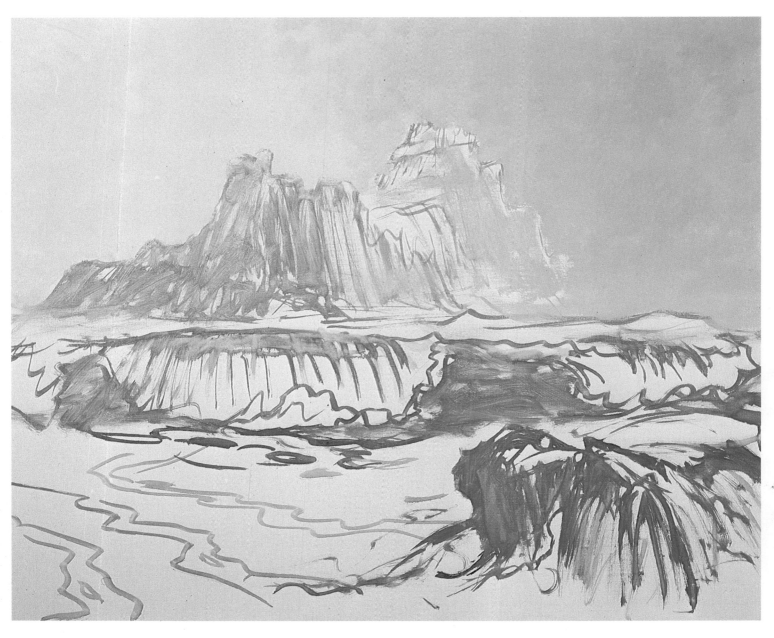

2. FOG COLOR

I always mix a large pile of whatever color I use for the sky because it will be used again and again. The fog, as I mentioned before, is made of equal parts of ultramarine blue and burnt sienna mixed into white, with a touch of cadmium yellow pale to give it a sunny cast.

Working rapidly from left to right with a no. 10 bristle brush, I start to paint the foggy sky with a mixture containing more sienna than blue and enough white to keep it light. As I move across the sky, I gradually add more blue to the mixture, but not more white or sienna. The effect is a gradual change from warm and sunny fog to cool fog.

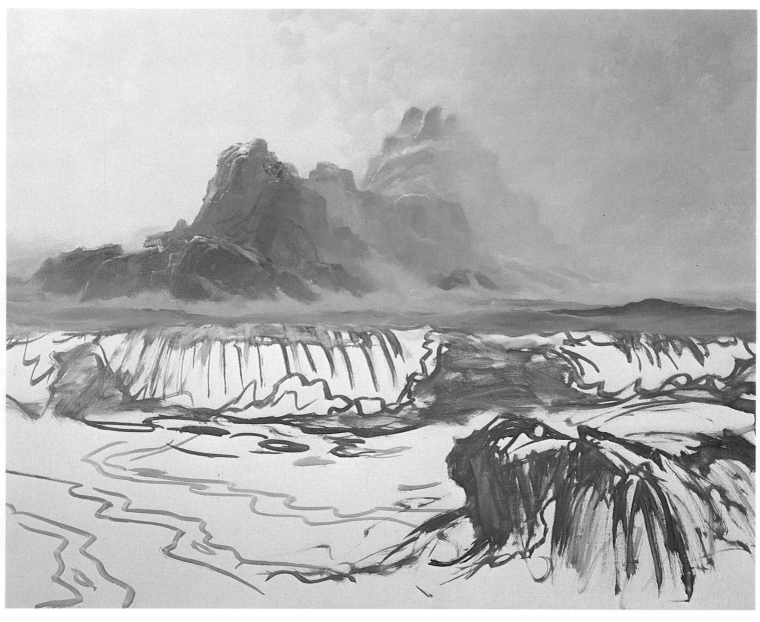

3. BACKGROUND ROCK

The colors in the rock are the same as in the sky, the only difference being in the amount of white. To paint it, I start with ultramarine blue and burnt sienna and mix them thoroughly. I then add a small amount of the fog color from the pile I have ready. I know just what value to start with because I sketched it in during Step 1.

Because the left-hand side is the darkest, I start there. Painting from left to right with a no. 6 bristle brush, I gradually add more and more fog color until the rock can no longer be distinguished from the background. Then I work back into the rock, using a no. 4 bristle brush, and add a few darker planes and cracks to it. I also reflect the fog into the tops of the rock prominences by painting them with the fog color. For the foamy white water beneath the rock, I scrub in a mixture of ultramarine blue and white, and add viridian green to the water mixture for the swells.

At this point, the rock looks too prominent, so I soften the edges of the right-hand side by whipping a dry, 2″ (5 cm) varnish brush over them.

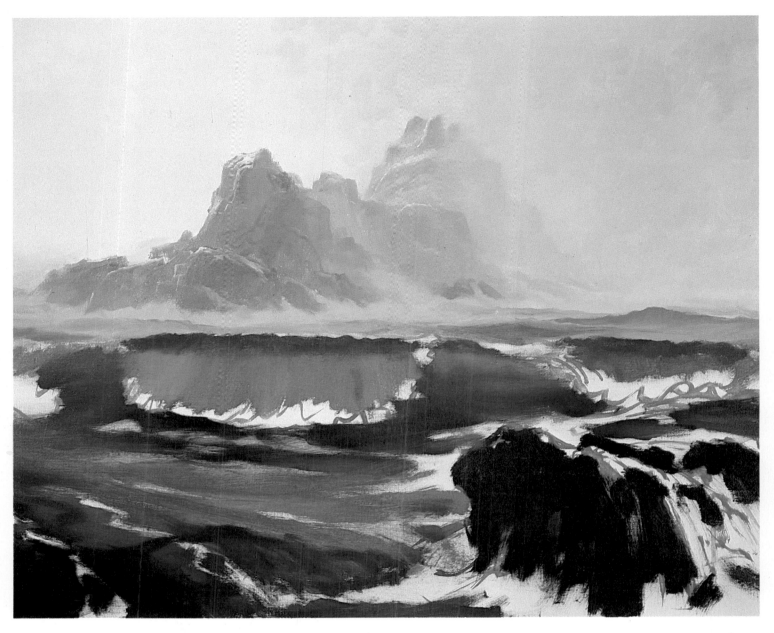

4. FOREGROUND UNDERPAINTING

The entire foreground, including the rock, is scrubbed in with a mixture of viridian green and burnt sienna. Obviously, the rock is more burnt sienna than viridian green, and the water is mostly viridian with just enough sienna to darken it. I work fast on this section, using a no. 8 bristle for everything. The rock, for example, is done in no more than seven or eight strokes.

The darkest portion of the water is the viridian-sienna combination, which has no white at all. The lighter green areas are made by mixing more of the fog color (the ultramarine blue, sienna, and white mixture) into the sienna-green mixture. Notice I left the areas where foam will go unpainted. I don't want the color of foam to mix with the green of the water or the color of the rock.

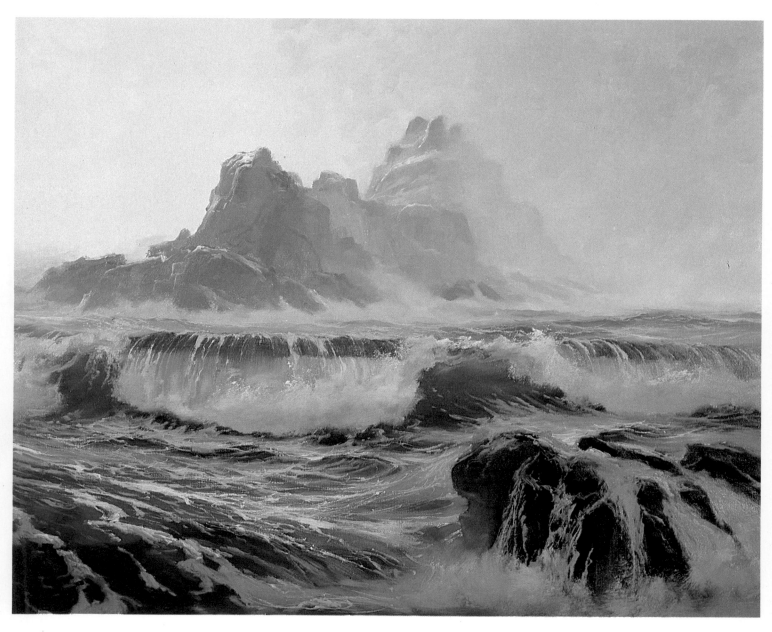

5. ATMOSPHERE AND FOAM

The breaker foam, foam trails and trickles over the rock are all painted with a combination of various values of ultramarine blue added to white. I start with the darkest blue areas first and gradually add the fog color to lighten them. The breaker foam and the large foam trails are painted with a no. 4 bristle brush, but I have to use a no. 0 round sable for the finer trails and the spilloff trickles on the rock.

I also use a no. 0 round sable to reflect the atmosphere onto the surface of the foam. Again I go to the pile of fog color and make short,

horizontal scalloped strokes to indicate small chops in the surf. These are reflections of the sky above. Notice that I place most of the sky reflections on the left-hand side of the wave because it's directly under the lighter side of the sky.

By this time I know the rock is much too dark, so I lighten it by scrubbing in some of the ultramarine blue-white mixture. In addition, I lighten the top portion of the breaker foam and make foam trickles on the roll of the wave using the lightest portion of the fog color again.

The Armed Knight. Oil on canvas, 24″ x 30″ (61 x 76 cm).

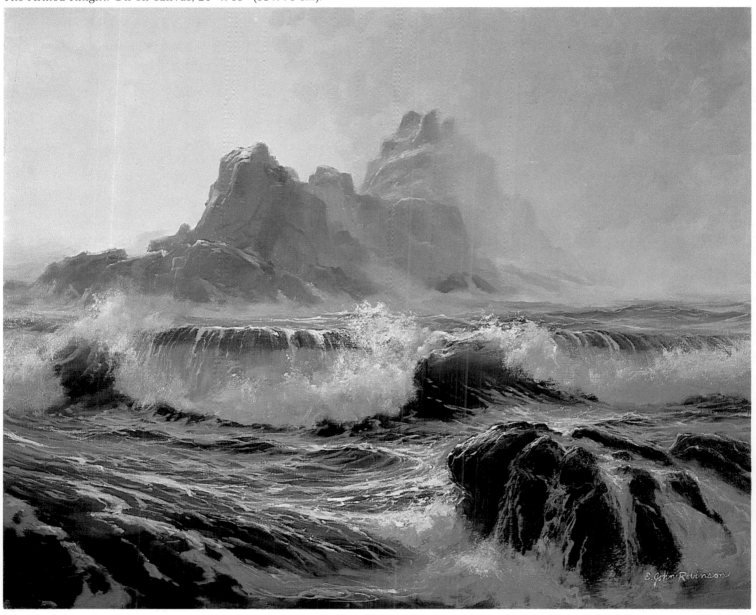

6. SUNLIGHT

As usual, I end with the addition of sunlight. It's most often the smallest amount of paint applied, takes the most patience, and has the greatest effect. In this painting, the sunlight is not the center of interest. But nevertheless it helps to set off the foreground rock and the wave.

For the color of sunlight I mix a very small amount of cadmium yellow pale into white. Using my smallest brushes, nos. 000, 00, and 0. I first highlight the wave by adding some sparkle to the very top of the roll. Then, with a no. 6 bristle, I add the sunlight color to the top of the breaker foam. Notice that I scatter the foam up and in front of the background.

The rock really needs to be set off, so adding sunlight to the water simply gives the rock the contrast it needs. Then I blend some of the sunlight color into burnt sienna already on the front of the rock. This gives it a warm, sunny, glistening effect, that shows the wetness of the rock. If you compare the preceding step with this one, you can see the difference just a little bit of sunlight can make.

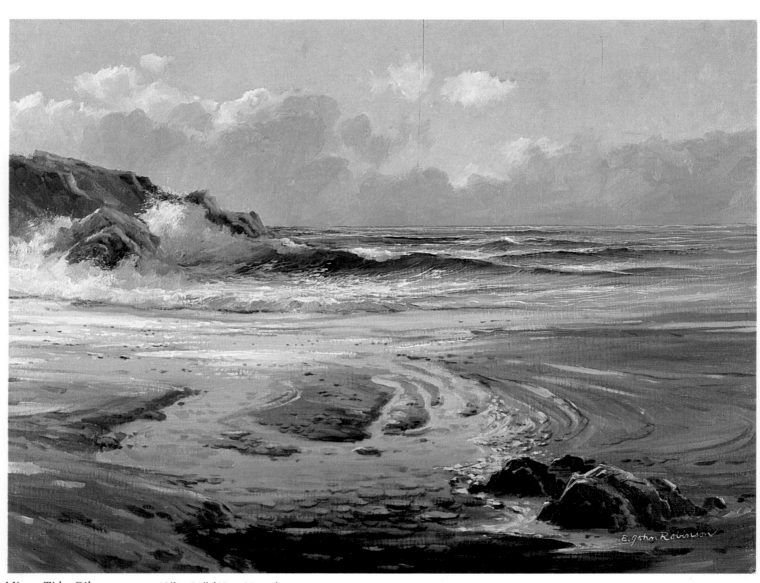

Minus Tide. Oil on canvas, 18″ x 24″ (46 x 61 cm).

OUTLETS

Only recently have I focused attention on anything other than the roughest of surfs. Of course, I haven't lost my interest in the active, dramatic sea, and I shall continue to paint it in every mood it shows. However, after all these years of painting the surf, when I stepped back from the action I soon discovered how interesting and challenging painting the beach can be.

At first I had the problem of making sand look like sand, but then came the real challenge, painting the outlets. Outlets may be backwashes from the surf or shallow mountain streams finding their way to the ocean. It's fascinating how they wander about in the most interesting patterns, and when the sun is reflected on them, they fairly glisten!

ANALYSIS OF THE PROBLEM

In some ways, painting outlets is similar to painting shallow water such as that described in Project Two. Like clear water, there are two layers involved, the floor and the surface, and each has its own characteristics and influences. But when you compound these characteristics with additional influences such as

the layers and humps of both wet and dry sand, a stronger sky reflection than that seen in clear water, plus the reflection of the sun, then the situation can become quite complex.

As I said earlier, the color of sand may vary from nearly white to nearly black, depending upon where it's located. It may be made up of fine grains or may be nearly gravel. It may be covered in varying degrees with seaweed, driftwood, boulders, birds, people, and everything else that goes along with them. As I prefer less-traveled beaches (by either birds or people), my demonstration may appear a bit lonely. However, I'll demonstrate how to paint a typical outlet meandering through a rather typical beach, but one without much clutter.

A TYPICAL OUTLET

Let's take a look at the scene of *Minus Tide* on page 82. On the West Coast this would be a warm, sunny morning with the sun just touching the sand and surf. There are a few scattered pebbles, a group of rocks, and some flat rocks under the water. For the most part, the outlet reflects the sky. It's only up close that you can see below the surface.

Notice also that the ocean is relatively calm. Big action usually takes place against large rocks and bluffs.

The surf at beaches is generally much quieter because the ocean floor is smooth and rather shallow for quite a distance.

THE SLICK

When outlets reach the surf, they enter an area I call the *slick*. It's just wet sand, the area the waves wash upon. When the spent wave flattens and recedes, it leaves the sand wet. The slick is a mirror for the sky, but it may be broken up by reflected sunlight or pebbles.

Quite often waves break upon the slick in swirls and eddies. This leaves behind patches of drier sand that don't reflect the sky. Although these humps can be arranged in patterns of any kind, I particularly like to use them as trails or "stepping stones" that lead the eye to the sea, which is usually the center of interest.

Although most of the outlets I've studied are in Oregon, outlets can be found everywhere. You may even go out of your way to seek them out after studying this project because you'll see how interesting they are and how they can break up an otherwise uninteresting stretch of beach. You'll also find that they aren't as hard to paint as they look.

Studying the Scene

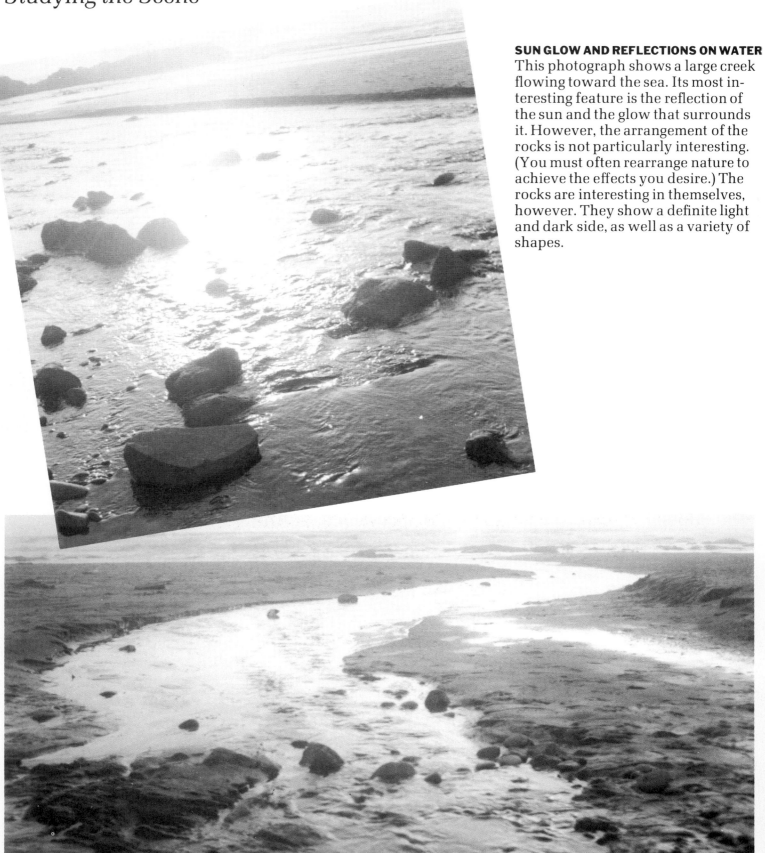

SUN GLOW AND REFLECTIONS ON WATER
This photograph shows a large creek flowing toward the sea. Its most interesting feature is the reflection of the sun and the glow that surrounds it. However, the arrangement of the rocks is not particularly interesting. (You must often rearrange nature to achieve the effects you desire.) The rocks are interesting in themselves, however. They show a definite light and dark side, as well as a variety of shapes.

S-CURVED CREEK WITH VALUE GRADATION
Here's a ready-made S curve leading to what could be a center of interest, if I were to put one in. The interesting features here are the ripples around the small rocks and the change of values in the creek. Notice that the creek is dark in the foreground and gradually lightens as it moves away. This is because of the angle of the creek to the viewer. Up close, you can look down through the water to the sand and rocks, but in the distance, where it's at a flatter angle, the sky is reflected.

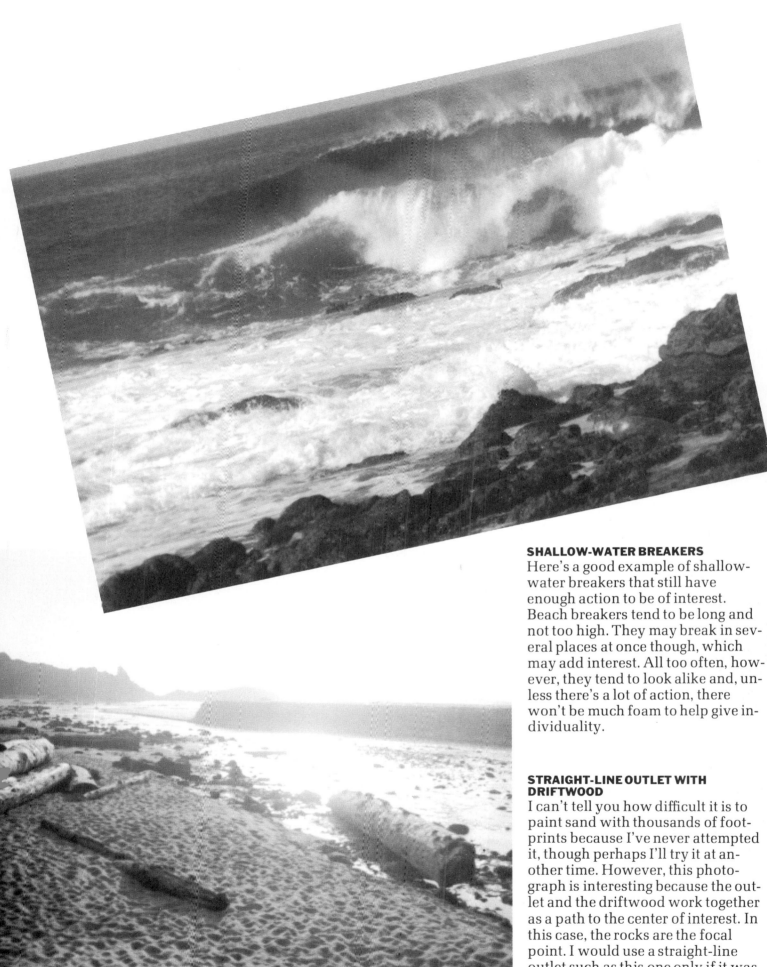

SHALLOW-WATER BREAKERS

Here's a good example of shallow-water breakers that still have enough action to be of interest. Beach breakers tend to be long and not too high. They may break in several places at once though, which may add interest. All too often, however, they tend to look alike and, unless there's a lot of action, there won't be much foam to help give individuality.

STRAIGHT-LINE OUTLET WITH DRIFTWOOD

I can't tell you how difficult it is to paint sand with thousands of footprints because I've never attempted it, though perhaps I'll try it at another time. However, this photograph is interesting because the outlet and the driftwood work together as a path to the center of interest. In this case, the rocks are the focal point. I would use a straight-line outlet such as this one only if it was broken with rocks and driftwood. Otherwise it would be uninteresting as compared to one with curved or meandering lines.

Sketching the Subject

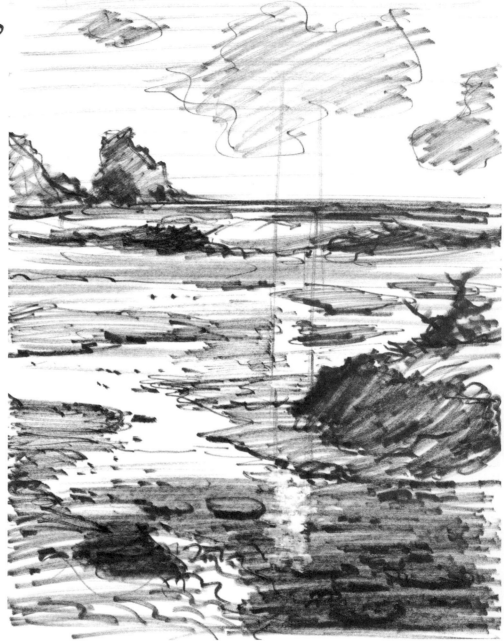

ROCKS AND SKY REFLECTION (*Above*)
This very simple sketch shows the rocks in shallow water. They're visible, but greatly reduced in detail. The closer they are, the darker they appear because there's less light sky color reflected on the surface of the nearby water (because of your angle), so you can see their true color more clearly. However, as they get further away, more sky is reflected on the water, lightening it and gradually making the rocks less visible.

WATER AND SAND PATTERNS (*Below*)
This is an example of any number of patterns that can be created with swirls of water between humps of sand. The important thing to remember here is that, as in the previous example, there's an interchange of values. While the water is gradually lightening (due to sky reflection), the sand gradually darkens as it recedes. This is mostly due to the contrast in value between the lighter water and the sand. But it also occurs because the sand is wetter (and thus darker) as it nears the surf.

WORKING SKETCH
I call this a "working" sketch because I can't quite accept it as a final sketch. I like the background, but I'm not totally satisfied with the foreground. As I've laid the scene out, the major outlet fights for attention with the path of sunlight that I want. It also doesn't lead to the wave as I want it. I also don't care for the lone, scraggly piece of driftwood. There should be more pieces, or none at all.

It's for reasons like these that I recommend your doing several preliminary sketches before moving on. In this case I know I can correct it, and do so in the linear composition that follows.

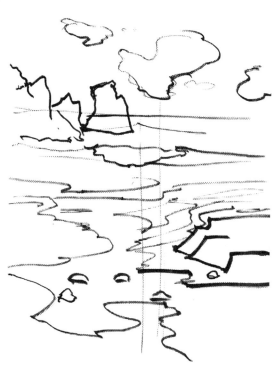

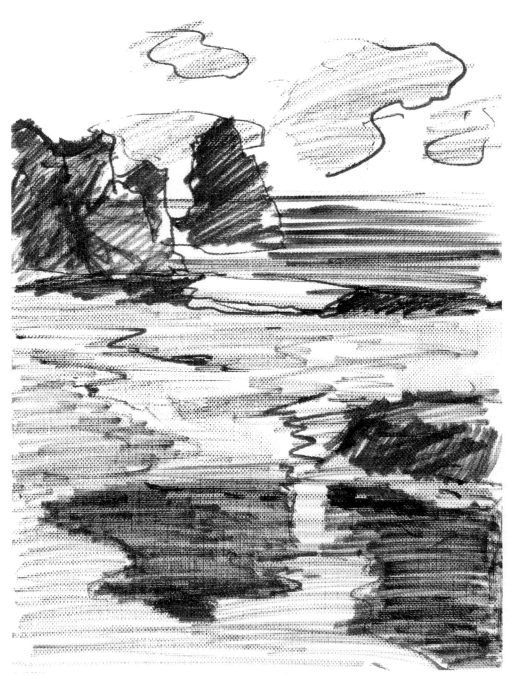

LINES

A linear sketch simplifies everything. When you're not dealing with values, details such as pebbles and ripples, and other things that will come later, it's much easier to compose.

I've now corrected those things that bothered me in the working sketch. I've drawn the outlet so that it meanders toward the wave, and placed two vertical lines exactly where I want to have a path of light. I've also decided that the driftwood might be too distracting, so I've left it out. From this composition I can easily develop the values necessary to hold it together, which is the next step.

VALUES

I decide that this will basically be a light painting, but with some heavy dark areas in the foreground, repeated in the rocks in the background. By making the foreground the darkest area and the sky the lightest, there's a feeling of open-aired space. Because this painting depicts the sea from a distance, a long view to the sky is necessary. Otherwise the sea would appear too close for what I want to show.

While the outlet is very interesting, I don't intend it to be the center of interest. Although it will be noticed immediately, together with the help of the path of light, it will then lead the eye to the sea beyond. Having dark rocks in the background surf also helps attract attention and lead the eye into the distance.

Selecting the Colors

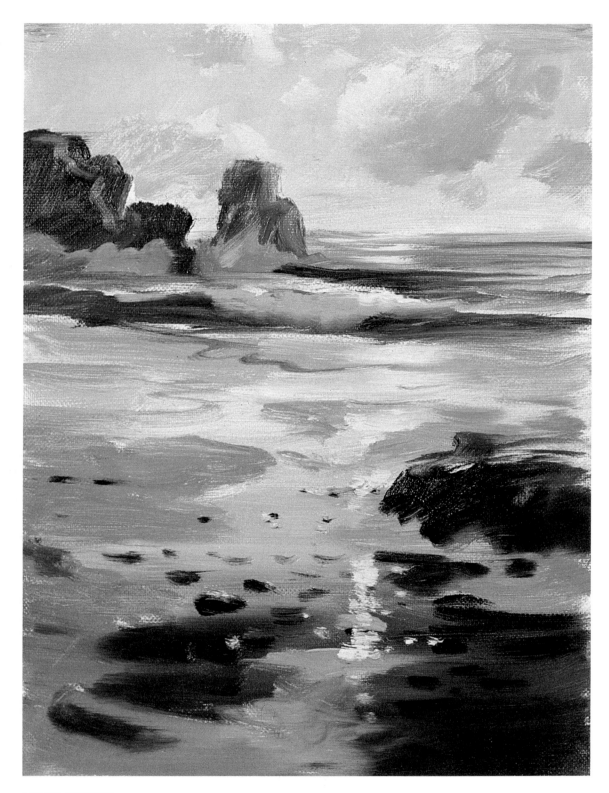

COLOR SKETCH

As I mentioned before, I want this painting to have an open-aired brightness. Therefore I don't want to use dark, moody paints. So I select manganese blue because it's a light, almost transparent blue. I also choose burnt sienna rather than burnt umber because it's light and warmer in tone. In addition, I use viridian green (which is a transparent green), cadmium yellow pale, and white.

Notice that I keep the same outline and basic values of the compositional sketches in the color sketch. At this point, if the colors that I want to use interfere with these values, I can correct it. But as it is, the colors work well and I proceed to the canvas—and the demonstration.

There are two important matters to be understood before attempting to paint an outlet. One is the reflecting qualities of shallow water and the other is the path of light created by the sun.

THE NATURE OF WATER

Though water is generally transparent, and you can see through it, it's not always translucent. (That is, it doesn't always allow light to pass through.) In the case of shallow outlets to the sea, we'll assume that the water is both transparent and translucent. It will be clear enough to allow light to pass through it and you should also be able to see the floor or bottom of the creek.

REFLECTED LIGHT AND COLOR

Look closely at the illustration. The vertical lines represent light and color from the sky and sunlight falling upon the outlet and sand. As you can see from the diagonal lines, the sand reflects either nothing or very little of this color and light, depending upon whether it's dry or wet. The rocks above the water, like the sand, also reflect little, but the rocks below the water reflect back enough

color to make them visible to the viewer, especially when sunlight strikes them. The floor, or bottom of the outlet also reflects its color, but the intensity of that color depends on the depth of the water.

Finally, the surface of the creek is the best reflector of them all. If the water's surface is smooth and unrippled, it will reflect like a mirror. If it's rippled, of course, the mirror image will be distorted. But even then it will reflect light and color back to you. In short, the arrows in the diagram below indicate two things: (1) that light (from the sun or sky) strikes the water and is reflected back, and (2) that light penetrates the water and is reflected back from objects below the surface or from the ocean floor or from the floating particles of matter (density) of the water itself. In the case of active water, with a lot of air in it, the light will penetrate even further.

REFLECTED SUNLIGHT ON WATER

The second matter that must be understood is the reflection of sunlight on water. Its reflecting powers depend entirely on the nature of the surface of the water. Though it helps to make underwater objects visible,

it reflects its own light and color mainly on the water's surface. But whether or not it reflects at all depends on the condition of the water and the angle of the sun in relation to the water. If the water is absolutely calm, the sun may be reflected as a mirror image. However, ripples, currents, or objects in the path of light will distort that image. Such disturbances may also reflect small glints of the sun away from the main path, acting like tiny mirrors that constantly wink on and off.

Also, reflections will always follow you. That is, as you walk along a beach or waterway, the path of light or reflections of objects always run in a direct line from the object to you. But in order to do this, the sun or the object must be in front of you. In other words, you won't get a path of light ahead of you if the sun is behind you. In the demonstration that follows, I've placed the sun in front of the viewer, but above the range of the picture. Its relative size is reflected by the width of the path of light that comes straight down to the viewer.

SKY AND SUNLIGHT

FLOOR ROCKS WATER SAND

Painting Outlets

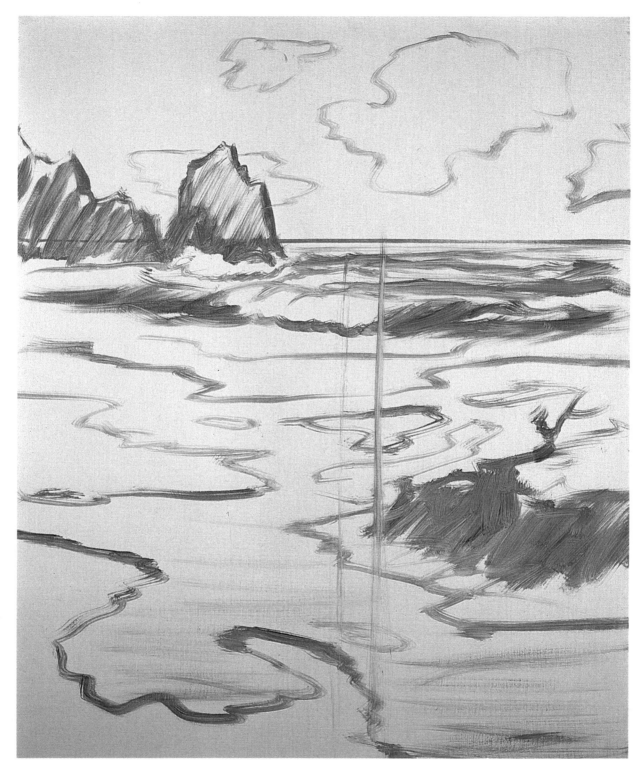

1. OUTLINE DRAWING

The first step, as always, is rather simple. The main idea in this step is to avoid getting carried away and painting before you have an outline.

I draw on the canvas with pure manganese blue and a no. 6 bristle brush. As usual, I indicate the darker values by scrubbing in more paint. In this case, however, I don't scrub in the dark area in the right-hand foreground because I don't want the manganese blue to mix with the color I use later for the creek bottom.

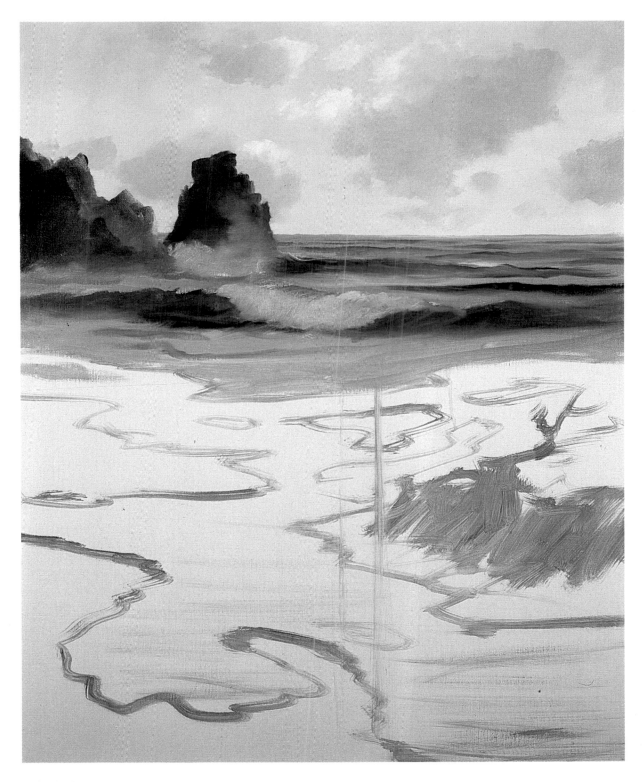

2. SKY AND BACKGROUND

I mix the sky color by working a small amount of manganese blue into a large pile of white. I paint the entire sky area except for the clouds, adding a bit more blue to the upper area of the sky. I use a no. 8 brush. The clouds are a warm gray made of burnt sienna, a touch of manganese, blue, and white. I keep the cloud color slightly on the sienna side, and very light. The sunlight part of the clouds is white, with a small touch of cadmium yellow pale.

I paint the entire background sea with manganese blue, lightening it near the horizon line with a bit of white and darkening it near the surf by adding viridian green with no white at all. At this time I don't put in details.

The background rocks are made with burnt sienna and an equal amount of viridian green for the darkest portion. I lighten some areas by adding the light blue color of the sky. The breaker and foreground foam are painted with manganese blue mixed into white and scrubbed in with a no. 6 bristle brush.

3. OUTLET UNDERPAINTING

This outlet blends right into the "slick" or wet sand area in front of the surf. Starting at the slick, I paint in the lightest value of the sky color, the manganese blue mixed into white. I use a no. 6 bristle brush and make horizontal strokes. As I work downward, I keep adding a small amount of manganese blue to the

mixture to darken the reflection, since the sky directly overhead is darker than the sky at the horizon line.

Working still farther down on the outlet, I begin to add paint from a pile of dark sand color. It was mixed from equal parts of burnt sienna and viridian green, with no white added. This isn't the color of the surface sand, but of the darker *wet* sand that

lies beneath the transparent shallow water. I gradually add more and more dark and less pale blue until the outlet at the very bottom of the painting is pure dark sand. By brushing horizontally and going slowly, the transition from blue to brown can be quite gradual.

4. SAND AND ROCKS

I now mix the color of the light surface sand by blending a small amount of burnt sienna and manganese blue into white. In the foreground near the path of the sun, I put more sienna and less blue in the mixture. But as the sand recedes from the path of light, especially out in the slick, I add more blue than sienna, in order to show the in-fluence of the path of light that will be painted in later.

All of the rocks are painted with the mixture of burnt sienna and viridian green and with a no. 4 bristle brush. I paint the shadow side of the large rock and the smaller rocks below the surface with the darkest version of the color I can make. To paint the lighter areas at the top of the rocks, I add blue from the pile of sky color on my palette to the mixture. I fade the rocks under water by adding some color from the pile of sky blue to the sienna-viridian color of the rock mixture and painting the submerged rocks. As the rocks move into the sky-reflected area I gradually add more and more blue until they finally disappear.

5. ATMOSPHERE

Now I return to the pile of manganese blue I mixed into white for the sky color, and also go back to the tiny brushes. Starting at the horizon line with a no. 000 round sable and the lightest color of the sky, I make short, choppy strokes over the background swells. As I move downward, I add a bit more manganese to the mixture to reflect the darker sky overhead. I also use this mixture for the light front and tops of the background rocks. But for the breaker foam and the surface foam I use a lighter blue-white value because even though the foam is in shadow, it's still white.

On the other hand, the atmosphere that reflects on the sand and foreground rock is darker. Here, I use a no. 0 round sable and begin to show the swirls in the sand by reflecting the color of the sky off the ridges. The atmosphere reflected off the large rock helps define the planes and general shape of the rock.

To the Sea. Oil on canvas, 24″ x 30″ (61 x 76 cm).

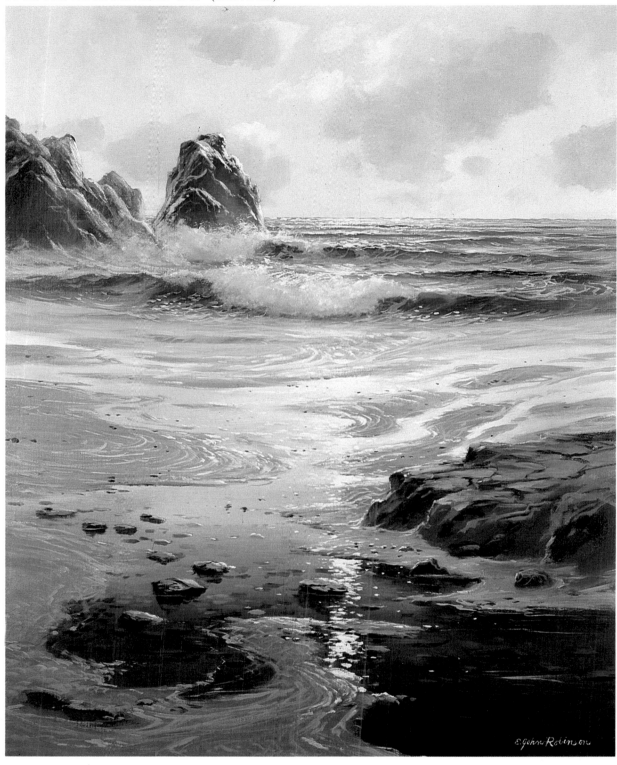

6. SUNLIGHT AND TEXTURES

Using a no. 00 round sable and sunlight color mixed from a touch of cadmium yellow pale added to white, I put in the sparkle I think is so necessary to my paintings. At the horizon I make short, horizontal strokes and let the effect spread outward a bit. I then put a few touches on the front of the rock and over the breaker. I add quite a bit to the breaker foam at the top. From the breaker on, I reflect the sun into a path whose width is determined by the width of the sun itself. Notice that the path is made up of a series of closely bunched strokes or spots of sunlight color. In addition, I add a few sparkles beyond the sun's path, and some on the sand as well.

Because the atmosphere and sunlight adds so much texture, there is little left to do. I return to the sienna-viridian rock mixture and add a few more pebbles and some cracks to the rock. I add only enough to add interest. More might make the area too busy and distracting.

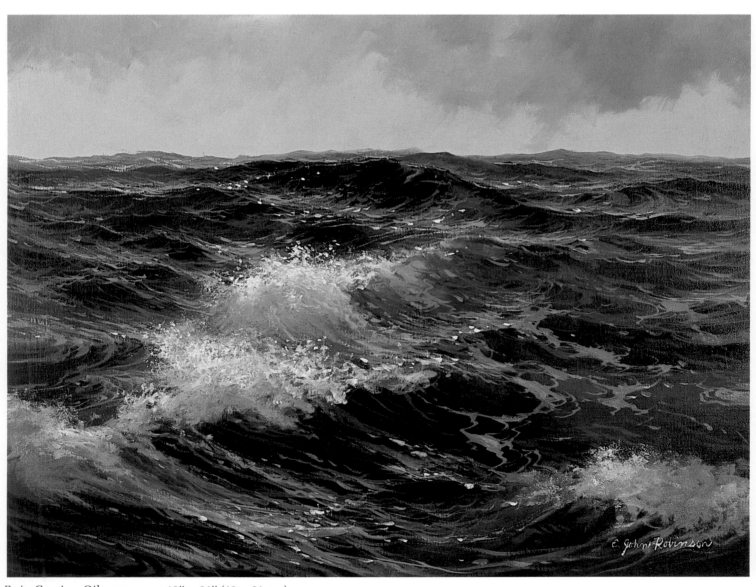

Rain Coming. Oil on canvas, 18″ x 24″ (46 x 61 cm).

THE OPEN SEA

After years of painting the sea with both feet planted firmly on the ground, I finally had the opportunity to study the open sea from the deck of a large ship as I crossed the North Sea from Holland to England. Needless to say I was a bit apprehensive, but not for long. Not only was the ship stable, but I didn't pay much attention to the motion anyway. I was too busy studying the sea.

I love to watch the breakers at the shore, the rocks with their trickles and overflows, the spume from water crashing against the bluffs, and all the drama that goes with the surf, but the open sea has a fascination all its own.

SWELLS

The waves on the open sea vary from those near shore. At the shore, a swell becomes a breaker because the motion carries it into shallow water and it tips forward, crashing against the beach. At sea, there's no shallow water and no beach or rocks. But, nevertheless, the swells at sea break in their own manner, since they can only grow so tall before they must tip over. However, they don't break evenly, as at shore. Usually when they break, foam is created along the top edge and often cascades down the front of the swell until it flattens out into foam patterns similar to those at shore. These are called whitecaps and are the result of wind and rough action.

Sometimes the swells are thin enough to let light penetrate through them, creating the same translucent effect that we paint in surf waves. Foam patterns also can be over the swells and, if the wind is active enough, puffs of foam may blow off the swells much like a foamburst at shore.

CENTER OF INTEREST

The open sea has a fascination all its own. But it also poses a number of challenges that must be worked out before a successful painting can emerge. One of the first problems is finding a center of interest, since many of the props used to paint the surf at shore (such as rocks, headlands, beaches, and even a true breaker) are obviously missing. Many open-sea paintings use a ship as a focal point, but since I'm not a painter of ships, I've had to find other solutions.

I've since learned that, to find a center of interest on the open sea, you must look for patches of foam, the occasional translucent tip of a swell, and, of course, the reflection of the sun and sky. When all else seems to be missing, if you turn so that the sun's reflection bounces from the sea to you, you can always paint the glitter.

Take a look at *Rain Coming* on page 96. This is from a sketch I made out of Vancouver, British Columbia, and is the result of studying the wake from the bow of the ship. Notice the froth on the leading edge of the swells and the touch of translucent water. They have become the center of interest in a composition that would otherwise be monotonous. The addition of a few foam patterns and some sparkle from the sun also help to make the painting interesting to view.

VARYING VALUES

Another problem that needs working out is that of developing an interesting composition. Without any earth and rocks for interest, the possibilities seem limited, especially in terms of values. But even though the open sea appears to be only one dark value, you can always arrange for as many areas of light or middle values among the darker ones that you wish.

DEVELOPING MOVEMENT

Even more than the sea at shore, the open sea has the feeling of movement in your painting. Although the waves at shore roll in and out, open sea swells move up and down in a constant agitation. This is hard to show, but one way to do it is by placing more emphasis on diagonals and long sweeping lines in the composition. Of course, soft edges on any foam or whitecaps will also aid in showing movement.

Studying the Scene

FOAM PATTERNS
Here's a good example of typical scattered foam patterns that may be found in open water. Though they're the result of a passing ship, foam patterns can also be caused by wind action. To understand the nature of these foam patterns, picture a swell of water that's in constant agitation. The foam at the top falls over the face of the swell, then the action of the swell stirs it into a scattering of patterns.

THE SWELL
There's really no such thing as a typical swell, but this is a good example of those found at sea. In the background the sea is fairly smooth, while the foreground is textured with smaller, varied swells. The major swell at the upper right is quite dark and the bit of foam at its top is typical. Notice that the foam is not breaking over like a shoreline wave. In fact, the swell may move out from under this foam leaving it to flatten out into patterns that may be picked up by the next swell.

SKY REFLECTIONS
At sea, where there's little variety of color, you must depend on the sun and sky reflections for interest. Not only do they provide needed color, but they also define the surface of the sea. This surface is a series of chops and swells of various sizes that show up mainly as dark shapes against the light sea. For example, in the photograph, the surface of the water is light because it reflects both sky and sunlight, while the vertical sides of the swells and the foam that's in shadow and don't face the sky are dark. Actually, because these dark shapes are unaffected by the lighting, they're closer in color and value to the real (that is, local) color of the waves.

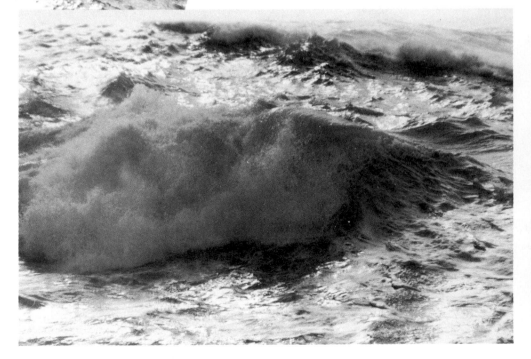

WHITECAPS

Here's another quick sketch, made with the same materials. This time I wanted to record my impression of the whitecaps, the foam that's stirred up on top of the swells. To show their shape and form, white-caps must be painted with both light and shadow sides. Usually, unless the sun is hitting them straight on (as it would very early or very late in the day), the top of the foam would be in sunlight and the rest in shadow, as it is here.

PATTERNS

This is one of many sketches I made while on the ship. It's a quick sketch, but perfectly adequate to aid me later in the studio. I used heavy (300 lb) unstretched watercolor paper because it doesn't wrinkle, and cut it into 9" x 12" (23 x 31 cm) sheets. I applied black acrylic paint in the dark areas and titanium white acrylic in the opaque foam patterns. (Working in only black and white is one of my fastest ways to sketch; felt-tip pen, of course, is even faster, but doesn't give me an opaque white.)

I show this sketch mainly because of the shape of the swell, which I wish to use in my demonstration painting. It's dark and rises above the horizon line. At its base there are a series of patterns left by a previous cascade of foam. The top or leading edge of the swell is scalloped and uneven, which shows that the swell is made up of smaller swells and that it's in constant movement.

REFLECTING THE SUN

As I mentioned earlier, finding focal points or centers of interest for a painting can be difficult on the open sea. While the occasional tip of translucent water may be enough, I prefer to add more interest. Because I enjoy using sunlight in my paintings, I decide to make the reflection of the sun the focal point of my demonstration painting. This sketch is a study for that.

Using black acrylic, I first paint the dark swells. Then, with white, I add the light lines of the sky reflections that show the ocean's contours, and last, place the round spot of sun reflected on the water. When reflecting sun on water, it's important to paint it nearly the same size it appears in the sky because the reflection is basically a mirror image. There may also be a glow of light around the area that may make it appear larger (see Project Eight). I create the glow effect here by blending pure acrylic white into the surrounding area, while leaving the central portion unblended. Adding a few sparkles in the vicinity also enhances the effect.

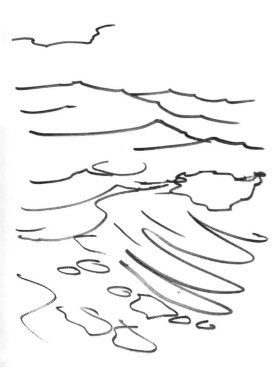

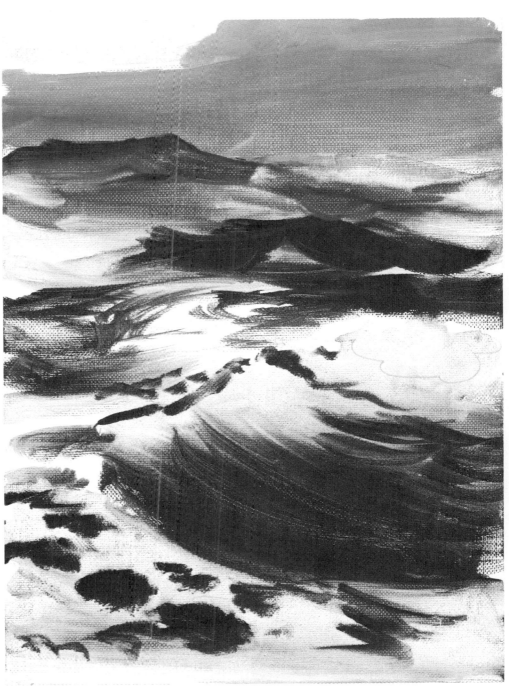

LINES

In creating the composition for this demonstration, I'm careful to select diagonal lines. Diagonals show movement, whereas a horizontal or vertical line is fixed and static. At the top of the composition I line up a series of four major swells so that they also fall on the diagonal. Below I place a series of sweeping diagonal lines on the major swell, the one that I wish to make the focal point. I also indicate where I want to place foam patterns. Notice that they, too, create a diagonal line.

VALUES

I follow the linear composition here and make the values match it. The diagonals and long sweeping lines are still there, but now they are more defined. The composition is beginning to come together.

I decide to keep the sky a middle tone, but with a patch of light to break up the space. I want the background dark to emphasize the depth and strength of the open sea. My focal point is to be the patch of reflected sun and the translucent tip of the major swell, so I leave that area light. All else is a middle value. Other variations in value will appear later, as the painting progresses.

Selecting the Colors

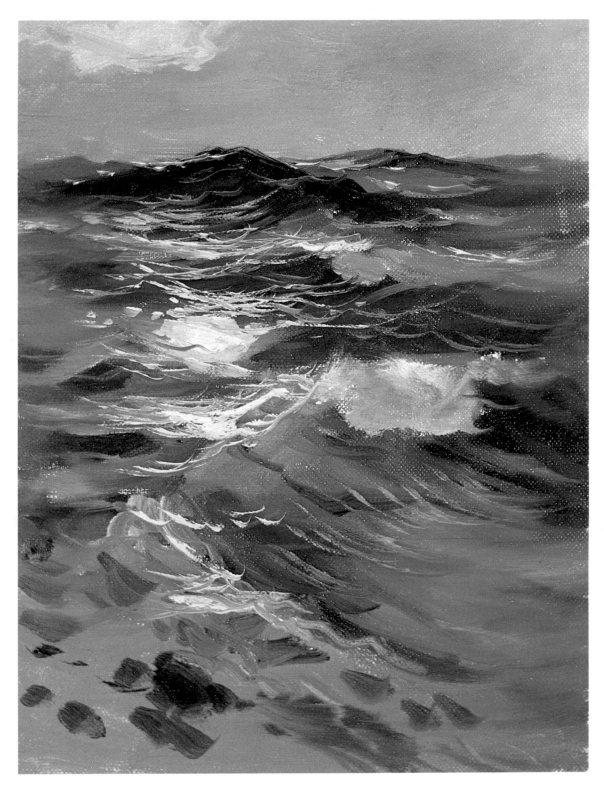

COLOR SKETCH

As usual, in the color sketch I decide the colors I'll use in the actual painting. The dominant colors I choose for this demonstration are phthalo green and ultramarine blue. Phthalo green, the base color of these particular waves, is a potent, almost acidic green and must be toned down. Here I'll use either ultramarine blue or burnt sienna to quiet it. In addition, I use the same combination of colors, burnt sienna and ultramarine blue, mixed into white for a warm or cool gray (depending on the amount of each used).

Although I want the mood to be fairly dark, I do want to have some warmth in the painting. I therefore add warmer colors to the sky, since the sky reflects on the sea and will therefore warm it up. Selecting the cooler versions of these colors, so they don't destroy the mood, I choose a cool dark red, alizarin crimson, to warm the sky and cadmium yellow pale, a cool yellow, for the sunlight color.

As I said earlier, the major problems in this painting are to find a focal point and to reflect the sun and the sky. By reflecting the sun near a major swell with some translucent water I can solve the problem of a focal point, but the business of reflecting the sky must still be studied further.

PAINTING PROCEDURE

I paint the reflected colors and values of the sky and sun as follows: (1) First I paint in the value and basic (or local) color of the swell. Remember that most of this area rises from the flat surface of the sea and doesn't reflect the sky because it's vertical or near vertical. (2) Next I mix the darkest value of the sky (whatever I have chosen for a given painting) and, with this color, I outline the larger secondary chops on the face of the major swell. The outline represents the top portion of the chops, a small, light area that faces the sky. (3) Finally, using the lighter color of the sky or, in some cases, the color of the sunlight itself, I paint in the smaller chops in the path of light.

Of course there can be more than three stages. If the sky color is more complex, I may decide to reflect more than two values and colors, depending on how many are there. But the point is that the sky does reflect, and it outlines the contours of the sea in doing so.

VIEWER RESPONSE

Now a word of caution. Like the sea at shore, the open sea is a vast area—only more so. When I looked out on the North Sea at nothing but sea, I was overwhelmed by the distance and loneliness of the mood. The swells seemed to go on forever, and it was easy to feel alienated, and

even a bit fearful. It's for this reason that I believe paintings of the open sea are not favored by the general public. They want to feel solid earth beneath them or at least have some reference to land or other humans, as they might in ship paintings.

While I recognize these feelings, I paint open-sea paintings anyway. I paint them for myself because I enjoy the new challenges and even the

moods, and so far I've found others who share these feelings. In other words, you must recognize peoples' feelings, but not be governed by them. Paint what you must paint first and paint what the public wants second, you'll be truer to yourself. Besides, you'll probably find a segment of the public who'll actually seek out your paintings because they share the same feelings.

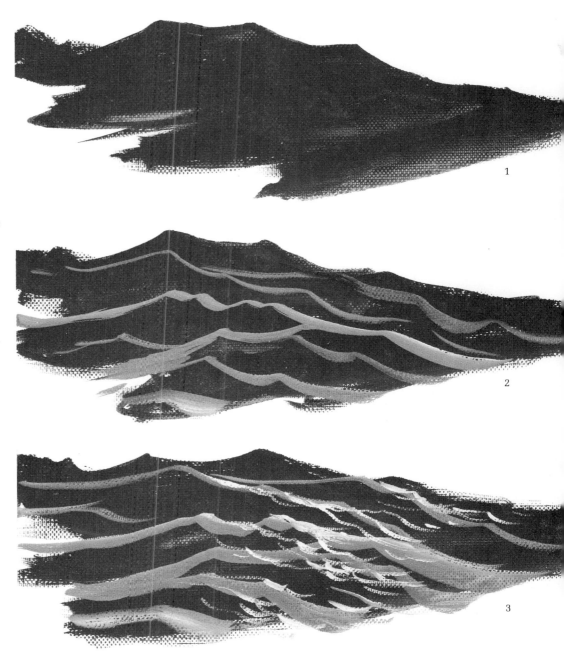

Painting the Open Sea

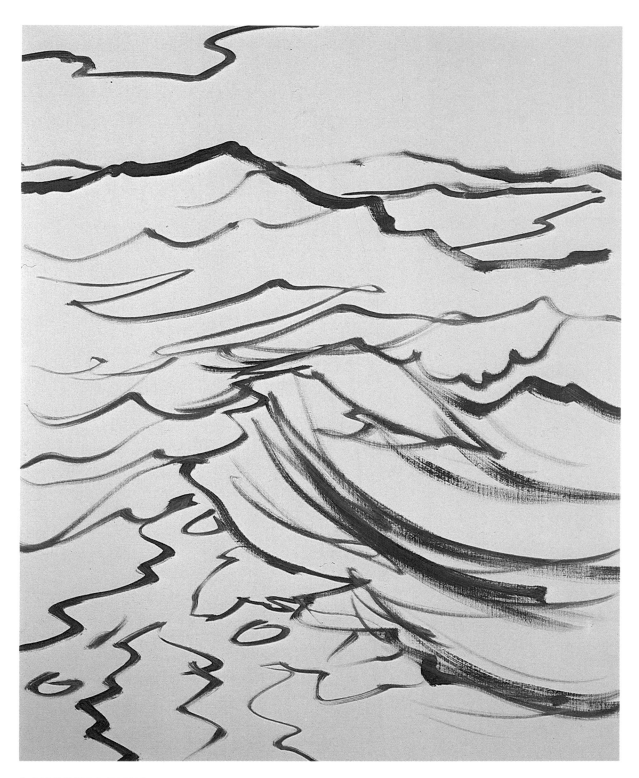

1. OUTLINE DRAWING

I keep the lines simple for now and only show what I need to get started. Using a no. 6 bristle and straight ultramarine blue for the outline, I emphasize the major swells and indicate where in the foreground I want to place the reflection of the sun and the foam patterns. This is all the information I need at this point. Anything more will get covered up because there's a lot of underpaint to be applied before any detail can be added.

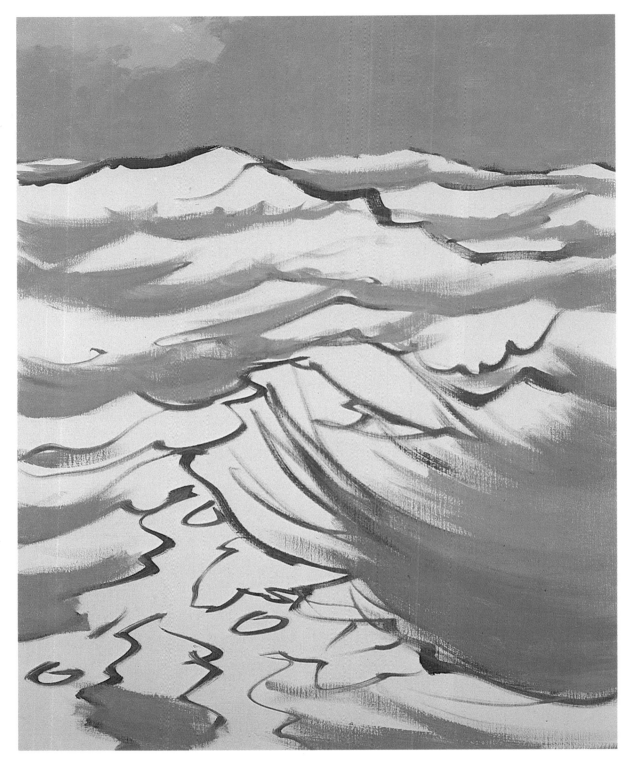

2. SKY AND REFLECTION

I keep the sky simple because the rest of the painting is rather busy. With a no. 8 bristle brush and a mixture of ultramarine blue and white with a touch of alizarin crimson to warm it, I paint the lighter portion in the upper left. Then I mix a large amount of neutral gray with equal amounts of ultramarine blue and burnt sienna added to white and paint the entire cloud area with it. Then I warm it up a bit with alizarin crimson and scrub it into the center of the cloud, then I add more blue to it for the outer edges of the cloud where it's cooler. I also paint the cloud color into the troughs below the major swells where the sky color is reflected. (Later, I'll blend the water color into it.)

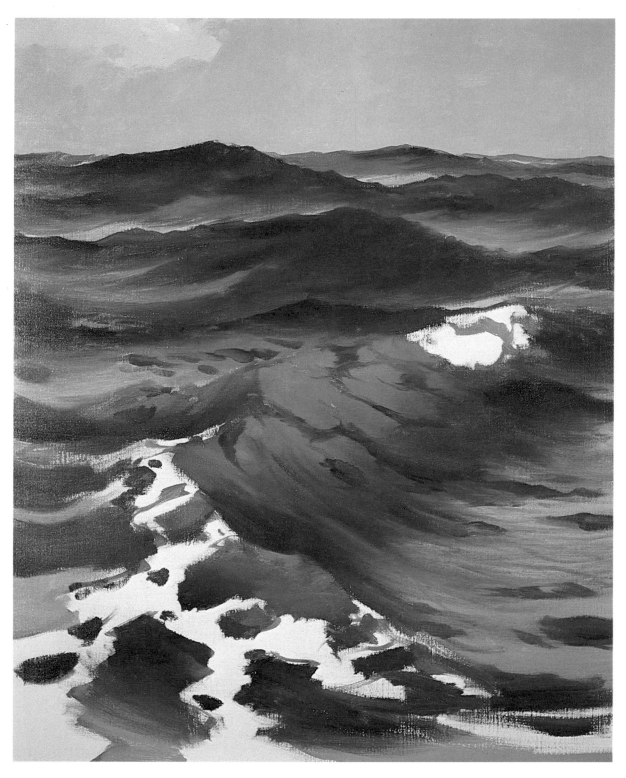

3. BASIC WATER COLOR

I underpaint the water with an equal mixture of phthalo green and ultramarine blue. Using a no. 10 bristle (a no. 12 might be even better), I first scrub in the major swells. The mixture is lighter where it blends into the still-wet cloud color in the troughs below, and gradually darkens to the basic water color as the swell moves upward. I brush the color on in the direction of the water's movement, sweeping upward in this case. To achieve a translucent effect on the major wave, I first use the dark basic water color to underpaint it. Then, starting at the top, I paint a light green of phthalo green and white with a touch of cadmium yellow pale. Next, with a dry bristle brush, I gradually blend the two colors using the same sweeping strokes as before.

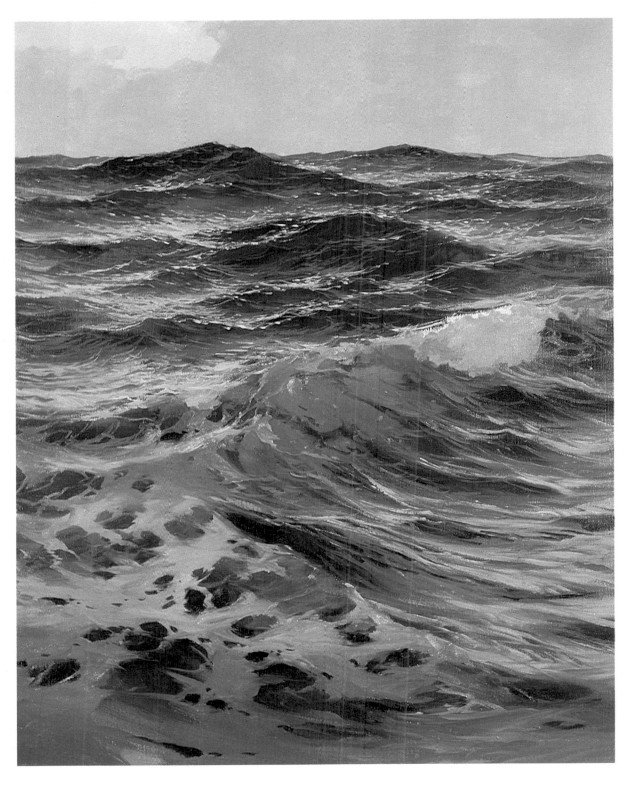

4. ATMOSPHERE

I start by mixing a dark gray-blue for the shadowed areas with ultramarine blue and burnt sienna added to white. With a no. 0 round sable, I outline secondary chops on the major swells where they don't reflect the sky, mostly near the tops. Next, using the cloud color, I make short scallops and chop outlines further down the side of the swells and into the trough area. Then I reflect the lightest portion of the sky (see the demonstration on page 103) using the color I mixed in Step 2, working with a no. 00 round sable for sharper detail. The whitecap foam and foam patterns are ultramarine blue and white with a touch of alizarin crimson and phthalo green, added with a no. 6 bristle brush.

North Atlantic. Oil on canvas, 24″ x 30″ (61 x 76 cm).

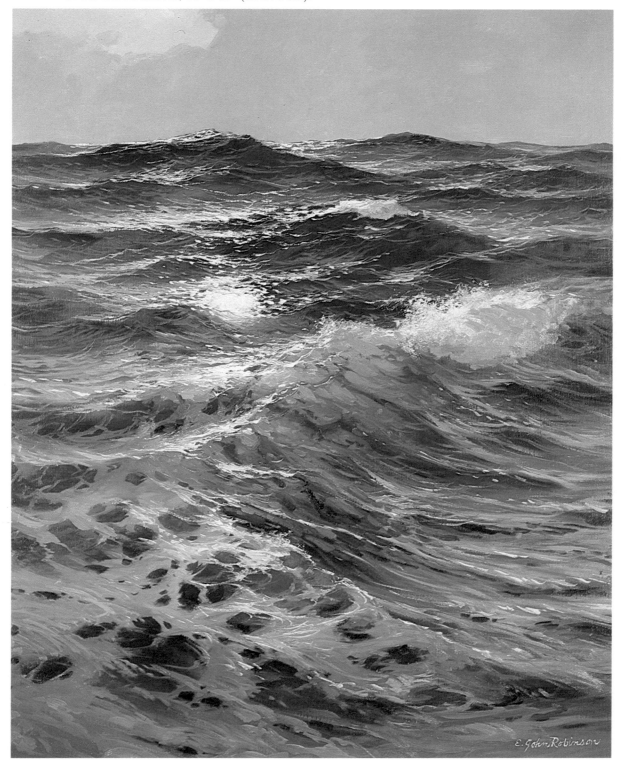

5. SUNLIGHT

I mix a pile of sunlight color by adding a touch of cadmium yellow pale to white and paint in the spot reflecting the sun, adding a stroke of pure white to its center. On the outer edges, I fuzz the color and let it gradually blend into the water. Next I add a touch of alizarin crimson to the yellow-white pile for the rest of the light reflection. With this color and a no. 000 round sable, I add the glitter of sun with tiny scalloped strokes along the tops of the swells and in the path of light above and below the spot of sun reflection. I also use this warmer color to lighten the foam on the swells. As a final touch, I add a few more holes in the foreground patterns with the phthalo blue mixture. I also lighten the translucent area by blending in more yellow-white.

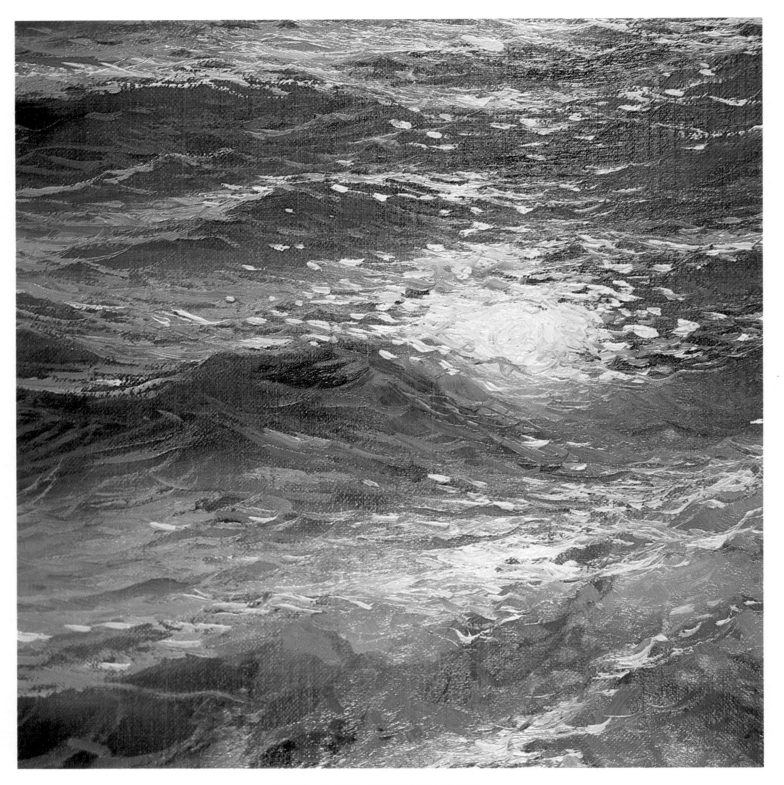

DETAIL OF THE SUN'S REFLECTION

In this detail you can see how I handle the reflection of the sun. Notice the fuzziness of the outer edges and the fact that the water is too choppy to give an exact mirror image. Because of the strong contrast in value between the sun and the sea, and within the sun reflection itself, it glows and its light is scattered around the spot as sparkles. I've also placed a minor swell in front of the reflected spot and made it translucent as a result of the light. This, along with the spots of sparkle, give the painting a much-needed focal point.

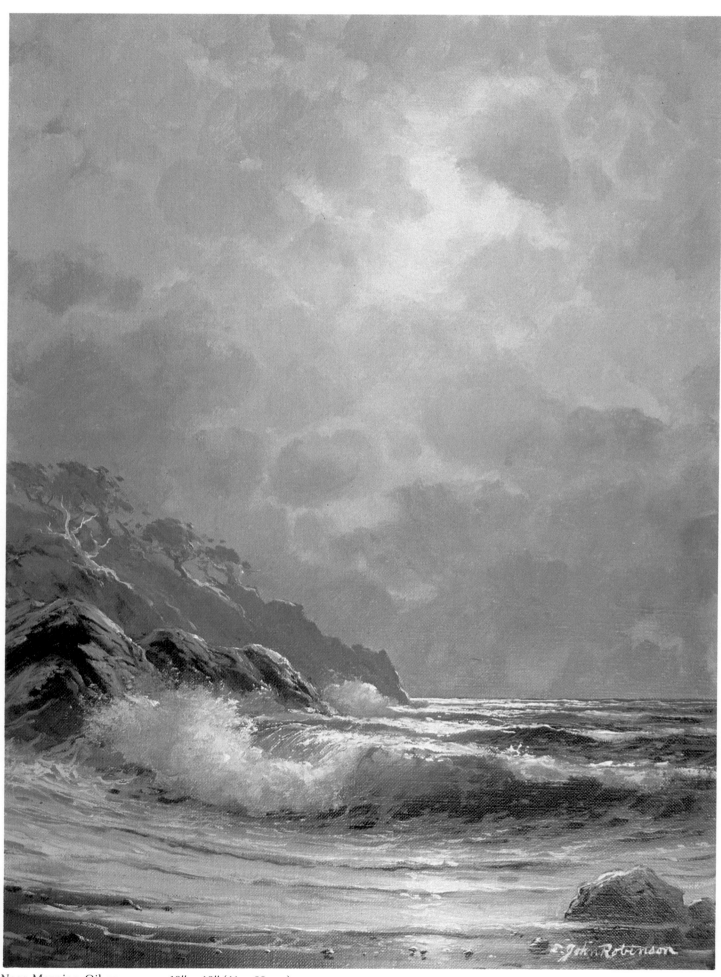

Near Morning. Oil on canvas, 16″ x 12″ (41 x 30 cm).

MOONLIGHT

I enjoy painting moonlight because it gives me the opportunity to paint a completely different light and atmosphere from my daylight paintings. I realize moonlight seascapes are often labeled "sweet" or "romantic" or some other critical adjective, but there are some rather pointed questions that should be asked first, before anyone quickly snorts in disgust.

What, for example, is the color of the light? What is the color and value of the atmosphere that washes over everything? Just how light or dark should the painting be? I've had people ask me if my painting was of a storm when I thought it was obviously of moonlight. The fault was mine, not theirs, because I hadn't achieved the desired effect. There's quite a challenge to painting moonlight that is recognizable as such.

Over the years I've studied the beach and the sea at night as well as looked at photographs and paintings and I've come to this conclusion: Getting a moonlit effect doesn't depend on how dark you make your sky and atmosphere. It's based on your selection of colors and how you use the light.

THE COLOR OF MOONLIGHT
Moonlight is a soft light. It may cast some pretty dark shadows, but rarely strong, hard-edged ones. The color of moonlight is whiter than sunlight, but sometimes it seems to have either a bluish cast or a touch of lemon yellow in it. When there is a glow of a warm color surrounding the moon. I may put a touch of alizarin crimson into whatever color I may be using.

I've found that the obvious color to avoid is the bright blue of daylight skies. Therefore I start with any of the usual blues, but gray it down by mixing in a bit of burnt sienna—I also use much less white. Burnt sienna is basically an orange and acts like a complementary color by neutralizing the blue. The result is a subdued color rather than a bright one.

THE ATMOSPHERE OF MOONLIGHT
The atmosphere may be very light at times, as in *Near Morning* on page 110. Even though the painting is very light, I consider this to be a moonlit scene. The time is actually just before daybreak, and the sky has lightened considerably. The moonlight is partially obscured by clouds and casts a somewhat weak reflection over the sea. There are no harsh shadows, and objects are visible well into the background.

There's a warmth around the moon and that atmosphere is also cast over the scene. In addition, I've grayed all the colors so they lack the brightness they would have in a daylight atmosphere. You may choose nearly any value or color so long as it's used correctly.

On the following pages I'll show how I use color to give the effect of moonlight. It isn't nearly as easy as critics may think, nor is it as hard as art students might think. It is, however, fun.

Studying the Scene

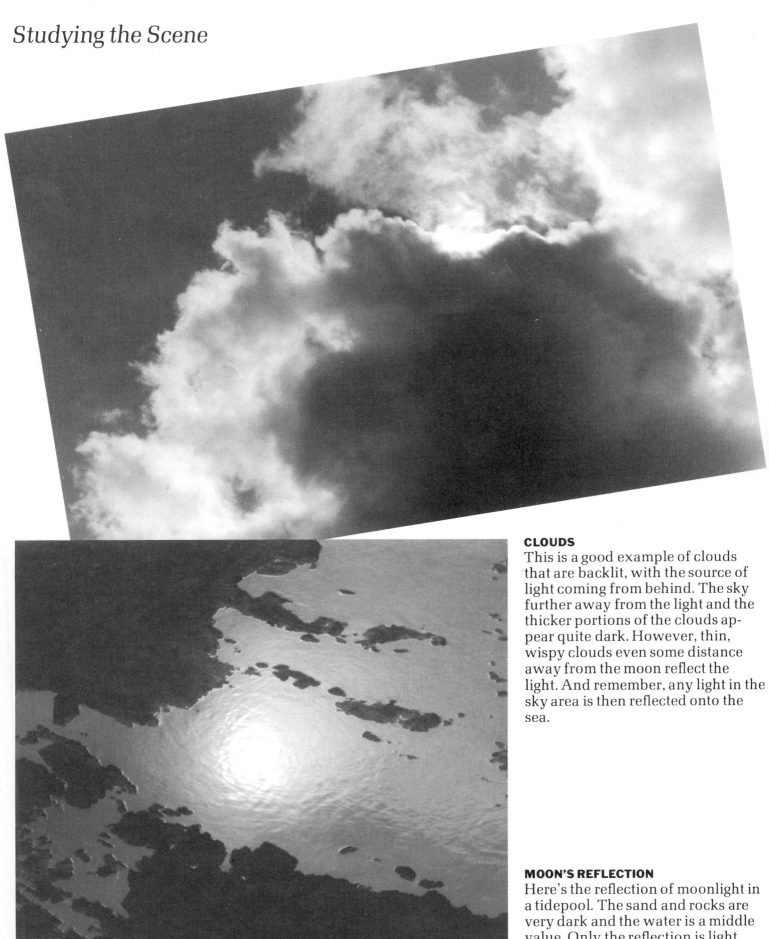

CLOUDS
This is a good example of clouds that are backlit, with the source of light coming from behind. The sky further away from the light and the thicker portions of the clouds appear quite dark. However, thin, wispy clouds even some distance away from the moon reflect the light. And remember, any light in the sky area is then reflected onto the sea.

MOON'S REFLECTION
Here's the reflection of moonlight in a tidepool. The sand and rocks are very dark and the water is a middle value. Only the reflection is light. The slight texturing in the light area is due to the slight movement in the water. Any more action would break up the reflection further, according to the amount and size of the movement.

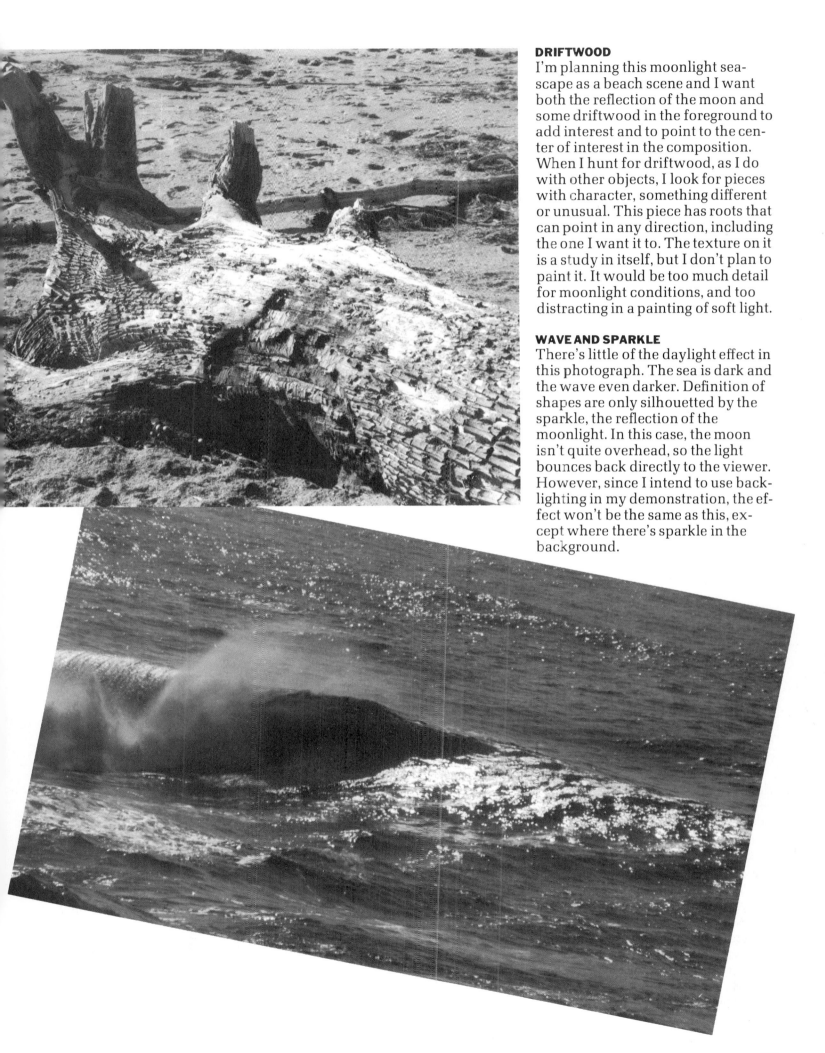

DRIFTWOOD

I'm planning this moonlight seascape as a beach scene and I want both the reflection of the moon and some driftwood in the foreground to add interest and to point to the center of interest in the composition. When I hunt for driftwood, as I do with other objects, I look for pieces with character, something different or unusual. This piece has roots that can point in any direction, including the one I want it to. The texture on it is a study in itself, but I don't plan to paint it. It would be too much detail for moonlight conditions, and too distracting in a painting of soft light.

WAVE AND SPARKLE

There's little of the daylight effect in this photograph. The sea is dark and the wave even darker. Definition of shapes are only silhouetted by the sparkle, the reflection of the moonlight. In this case, the moon isn't quite overhead, so the light bounces back directly to the viewer. However, since I intend to use backlighting in my demonstration, the effect won't be the same as this, except where there's sparkle in the background.

Sketching the Subject

OUTLET

Again I'm planning to use an outlet in this scene, but this time as a minor part of the painting, to reflect the moon and help lead the eye to the major wave. At this point I am also trying to decide what values to use. I find that a fairly dark night with a strong moonlight is what I want to show off the driftwood and major wave. This means that the sand and sea will have to be rather dark, except for what is in the path of light. I sketch this picture accordingly.

DRIFTWOOD

After a number of rough sketches, I finally choose to use this position and character for the driftwood. It is nearly a mirror image of the driftwood in the photo on page 113, but its character has been retained.

I want the driftwood to be interesting, but not distracting. I decide to place it so that some of its roots reach up in front of the wave. This should give depth to the painting by showing the viewer that one object lies in front of another, and create perspective by showing the log diminishing in size as it recedes.

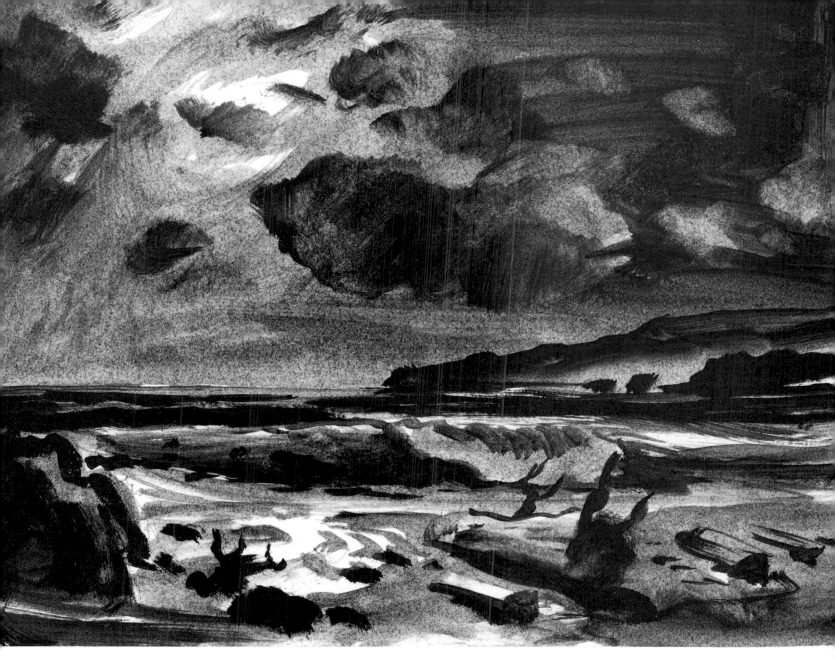

FINAL SKETCH

I painted six different sketches before choosing this one for my demonstration painting. I sketched it with black oil paint on a scrap of illustration board and I controlled the values by varying the amount of thinner I mixed with the paint.

The main features are taken from the preceding sketches. Ideas I gathered in studying the photographs earlier are also incorporated. As you can see in the sketch, I have decided to feature the outlet, bright with reflected moonlight, leading to the major wave. The driftwood also is placed to point to the focal point.

Because moonlight is generally too soft to make the wave trans-

lucent, I am adding more sparkle to the background sea. This will make the wave stand out in contrast against the moon's light.

The headlands were another addition I struggled with. At first I didn't want them, but after adding them to this sketch I realized that they helped to balance the composition. The path of light, the center of interest, and the foreground rocks are all on one side, and the headlands on the other side balance it nicely. They also stop the straight line of the horizon from going across the entire canvas, which would have been too distracting in a painting with soft edges and gently moving lines.

Analyzing the Composition

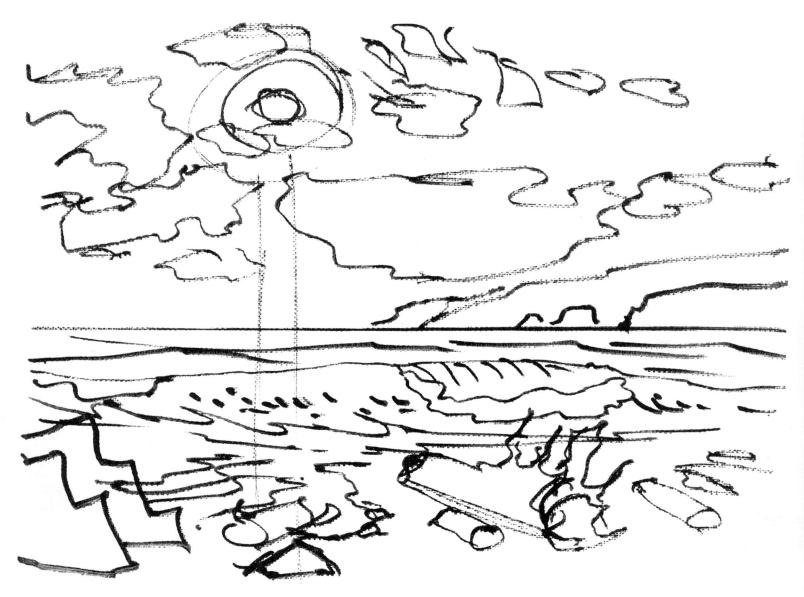

LINES

You can see the importance I'm giving to the path of light between the moon and its reflection in the foreground outlet. I deliberately place the path off-center because a perfectly centered path would divide the canvas equally and be less interesting. At this point the composition looks terribly busy, but I know that is because lines are not as effective as values in this case, in showing the moonlight. The final painting will not be this busy.

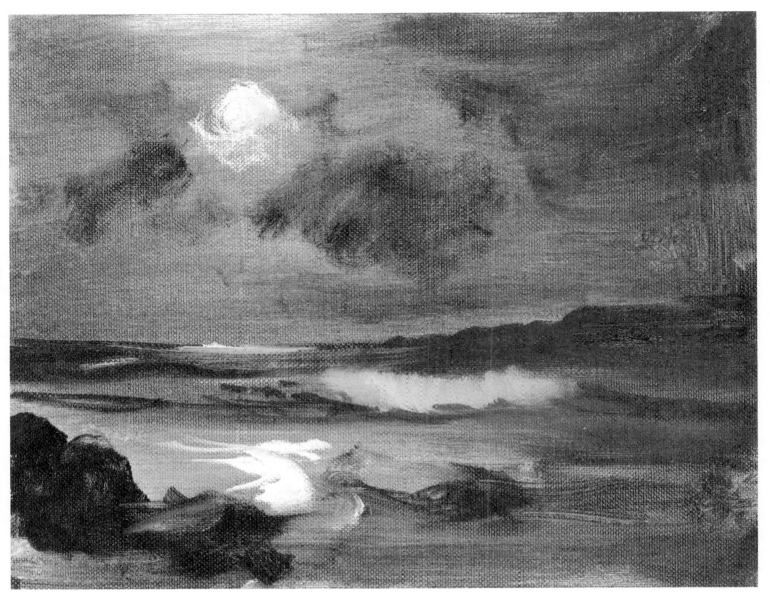

VALUES

While the linear composition appears too busy, the value composition seems too simple. Of course, it should be. I am not interested in showing details at this time.

This value sketch does, however, indicate the structure that the final painting is to be built upon. I have planned the painting to be quite dark overall, with the darkest features the background sea, the headlands, and the foreground rocks.

The sky, clouds, and sand are middle-to-dark areas, and only the moon, the path of light, and the reflection are to be light.

This sketch, like the final one on page 115, was painted with black oil paint on a scrap of illustration board, and a large bristle brush. It is too difficult and time-consuming to make a value sketch with anything but paint and a large brush.

Selecting the Colors

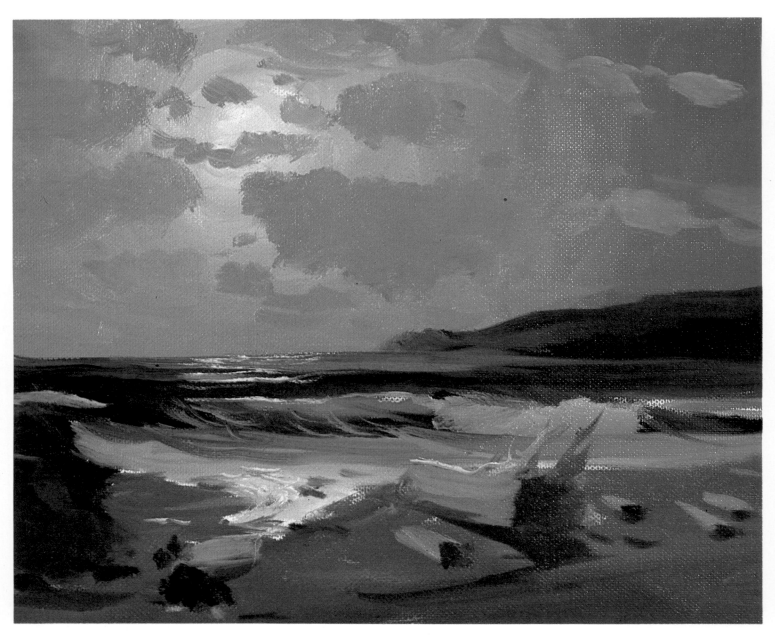

COLOR SKETCH

I had so much fun making this sketch that I nearly continued on to produce a painting. As I mentioned earlier, the dark sky area is a blend of cerulean blue and burnt sienna. As it nears the moon, I lighten it with white. A touch of lemon yellow added to white paint suggests the pale light of the moon.

In order to get a dark, shadowed sand, that is, sand seen under nighttime conditions, I use the same blend of colors I normally would for daylight (that is, burnt sienna mixed into white with a touch of ultramarine blue), but simply add more blue into the white for a nighttime effect, because there's less light. The same formula also applies to the rocks; I eliminate the light colors of daylight and add the darkness of night.

In addition, I use a blend of phthalocyanine green and alizarin crimson for the color of the water. The alizarin cuts the acidity or rawness of the phthalocyanine green and neutralizes it slightly.

As I mentioned before, the *color* of moonlight is much more important than its value. I've found that graying the colors in the scene also helps give them that special moonlit effect.

GRAYING COLORS

Although you are no doubt aware that black can be used for graying color, I don't approve of that method. As far as I'm concerned, there is no black in nature, and so I don't like its use in paintings of nature. Besides, when black is used, the resulting gray is colorless, if not muddy.

A much better way to gray colors is by blending them with their complements. In the illustration here I have drawn a simple color wheel showing the arrangement of the primary colors on the outside and the secondary colors on the inside. A line drawn from any primary color leads directly to a secondary color.

When those two colors are mixed, the result is a gray or neutral effect, marked as N in the center of the wheel.

CONTROLLING COLOR TEMPERATURE

Of course, these mixtures don't produce a true neutral gray such as that made from black and white, but they do produce a colorful gray and you can control its warmth or coolness by the amount of warm or cool color you use. For example, if you mix red (a warm color) with green (a cool color), an equal blend would produce a neutral gray. But if you want the gray to be warm, you'd add more red; to cool the gray, you'd add more green.

MIXING A MOONLIT SKY

This is the method I use to mix a moonlight sky color: I blend two complements, a blue and an orange. In this particular painting I decide to blend cerulean blue with burnt sienna. (Yes, burnt sienna is an orange.) At first it's hard to know just how much of each color is needed. Here I actually use about two-thirds

blue and one-third sienna. Because this produces a dark mixture that's hard to visualize, I check its color by blending a touch of it into a small amount of white. If it's too warm or too cold I can easily adjust it now, long before I apply it to the canvas.

MIXING OTHER NEUTRALS

Red and green, specifically alizarin crimson and viridian or phthalo green, blend to a very rich neutral rock color. Other complements, purples and various yellows, are harder for me to use. They tend to be a bit muddy and I find them unsuitable for my taste. Then, too, there are many shades of each of these colors. Some neutralize better than others and some seem more appropriate for particular areas than others. That's why I've recommended a blend of cerulean blue and burnt sienna. I could have also used ultramarine blue and burnt sienna, but the combination creates much darker color than I want for this painting.

Painting Moonlight

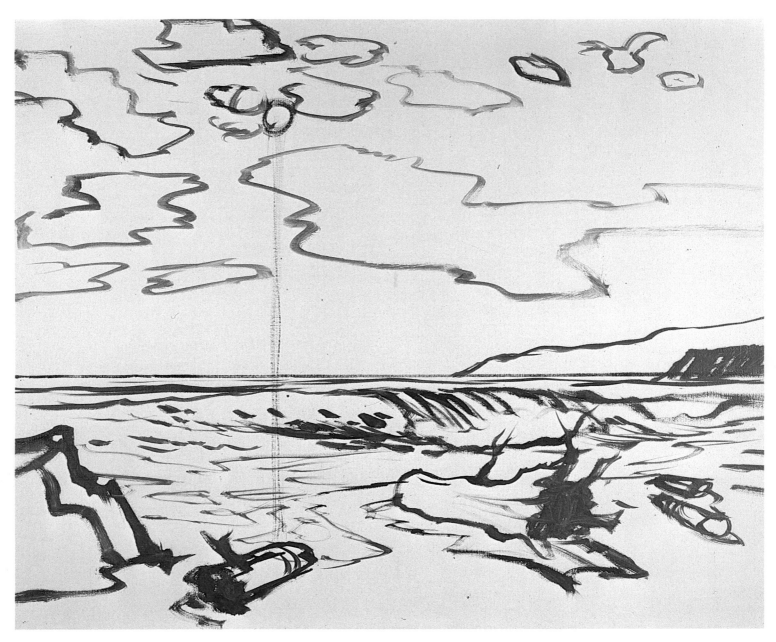

1. DRAWING

I draw on the canvas with cerulean, the blue I'll use as a dominant color in the painting. This is my usual approach, but there's nothing magical about it. You may use any color you wish for the outline so long as it doesn't bleed through later. That's why I stay with the dominant color in each painting. Also, the paint should be applied thinly so that it doesn't interfere with later applica-tions. As usual, I draw this with a no. 6 bristle brush.

Notice that I indicate the moon's path and only a limited number of objects. Because I made sketches earlier, I can always refer to them should I need more information. For example, I expect to add many more clouds and other details that don't need to be drawn at this time, and my sketches will remind me of these intentions later.

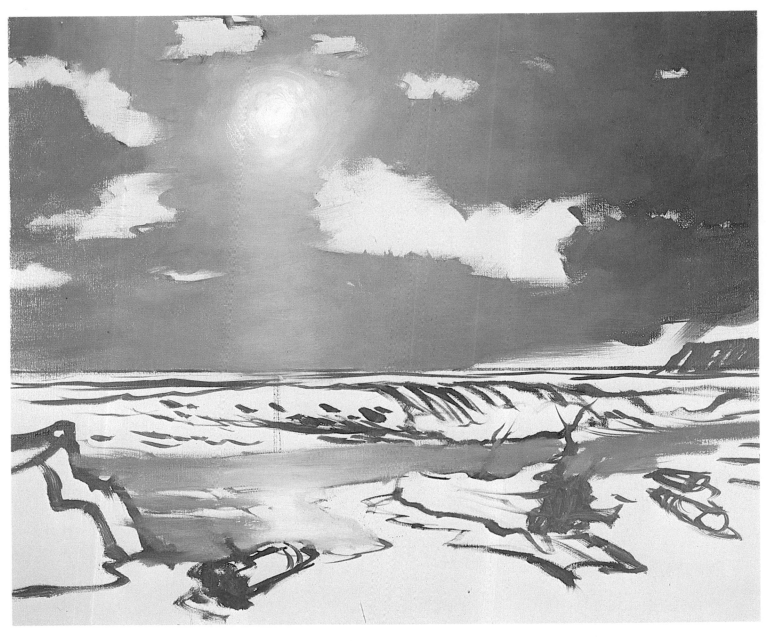

2. THE BASIC SKY

I begin by mixing the grayed blue I mentioned earlier. On my palette, I blend about one-third burnt sienna with two-thirds cerulean blue, mixing them well, and test the color by adding a bit of white to a small amount of it. This is a very dark color, but except as a check, it should not yet be mixed with white.

With a no. 10 bristle brush, I start applying this dark blue in the upper right-hand corner, working it well into the canvas. As I move to the left, I begin to add white to lighten the blue, adding more and more until I reach the path of moonlight. Then I start on the left-hand side and repeat the process as I move to the right. I leave the major clouds unpainted, as well as a spot where the moon itself would be.

Next I mix a tiny amount of lemon yellow into white and paint the moon. Then, using the white, I make circular strokes around the moon until it blends into the surrounding blue. I also blend more white into the path of light to make it more prominent. Finally, I repeat in the foreground what I did in the sky, working in the slick area that reflects the sky, even at night.

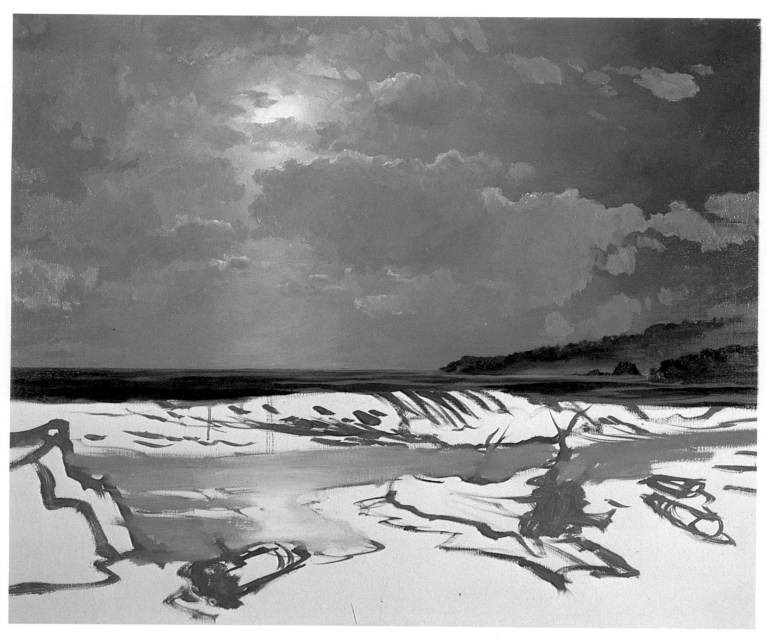

3. CLOUDS AND BACKGROUND SEA

Since the clouds are a lighter version of the sky, I merely add more white to a pile of the cerulean-sienna sky mixture to get their color. Then, because I want a warmer glow near the moon, I blend a small amount of alizarin crimson into the mixture. I paint the clouds with a no. 6 bristle brush, but use a no. 0 round sable to highlight the clouds near the moon with white—that is, white that already has a touch of lemon yellow.

The background sea is also a mixture of cerulean blue and burnt sienna, but with more cerulean than in the sky. I also add some phthalo green to the mixture near the major wave. The headland is the same mixture too, but this time there's more sienna than cerulean. Notice that I fade it lighter (with white) toward the base of the headlands. This gives the appearance of mist as well as atmosphere above the sea.

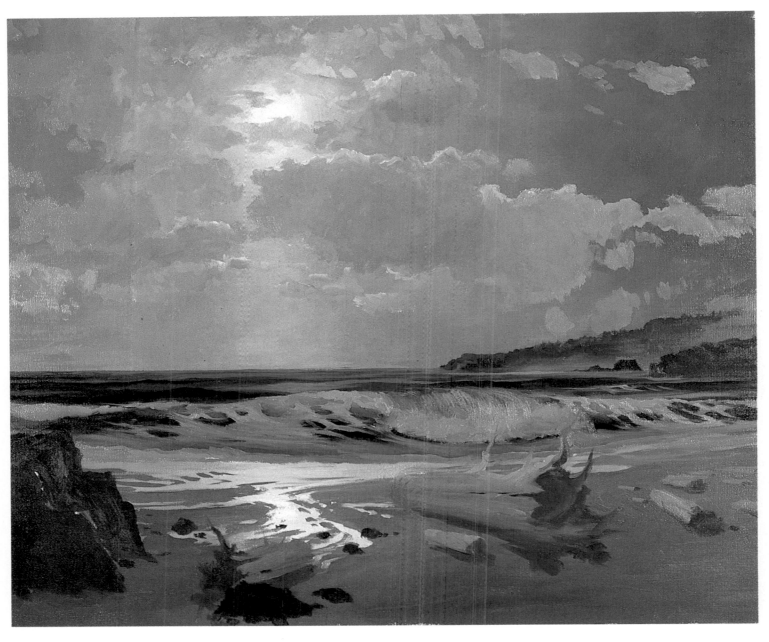

4. FOREGROUND

Phthalo green is a good, dark, transparent green but it's too strong, so I tone it down by adding burnt sienna. (There's just enough blue in phthalo green for the orange of the sienna to neutralize.) I then use this darkened green for the major wave, but I leave the upper half of the wave unpainted. Next I mix a small amount of phthalo green into white and add a touch of lemon yellow. I paint this into the upper portion of the wave and blend it where it meets the darker green below. Over this color I add the shadowed foam which I mix just like the cloud color.

It's cerulean blue with a touch of sienna and of alizarin. I rough in the major foam patterns and then carry it forward to cast a shadow in front of the wave.

The sand is just what daylight sand should be, a mixture of burnt sienna added to white. I then darken it for a moonlit effect by adding an equal amount of the sky color. The lighted side of the driftwood is the same mixture as the sand, but with more white. The rocks and the shadow side of the driftwood are painted mostly burnt sienna with a touch of cerulean blue.

Near Midnight. Oil on canvas, 24″ x 30″ (61 x 76 cm).

5. HIGHLIGHTS AND TEXTURES

Starting at the horizon line, I add reflections of the sky on the background sea with a no. 000 round sable and a mixture of cerulean blue added to white. Near the moon's path I add a bit of alizarin, and directly below the moon, I add sparkles to the sea with the same small brush and the lemon yellow-white mixture.

For the additional foam trails on the wave and most of the texturing on the rocks and driftwood I use the cloud colors, cerulean blue mixed into white with a touch of alizarin. I use a no. 00 or 000 round sable and make swirls in the sand or follow the contours of the rocks and driftwood. The sand is swirled from wind and washes of the tides and often has a ribbed pattern.

The final touch is, of course, the moonlight itself. For this I use a touch of lemon yellow added to white and a no. 000 sable. I strengthen the reflection of the moon in the outlet, then highlight the rocks and driftwood near the moon's path. But I don't carry the highlights much beyond the path of light or it would be too much for this effect. It's important to know when to stop!

SKY DETAIL

I am showing a closeup of the moon area of the sky to give a better idea of how it was painted. There are basically three levels: The first is the sky and the light of the moon; the second is the distant clouds, one of which is in front of the moon; and the third is a series of closer and darker clouds. On top of this, there are a few highlights.

You can see that my brushwork is rough. I refine my brushwork in areas of interest, but allow secondary or background areas to remain loose and almost impressionistic in style. This is merely my own personal approach to painting, however. You may prefer a different technique for your own paintings.

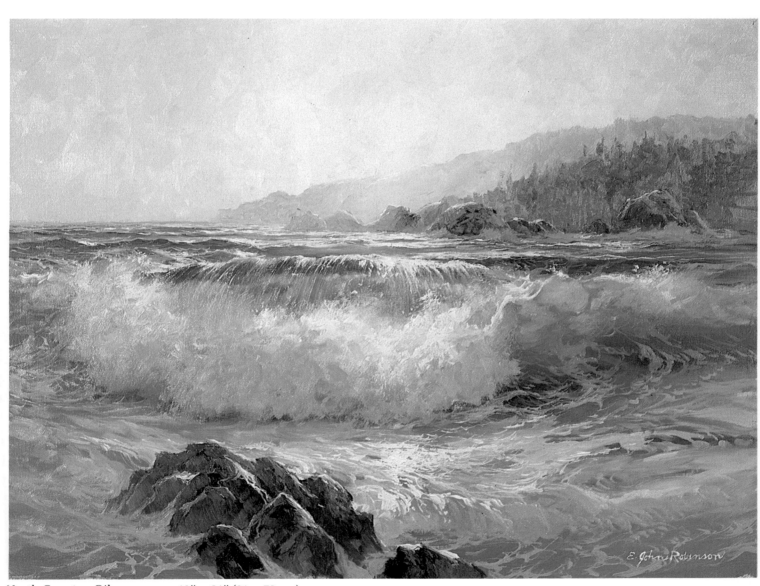

North Country. Oil on canvas, 18″ x 24″ (61 x 76 cm).

SUN GLOW

By now you've seen the importance I place on sunlight (or moonlight) in my paintings. In some cases I use sunlight to help focus attention in one spot. In other instances, I scatter sparkles across the background sea or a major wave to add interest. Still other times I use the reflection of the sun or its path as the focal point in the painting. But no matter how I do it, I always use the light of the sun to at least add that final touch, that something extra that brings to life an otherwise dull painting.

In this last demonstration I use the sun in yet another way, as the center of interest, the first focal point. Of course the sea and rocks will get attention too, but in this instance the eye will focus on the sun first, then move on to other points of interest in the painting.

ANALYZING THE SCENE
The inspiration for this painting comes from Canon Beach, Oregon, where there are two tall vertical rocks called "The Needles," near the famous "Haystack Rock" just offshore. The day I visited the beach, my attention was drawn to the south, where the sun was nearing the horizon line. The distant air must have been full of moisture that day, because the sun's brightness and color had spread outward, washing a warm glow over the sea and the distant hills. It was bright, but not enough to hurt my eyes. The challenge that presented itself to me that day was to capture the effect of the glow.

ANALYZING SUN GLOW
As I've said before, sunlight has its own color, and because the sea reflects light, it's always under the influence of the sun (when it's out). Of course the sea also has a color, but it can usually be seen undiluted only on the vertical sides of waves, where it's least affected by the color of the light. Notice the treatment of the spreading glow of the sun in *North Country* on page 126. Though it's not the center of interest in this painting, the influence of the sun is easy to see. The background headlands are softened by the sun's rays and carry its warm colors. The sea reflects the sun and its warmth, color, and position. The sea also reflects the sky, but in this case the sky is strongly colored by the sun's glow. Only the portion of water that's vertical or nearly so does not reflect the glow.

In this project, I intend to make the sun glow much stronger than I did in *North Country*, which entails spreading a stronger wash of sunny colors over the sea. One of my main problems will be to mix my colors so that they show both the basic color of the water *and* the influence of the sun. But I'll only be able to discover the mixture by trial and error. Let's examine how I go about doing this.

Studying the Scene

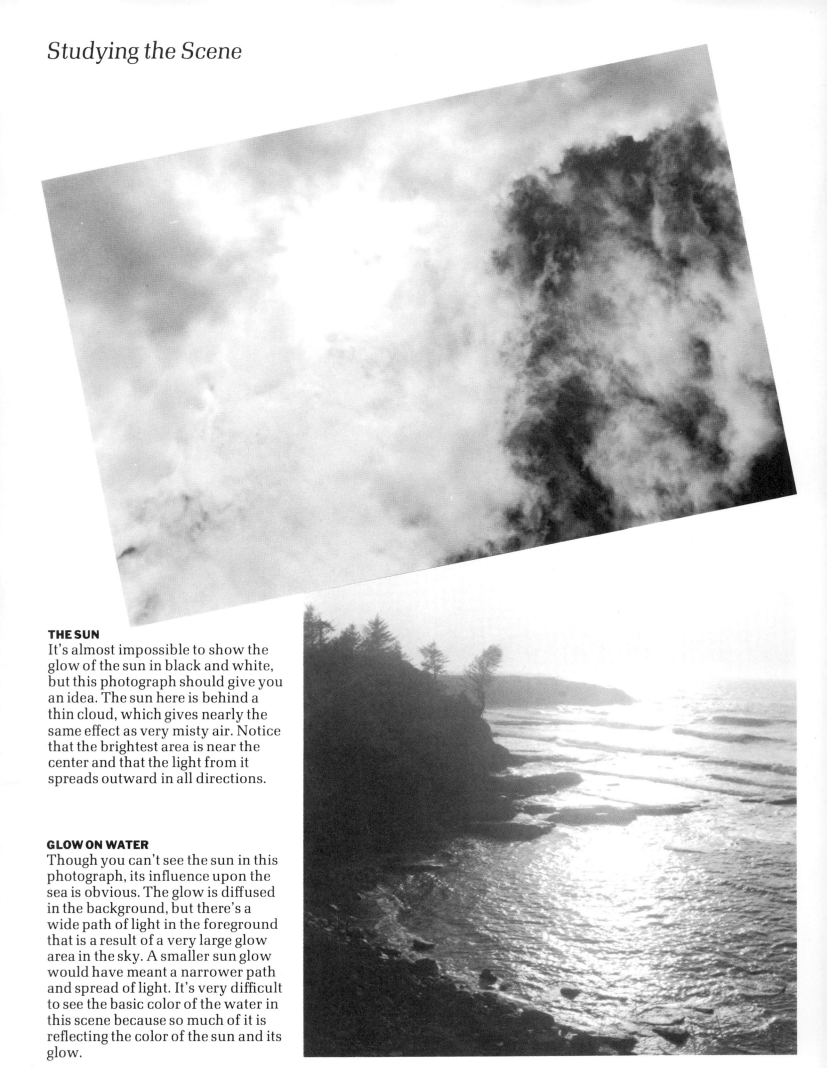

THE SUN

It's almost impossible to show the glow of the sun in black and white, but this photograph should give you an idea. The sun here is behind a thin cloud, which gives nearly the same effect as very misty air. Notice that the brightest area is near the center and that the light from it spreads outward in all directions.

GLOW ON WATER

Though you can't see the sun in this photograph, its influence upon the sea is obvious. The glow is diffused in the background, but there's a wide path of light in the foreground that is a result of a very large glow area in the sky. A smaller sun glow would have meant a narrower path and spread of light. It's very difficult to see the basic color of the water in this scene because so much of it is reflecting the color of the sun and its glow.

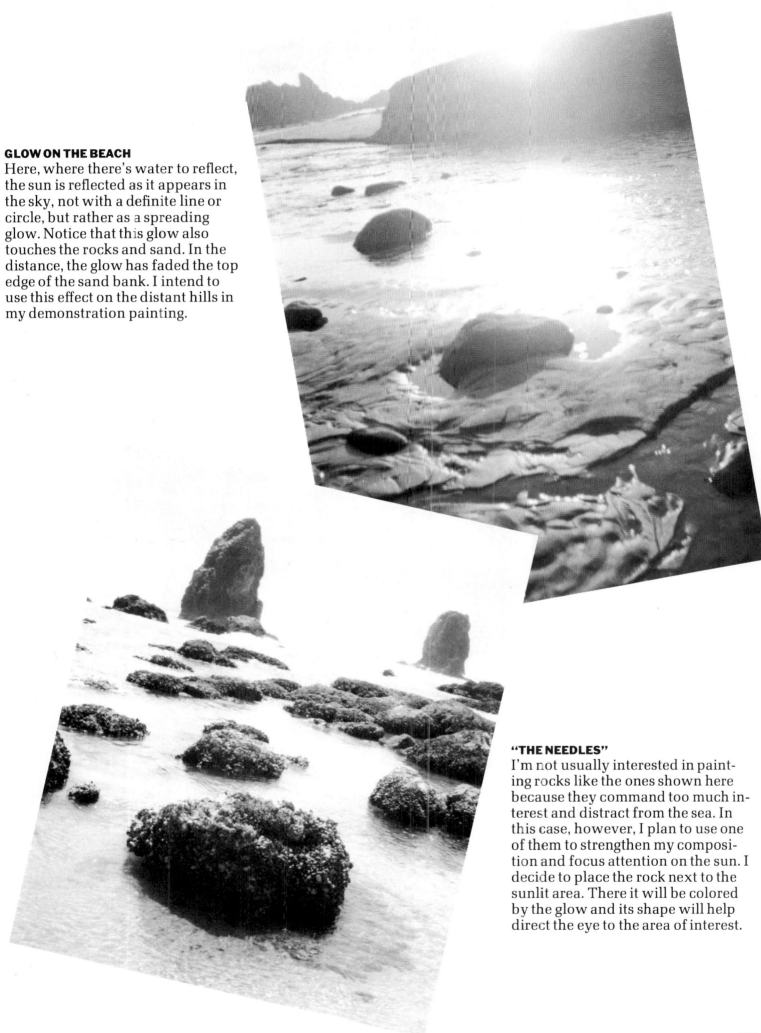

GLOW ON THE BEACH

Here, where there's water to reflect, the sun is reflected as it appears in the sky, not with a definite line or circle, but rather as a spreading glow. Notice that this glow also touches the rocks and sand. In the distance, the glow has faded the top edge of the sand bank. I intend to use this effect on the distant hills in my demonstration painting.

"THE NEEDLES"

I'm not usually interested in painting rocks like the ones shown here because they command too much interest and distract from the sea. In this case, however, I plan to use one of them to strengthen my composition and focus attention on the sun. I decide to place the rock next to the sunlit area. There it will be colored by the glow and its shape will help direct the eye to the area of interest.

Sketching the Subject

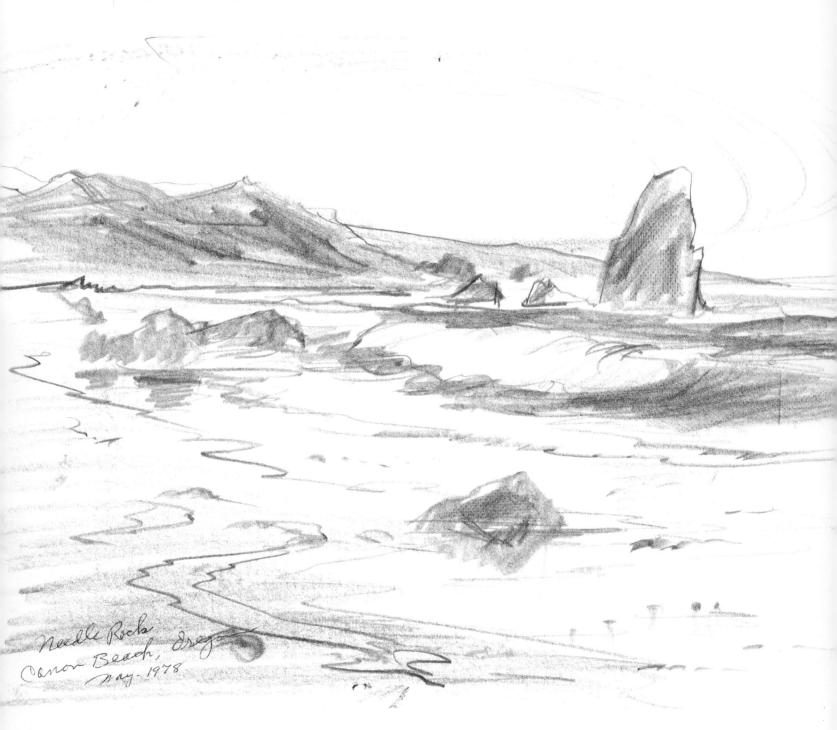

Needle Rocks
Canon Beach, Oregon
May 1978

ORIGINAL SKETCH

This is my penciled impression of the beach, rocks, and surf I saw that day in Oregon. The hills in the background are part of the coastal mountain range. I know I don't have to be too literal, but because I grew up along this coast, I feel a need to present a fairly accurate view of it. Therefore I follow it rather closely in this sketch, and in the final painting as well.

Though a pencil sketch can't really give a good impression of sun glow, it can indicate its location and help jog the memory of it later. The center of interest in this sketch is the sun glow, represented here as swirls in the sky; the large rock thrusts up into that area. Everything else—the arrangement of the rocks, the area of wet sand, and the breaker—is subordinate, even though they're influenced by its color.

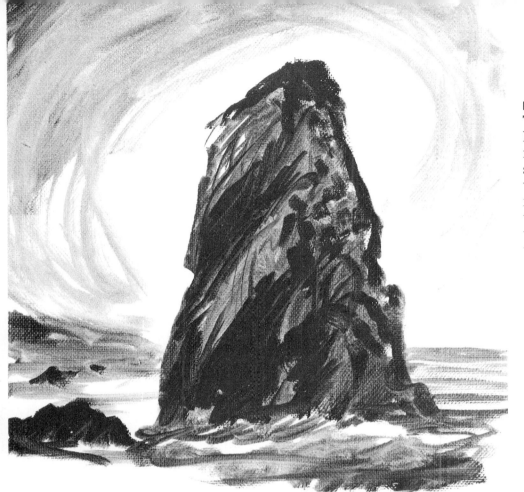

MAJOR ROCK

This is one of two rocks called "The Needles." It rises from the surf like a monument and is encircled by many smaller rocks that are often covered with water. I decide to feature this rock because it reaches up toward the sky where the sun glow is and will thus be the first object to reflect the influence of that glow.

SURF

I don't plan to paint an active surf or there would be a fight for attention between the sky and the sea. Most of the action on Canon Beach is pretty mild because the water is shallow and there are many rocks to slow down the waves. So I sketch a mild surf with a layer of foam reaching to the sand. The beach is wet and reflects the sky and the rocks.

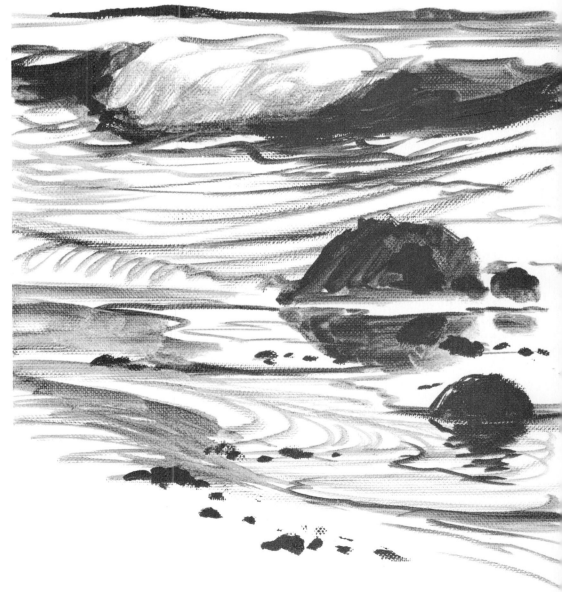

Analyzing the Composition

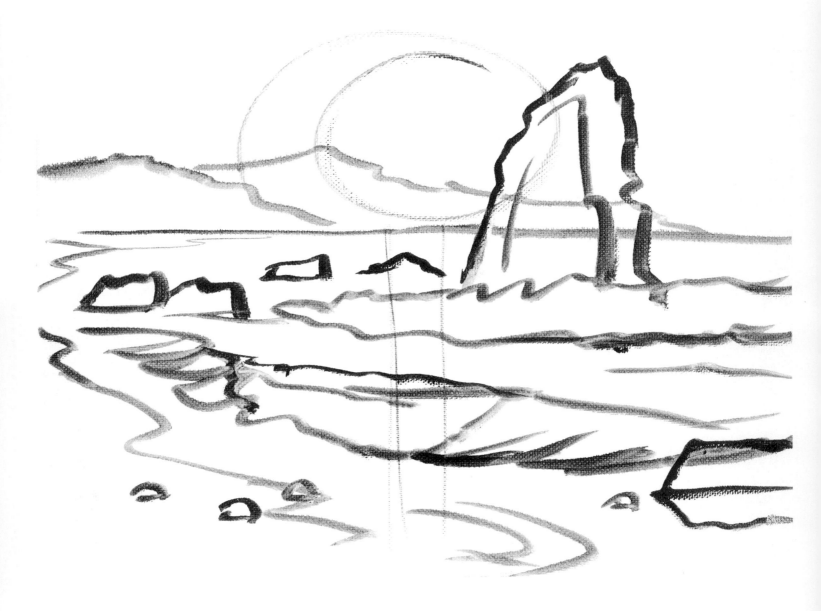

LINES

In translating my original sketch to a linear composition, I rearrange the rocks in the foreground and bring in the surf a bit closer. This allows the reflection of the glow to show up to better proportions. Before, there was too much wet sand for the amount of reflection I want.

Once again I indicate the path of light from the sun. This and the major rock give a strong vertical line to an otherwise horizontal composition. The rock also serves to stop the eye from following the edge of the distant hills and moving away from the glow area.

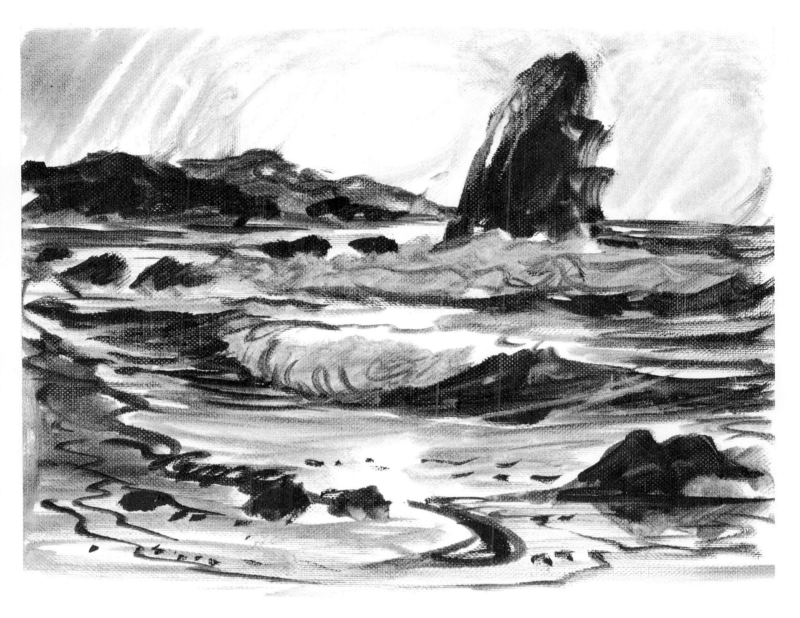

VALUES

I intend to make most of this painting a middle value, with the sun glow very light and the rocks and background hills dark. That way, the glow will appear even brighter in contrast to rocks. The dark rocks in the foreground help to balance the dark values in the composition by spreading them around.

Remember when painting glow that contrast is needed. If the value of the overall composition were lighter, the glow wouldn't show up. If it was much darker, it might appear unnatural.

Selecting the Colors

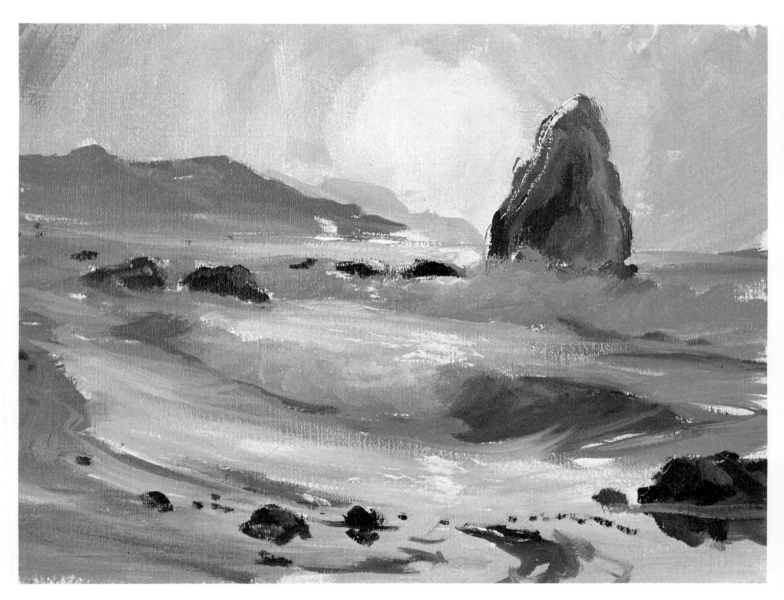

COLOR SKETCH

You'll get a better idea of how I arrange colors for painting a sun glow on the next page, but for now you can see how it appears in the rough in this sketch. I haven't bothered to blend the rings of color as I normally would, so they appear as separate circles, and you can see the colors I use. I start with a spot of white, then add pale yellow, next a touch of red to give the orange appearance, then I allow the last mixture to blend with the sky color. The sky blue is manganese blue mixed into white paint. I also use the manganese in conjunction with viridian for the wave and combine manganese with burnt sienna for the rocks, though the rocks are mostly sienna. The colors of the sky are quickly brushed in to give the reflections over the surf and the beach. The beach is a blend of burnt sienna and cadmium orange added to white.

Painting sun glow is easier if you understand the arrangement of the colors used. In the illustration here, I show the gradual change from light to dark and label the colors I might use to achieve this effect. (Of course, these colors are never actually painted in concentric circles; they must be blended into each other.)

PROCEDURE

I first start at the center with a small patch of pure white, which is the sun itself. Then I surround it with the next lightest color, a pale yellow that was first added to white (not a pure pale yellow), and blend this color with the first one at the edges, so there's no definite border between them. Next I add some orange to the preceding mixture (you could add a touch of red instead, since yellow is already in the mixture—you'll get orange either way), and encircle the yellow-white area, again blending edges between them. Next I add

even more red to the existing mixture, which by now is quite orange, and paint it around the orange circle. Finally, I paint the blue sky around the entire glow. As it blends with the reddish mixture on the outside of the circle, it begins to look purple.

Remember, starting with white (a large pile), the glow is affected by the continuous addition of each new color added to the original pile: yellow, yellow-orange, red, and finally the blue of the sky, which blends outward. Each ring blends so that the effect is gradual.

ALTERNATE SOLUTIONS

Depending upon the effect you want, you could also paint sun glow in other ways. You could first paint a blue sky all around, except for the last two or three inner circles, and gradually blend these inner colors with the blue sky as they're added. Or you might let the blue begin blending with the glow much closer to the sun than I did here. In any case, it is you, the artist, who must

decide how far the glow should be allowed to spread before it vanishes into the natural color of the sky.

COLOR AND VALUE PROGRESSIONS

You should also be aware of the order of the colors of sun glow. Starting with the color of the sun, they follow a natural progression around the color wheel from white to yellow to orange to red and, finally, to purple, before blending into the blue of the sky. I chose to start with white here to give brightness to the yellow that followed, but if the sun were quite red (as it might be at another time or type of day), you could start there and just go to purple, then the blue of the sky.

It's also important to be aware of the progression of values and color temperature in painting sun glow. Here the values go from light to dark, while the colors (when starting with yellow) first grow warmer, then cooler, as they recede from the sun.

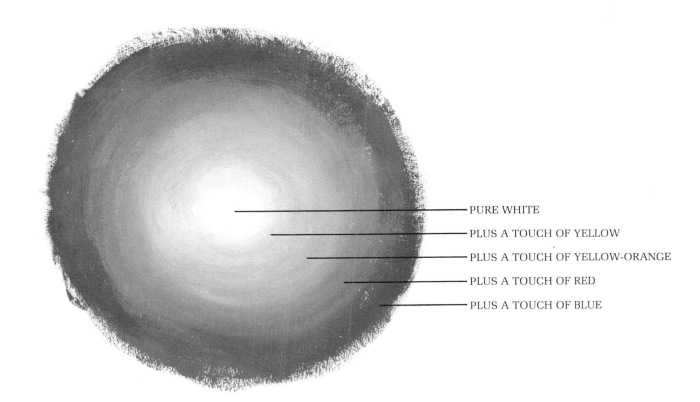

PURE WHITE

PLUS A TOUCH OF YELLOW

PLUS A TOUCH OF YELLOW-ORANGE

PLUS A TOUCH OF RED

PLUS A TOUCH OF BLUE

Painting Sun Glow

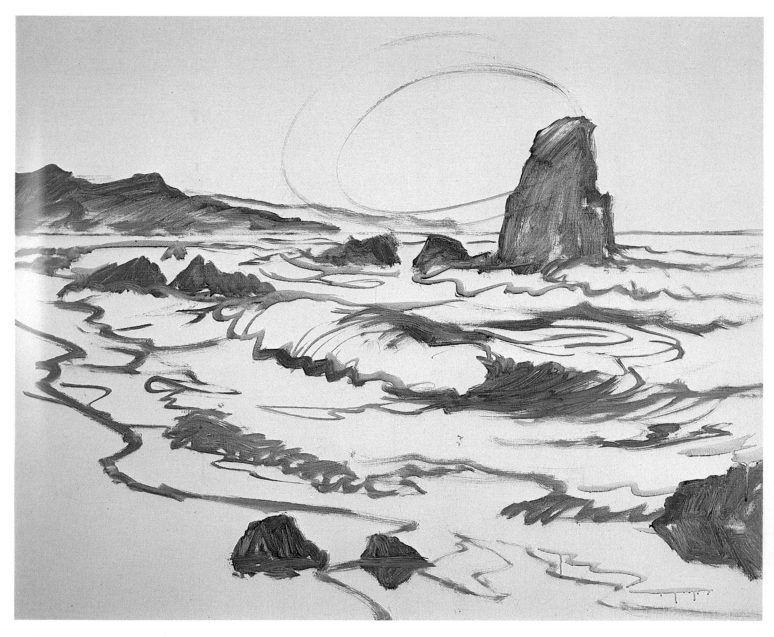

1. DRAWING

Using manganese blue and a no. 6 bristle brush, I follow pretty closely what I've worked out previously in my sketches. However, I do make one change and push the major rock back by making it slightly smaller. I'm afraid that it would be too overwhelming if I keep the proportions I used in the linear composition sketch. I also indicate where my dark values will be.

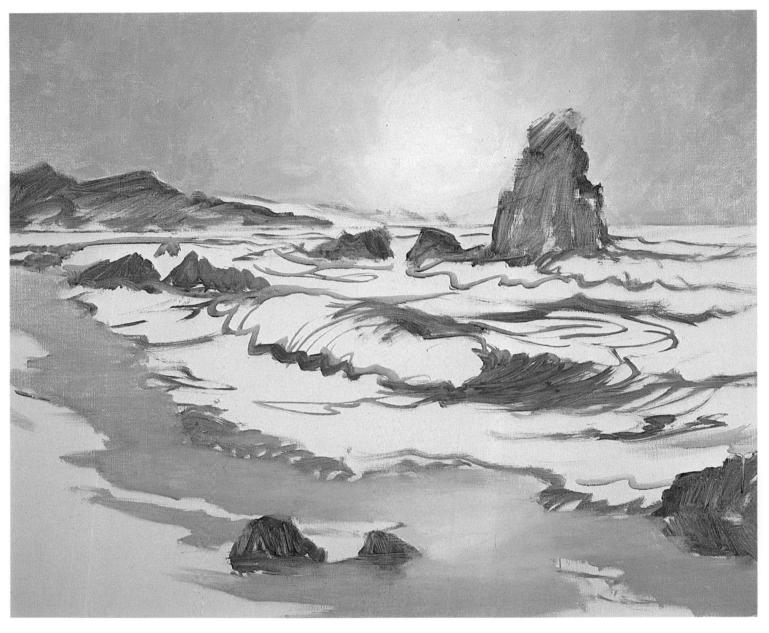

2. SKY AND REFLECTIONS

As I explained earlier, I start the glow by painting a circle of white for the sun. Then I mix up a large pile of white paint tinted with cadmium yellow pale and add a larger circle of this around the white. Putting some of this mixture aside, I next add a touch of alizarin crimson to it, giving it an orange cast, and paint this color around the pale yellow circle. Although I blend the edges between the circles so there are no definite lines, I don't create a perfectly smooth transition between colors because I like the painterly effect of having brushstrokes show. It also gives the appearance of moisture moving about.

Now I'm ready to paint the sky. I mix manganese blue into white and paint the remaining sky with it. Then I blend the blue of the sky into the orange of the glow where they touch. The effect is of a glow gradually spreading over the sky. Because the wet sand portion of the beach reflects the sky, I repeat the sky and glow colors in the areas directly below, blending their edges as I had in the sky.

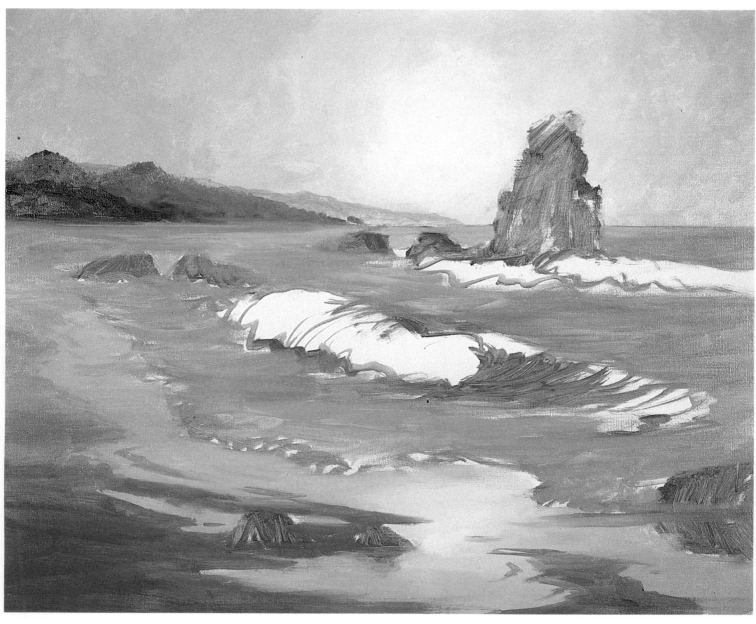

3. UNDERPAINTING

I begin this stage by painting the background hills. First I mix up the color of the closer hills, which are a blend of manganese blue and a touch of burnt sienna into white, keeping the mixture quite dark. I then blend a touch of this basic hill color into the yellow-pale orange mixture I'd mixed for the sun glow and, with a no. 4 bristle brush, I paint the most distant hills. Then I paint the closer hills, using less of the sun color to make them darker, and finally, I texture them with the darkest of the mixture.

Next, I scrub in the background and foreground water very quickly with a no. 10 bristle brush, using a mixture of manganese blue with a touch of alizarin crimson added to white. The result is a warm purplish color. It will be overlayed later with sun and atmosphere. Then I paint the beach. Like the hills, the beach is also a mixture of manganese blue and burnt sienna with a touch of white, but very little manganese. I work this in quickly, as I did with the water underpainting, using a no. 10 brush.

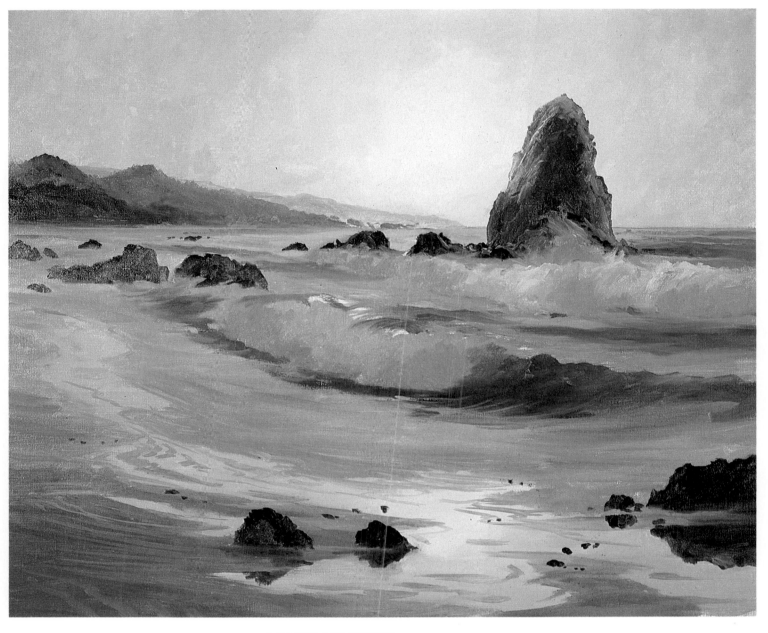

4. ROCKS AND WAVES

Like the hills, the rocks are burnt sienna and manganese blue, but I give them a warmer tone with the addition of alizarin crimson. I add quite a lot of alizarin to the major rock because it's so close to the sun. I also lighten the edge nearest the sun with some of the yellow-orange mixture I used for the glow. The rocks in the foreground and their reflections are also scrubbed in. This is just an underpainting of their local color. Both will later be influenced by the atmosphere.

The basic color of the foreground wave is viridian green with a touch of alizarin for the dark parts and a touch of cadmium yellow pale for the light areas. In the background, the swells have less viridian green and more manganese blue, since they're more affected by the sky color.

With a no. 6 bristle brush, I scrub in the shadow color of the basic foam, which is manganese blue added to white with a touch of alizarin. Then, with a smaller, no. 4 brush, I lighten the top of the foam with a mixture of white and manganese. Now that the local colors of these objects are established, I'm ready to paint the reflection of the atmosphere on top of it.

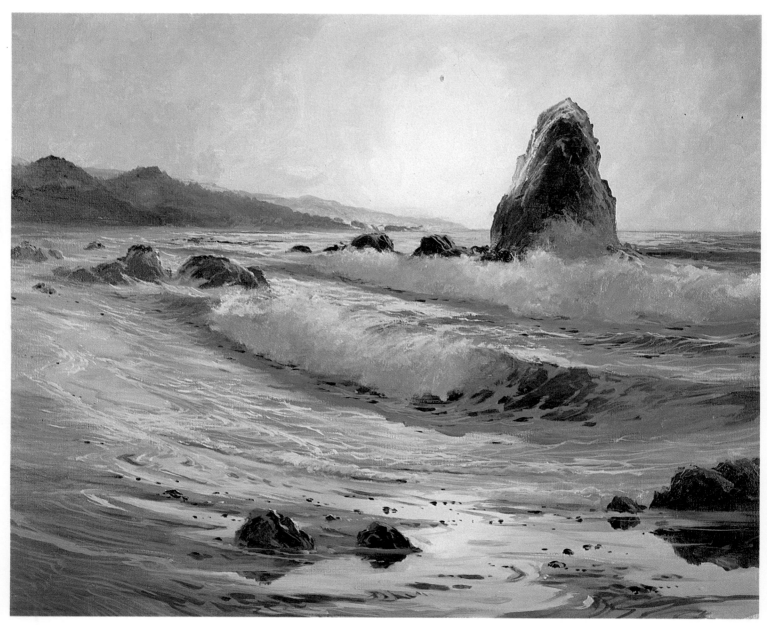

5. ATMOSPHERE

The atmosphere in this painting is really the colors of the sun glow, from the yellow-orange of the center to the blue of the sky. (I'm not including the white-yellow pale mixture because I consider that portion to be the actual sunlight.) To paint it, I go back to the tiny brushes, mostly nos. 00 and 0 round sables. But in this painting I don't start at the back horizon and work down, as I often do. Instead I start directly beneath the sun and work outward to each side. This is because I want to reflect

the changes taking place in the sky on the land below.

I start by reflecting the pale yellow-orange glow onto the sea from the horizon down to the foreground, spreading it directly below that portion of color in the sky. Next, I reflect the orange-blue color of the sky there in the same manner. Finally, I reflect the blue of the sky on the outer edges all the way down to the foreground. I also add a few more pebbles on the beach and reflect the atmosphere on the top of all the rocks.

Canon Beach. Oil on canvas, 24" x 30" (61 x 76 cm).

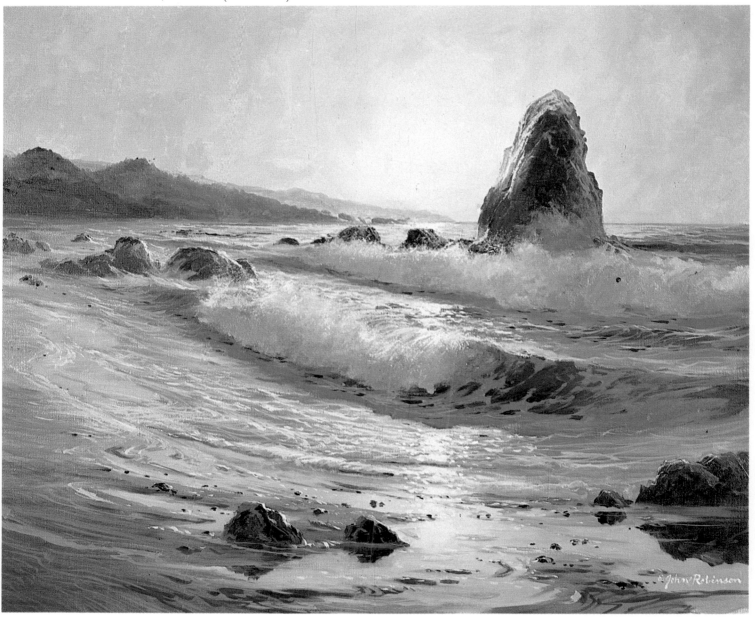

6. SUNLIGHT

There's very little added to the painting here, but I'm sure you'll agree that this final touch, the path of sunlight itself, is most important. To paint it, I use a mixture of a small amount of cadmium yellow pale added to white. With a no. 00 round sable I paint a series of short strokes to form a straight path from the horizon line down to the wet sand. Then I add a few small spots beside the path to show sparkle and put a few spots of sunlight glitter on the major rock where it faces the sun.

I now believe I've achieved what I set out to do: To feature the sun glow and yet still have a seascape. The composition is such that you first see the glow, then you're led down the path of light to the rocks and surf. Then, at the reflection in the sand, you're led back to the hills and return once again to the glow.

BIBLIOGRAPHY

Bascom, Willard. *Waves and Beaches; The Dynamics of the Ocean Surface.* New York: Doubleday, 1964 (paperbound)

Cooke, Hereward Lester. *Painting Lessons From the Great Masters,* New York: Watson-Guptill, 1972.

Hoopes, Donelson F. *The American Impressionists.* New York: Watson-Guptill, 1972.

Robinson, E. John. *Marine Painting in Oil.* New York: Watson-Guptill Publications and London: Pitman Publishing, 1973.

—. *The Seascape Painter's Problem Book.* New York: Watson-Guptill Publications and London: Pitman Publishing, 1976.

Sargent, Walter. *Enjoyment and Use of Color.* New York: Dover, 1923 (paperbound).

Special Section on Waves in Oceans Magazine, No. 5, September/October 1975, pp. 10-49. (Published by the Oceanic Society, San Francisco, California.)

INDEX

Analyzing
 clear water, 35
 composition, 24-25, 40-41, 56-57,
 72-73, 87, 101, 116-117, 132-133
 scene, 127
 sun glow, 127
Armed Knight, 67, 68, 70, 81
Atmosphere, 64, 80, 94, 107, 111, 140

Background rock, 78
Basic sky, 121
Basic water color, 106
Bibliography, 142
Breaker, 22, 53
Breaker foam and surface reflections, 47
Brushes, 17-18
 how to clean, 18

Canon Beach, 141
Canvas, 18
Cast shadows, 35, 53, 59
Clear shallow water and sky reflections, 36
Clear water, 34-49
 demonstration, 44-49
Clouds, 112
Clouds and background sea, 122
Color
 and mood, 43
 and value progressions, 135
 of moonlight, 111
 temperature, 119
Color sketch, 26, 42, 58, 74, 88, 102,
 118, 134
Composition, 21, 22, 27

Defining fog, 67
Developing ideas, 51
Developing movement, 97
Details, 15, 21, 49, 109

Drawing, 28, 44, 120, 136
Driftwood, 85, 113, 114

Easel, 17

Final details and sunlight, 48
Final sketch, 115
Foam
 and rocks, 31
 patterns, 23, 98
 trails, 39
Fog, 66-81
 color, 77
 demonstration, 76-81
Foreground, 123
 foam, 63
 rock, 69, 71
 underpainting, 62, 79

Glow
 on beach, 129
 on water, 128
Graying colors, 119

Haystack Rock, 127
Highlights and textures, 124

Importance of composition, 27
Introduction, 8-9
Island Surf, 48

Jagged rocks, 37

Lighting, 17
Lines, 24, 40, 43, 56, 72, 87, 101, 116,
 132

Major rock, 130
Marine Painting in Oil, 8, 21
Materials and equipment, 17-18
Minus Tide, 82
Mixing
 color of fog, 67
 moonlit sky, 119
 neutrals, 119

Moonlight, 110-125
 demonstration, 120-125
Moon's reflection, 112
Morning Fog, 66
Movement, 21, 97

Nature of water, 89
Near Kailua (Hawaii), 34
Near Midnight, 124
Near Morning, 110
Needles, 127, 129
North Atlantic, 108
North Country, 126

October Storm, 32
Open sea, 96-109
 demonstration, 104-109
Original sketch, 54, 131
Outlets, 82-95, 114
 demonstration, 90-95
Outline drawing, 13, 60, 76, 90, 104

Painting
 clear water, 35, 44-49
 fog, 76-81
 moonlight, 120-125
 outlets, 90-95
 sun glow, 136-141
 the big wave, 28-33
 the conflict, 60-65
 the open sea, 104-109
Painting locations
 Canon Beach, Oregon, 127
 Kona Coast of Hawaii, 35
 Land's End, Cornwall Coast of
 England, 67
 North Sea, 103
 Tintagel in western England, 51
 Vancouver, British Columbia, 97
Paints, 18
Palette, 18
Palette, knife, 18
Patterns, 99

Photographs, use of, 9, 127
Planning the mood and composition, 51
Powerful wave, 22
Projects, brief description of, 8-9
Proportions, 21

Quiet wave, 39

Rain Coming, 96
Reflected light and color, 89
Reflections, 30, 89, 100, 103
Reflections and rock underpainting, 30
Reviewing
 cast shadows, 59
 mood, 27, 43
 moonlight, 119
 outlets, 89
 reflections, 103
 spilloffs, 75
 sun glow, 135
Rocks, 38, 52, 55, 86, 93, 139

Sand rocks, 93
S-curved creek with value gradation, 84
Sea and Mist, 20

Selecting a subject, 11, 12, 43
Selecting the colors, 26, 42, 58, 88, 102, 118, 134
Shadow, placement of, 59
Shallow-water breakers, 85
Sketching, 11, 12-15, 23, 39, 55, 70, 86, 99, 114-115, 130-131

Sketching materials, 11
Sketching on location, 12-15
Sky, 29, 45, 55, 61, 91, 98, 105, 121, 125, 137
Sky and background sea, 29, 45, 61, 91
Sky detail, 125
Sky and reflections, 98, 105, 137
Slick, 83
Source of light, 27
Straight-line outlet with driftwood, 85
Studio study, 75
Studying the scene, 22, 36, 52-53, 68-69, 84-85, 98, 112-113
Sun glow, 126-141
 demonstration, 136-141
Sun glow and reflection on water, 84
Sunlight, 28, 32, 65, 81, 95, 108, 126-141
Sunshine and highlights, 32
Sunshine and textures, 65, 95
Surf, 52, 130
Swells, 97, 98

The Armed Knight, 81
The Armed Knight, 67, 68, 70
The Big Wave, 21-33
 demonstration, 28-33
The Conflict, 65
The Conflict, 51-65
 demonstration, 60-65
The Seascape Painter's Problem Book, 8
Tinagel Coast, 50
To the Sea, 95
Typical outlet, 83

Underpainting, 30, 46, 62, 79, 138
Understanding the cast shadow, 35, 53, 59

Values, 14, 21, 25, 41, 43, 57, 73, 87, 97, 101, 117, 133
Viewer response, 103
Viewfinder, 11
View North, 19

Water and sand patterns, 86
Wave and sparkle, 113
Waves, 21-33, 69, 70
Whitecaps, 99
Wind, 68
Working sketch, 86

Edited by Bonnie Silverstein
Designed by Bob Fillie
Production by Hector Campbell
Set in 11-point Melior